INTO NEON

A CYBERPUNK SAGA

MATTHEW A. GOODWIN

INTO NEON

A Cyberpunk Saga
Book 1
MATTHEW A. GOODWIN

Independently published via KDP

ISBN Number

Editor: Bookhelpline.com

Cover design by Christian Bentulan

For Amy and Eli, you inspire me every day.

PART 1

CHAPTER 1

Light crept up the walls as the sun peaked, an orange hue over a calm sea appearing on all six sides of the room.

Billions of pixels fired to life simultaneously. The recorded sound of lapping waves grew louder and the simulated smell of ocean air permeated Moss's nose. He had never been to a beach, never seen the sea or smelled the salt air, but it was as familiar to him as his own skin. *Lights*, he thought, and the simulation ceased. The overhead vitamin D lights flickered to life. His walls went blank, and a space opened next to the bed which slid out of sight. It would return that evening, washed and made up. As he did every morning, he stood up, feeling refreshed from a perfect night's sleep. *Bacon, eggs and orange juice.* He rubbed the base of his skull. His implant always felt odd in the mornings. He had asked his friends if they felt the same way, but none did. Though he had to admit to himself, the sample size was small.

The blue LED on his RePurp brand foodier turned on. He heard two dull thuds and the hiss of steam from the machine that was built into the wall in the small nook which served as a kitchen. The foodier slid out a plate with his juice and then two bags plopped out. He took the plate but was careful to give the bags time to cool.

Wake Up World. The wall in front of his table displayed the emblem of his favorite morning show before fading to the friendly face of Marisol Mae. Every morning Moss wondered at what time she must have to wake up in order to be on no matter when he tuned in. He was curious about what she was like—if she was as chipper off camera as she was on. Did she drink juice in the morning? Milk? Coffee? Did she bring treats for the crew on their birthdays? These thoughts floated about his mind as he watched the screen.

"Good morning employee. It's another beautiful day in Burb 2152 and if you're watching me, it's probably a good time to hit the gym," she said, smiling out from the screen. Moss loved her face in the morning but loathed the daily reminder to work out. Exercise was mandated by ThutoCo and while one was allowed to do it in the comfort of their own hex, it was monetarily incentivized to go to the floor's gym. "In local news, a severe storm hit B.A. City overnight but here in the burbs, we were unaffected. The storm warning systems worked to perfection and kept all employees safe and secure.

"In other news, 2152's very own Jonny Mukazi made it to the semifinals of Burbz Haz Skillz with his magic cards. I know I'll be rooting for Jonny tonight. Will you?" she asked into the camera and Moss knew he would be. He loved the show and always watched virtually from the audience after work. "If he is eliminated though, be sure to catch the new season premiering next week," Marisol continued. She kept talking as Moss ate and slid his dirty plate onto the waiting tray just before it glided into the wall.

He stood to get ready for the day ahead. He did not enjoy
the gym, but it was the only time in the day when he was guaranteed to see his friends, and that was the thing that made it worthwhile.

He arched his back before stepping over to his wardrobe. *Dermidos*. The door to the wardrobe hissed open as three metal arms unfolded from the ceiling. Moss raised his hands and the arms removed the white linen shirt from his torso before sliding off the white linen pants. He stepped out of the pants and the arms dropped them into a chute in the wardrobe for laundering. The arms then slipped on his Dermidos athletiskyn and sealed him in. It shimmered and buzzed as it read his vital signs and performed a health scan. His health and employment statistics appeared on the screen next to Marisol Mae.

ThutoCo Employee: 06187300

Days: 7,035

Weight: 77.14 Kg

Productivity Points: 7860/10000

He left his hex and stepped into the hallway. Fluorescent light filled the space with oppressive brightness and it smelled like freshly opened plastic wrap. He walked down the long white hall for what seemed to be an endless time, passing door after unadorned door. The space was silent except for his light footfall on the carpeted ground and the occasional screen projected on the wall where Marisol continued to speak.

Eventually, he entered the common space where small tables were surrounded by comfy chairs. A bank of elevators sat on the far side where, looking down into the open center of the burb. More hallways split in many directions and had lighted signs above. Employees were chatting, drinking coffee and watching television in the little area but Moss walked past without saying a word to anyone.

He followed one hallway toward the gym, smelling it before the doors even came into view, cleaning solution and sweat filling his nostrils. As he entered, he was greeted by the

backs of several men pretending to stretch or limber up before stepping onto the machinery. He knew why, and as he pushed through the throng; he saw them.

The Butler sisters were side by side on stair machines, stepping up and down in unison as the men leered. Twins in their young twenties, the sisters were as famous for their beauty as they were for their parties. Moss had never spoken to the sisters, much less attended one of their parties, but they were the stuff of legend. Moss paused a moment, watching the girls sway in their matching Dermidos second skins. Some of the men were staring so intently, Moss knew they were utilizing ocular implants to film the girls. As much as he enjoyed watching, the idea of saving it put him ill at ease and he began to make his way beyond the group.

"Moss!" he heard and snapped back to reality. He turned to see Gibbs and Issy on treadmills on the other side of the gym. They were both trotting at a slow pace, just enough to qualify for their daily incentive. He approached and Issy wrinkled her nose at him. This was the sign they had developed as children to indicate something was up. Moss knew her warning meant Gibbs was in a mood.

"Moss, we missed you last night!" Gibbs barked as he jiggled on his treadmill. His face was flushed, covered in a sheen of sweat. "Don't tell me you stayed home and watched Skillz when you could have been out with us!"

Moss hung his head in mock apology, admitting, "I stayed home and watched Skillz."

"Stupid," Gibbs admonished. "We watched the match and then chatted up some girls from Panel Repair. I even got one girl's hex number," he bragged as Moss stepped onto a treadmill between his friends. Issy scoffed.

"You guys had no chance with those girls!" she mocked. "Tell him what happened when you called her hex."

"Some guy answered," Gibbs said quietly before adding, "and had never heard of her. But she was drunk when we met and probably just said the wrong number!"

At this, Issy burst with laughter. "Oh, puh-lease!" she chided. "That girl wanted less than nothing to do with you, Gibby."

"Shut up, you don't know what you're talking about. And don't call me that, *Isabelle!*"

Moss listened to his friends bicker as sweat beaded on his forehead, legs, and back. Every now and again he stole a glance at Issy, but when she caught his eye, he looked away quickly.

Things had been different with her lately.

He had been in love with her since they were children. Their parents had been friends and enrolled them in the same company school. He had loved her for the way they played, the way she knew his mind before he did and when she grew into womanhood, he had lusted for her.

Gibbs had noticed, but when he asked about it, Moss used the ancient lie that, "she's like a sister." Gibbs had never bought it, but never pushed the issue either. For all his bluster, Gibbs was a good friend.

Everything had changed with Issy when Moss returned to his hex after a night of drinking and signed in to order a Relief Aide. When the question of customization appeared on the menu, he had paused. He knew people did it: had sex with their friends without consequence, but Moss had only ever entertained the notion. Gibbs had explained his night with the Butler twins in excruciating detail, but Moss had only groaned.

That night he found himself entering Issy's information and soon thereafter a perfect replica of his friend waited at his door. They drank together and, while the machine had none of

5

her personality, he stopped caring once he asked the facsimile to disrobe. He had run his hands over his friend in a way he had only ever dreamed. Squeezed. Licked. Entered. After his release though, he sent her on her way and was left with nothing but confusion, guilt, and a week's fewer wages.

Since that night, he could only look on her with shame, though she had seemed even sweeter, as though she could sense his discomfort and wanted to help. He shook the thought from his mind and sweat cascaded from his head.

"Watch it!" Gibbs snorted.

"Yeah, you're getting me all wet," Issy added and a chill ran down Moss's spine. The rest of the workout was uneventful, full of Gibbs bragging and Issy busting his chops. They parted ways and Moss was happy to return to his hex and begin his day.

He sat at his workstation and picked up his transmitter. He flipped the switch and felt the usual relay in the back of his head as his eyes faded from the world in front of him to the world outside the walls of the city. Hundreds, perhaps thousands of kilometers away where the bacteria was rampant, unprotected by the fields of misters, Moss's drudge, MOSS II, came to life and greeted its controller.

"Good morning, Moss," it said in a computerized version of his own voice. "Were Issy and Gibbs up to their usual antics?"

"You know it." Moss snorted with a laugh and MOSS II chuckled. The adaptive AI was becoming more like his controller every day—by design. The company took their employment motto, "work with yourself," very seriously and utilized brain maps to make the bot and operator as close as possible. ThutoCo had attempted fully autonomous units in the

past, but they never measured up to their guided counterparts. Despite huge advances in artificial intelligence, the drudges still required a human component. One which Moss was more than happy to provide from the comfortable solitude of his own hex. He loved spending the days with MOSS II, preferring him even to the company of his friends.

"How have you been?" Moss adjusted his sitting position, getting comfortable for the day's work.

MOSS II let out a digital sigh. "The night operator got me wedged in a service pipe and I spent most of the shift waiting for a repair unit."

Moss grunted. He wouldn't be so bothered if it weren't such a common occurrence but he felt like the night crew were dinging his drudge at least once a week. He observed once again, "they need to fab more repair units."

"They also need to fab more drudges in general," MOSS II added with disgust lacing his voice, a near-perfect mirror of how Moss would say it.

"Seriously, they shouldn't be dividing you guys between operators. I'm so sick of night shift denting you," he griped.

"Drudges are a scarce resource imported from another city at great cost to ThutoCo," he said the company line. Moss hated it when corporate programming overrode the AI.

"I know, I know," Moss groaned. "I just wish I didn't have to share you is all."

"Employees who reach Promotion Level Three receive exclusive use of a bot and at Promotion Level Five the right to customize their unit," MOSS II reminded him as though it was the first time.

"Yeah, thanks, Two," Moss moaned, fully aware of company policy. As he did every day, he regretted naming his

bot MOSS II. He had been so young when he began work and when he had been given the chance to name his drudge, he gave him the first name which came to mind. As employees were not given a chance to rename them until Level Three, he had been stuck with this name for years. He had spent countless nights trying to concoct a better name, but since he had only earned Level Two the year before, he had a long way to go before it would matter.

"Depot 2428 was raided last night," Two informed him.

"Really? Feels like it's happening all the time now. Scubas?" Moss asked, knowing the answer before he heard it. The company clearly wanted its employees to know some information, but not much.

"Don't know and couldn't tell you if I did," MOSS II answered easily.

"I know." Moss sighed. He would ask Issy later. Even though she worked internal Burb Security, she usually had good intel on what was happening outside the walls. "What's our first assignment? I can't expect to make Level Three if we shoot the breeze all morning."

"Truer words…" Two said. "First up is a panel repair." The HUD display in the corner of Moss's vision showed the direction of the needed repair. MOSS II stepped off his charging pad, walking over to a waiting solar bike, which Moss borrowed from the company without reading the Licensing Agreement— he knew he would be paying it off for years if he wrecked it. MOSS II threw his leg over the seat, gripped the handles, and after a quick interface, the bike hummed to life. It lifted easily off the hover-pad and Moss drove it out onto the service road.

What used to be an asphalt motorway had now fallen into disrepair and was cracked and broken where it hadn't been reduced to rubble. But it was a clear path and the bike glided above it easily.

The sun was still low. Waves of heat radiated off the ground. Moss had never experienced heat like what he saw through Two's camera, but it looked unpleasant and he knew it could damage the drudge over time.

Moss followed the indicator north along the road until he had to turn into the sea of solar panels. The cameras compensated for the dark of the shade as his drudge rode over the flattened earth between the tall metal supports. He hummed along the desolate sameness until the indicator blinked that he was getting close. Another bike sat parked at his destination.

"Oh, dick!" Moss said.

"Use of such language is unadvised and you will be docked one Productivity Point for the day," Two informed him sullenly.

"I know," Moss groaned, holding his minds tongue from further expletives. He parked next to the iridescent blue bike with painted red and yellow flames rising from the levitengine at its base. Ira had beaten him to another work order and while the practice was frowned upon by fellow engineers, it was allowed. It infuriated the employees to no end, though they all understood that the company wanted to encourage the competition. More work got done if every employee was in constant risk of having someone else complete their job. People like Ira may have been loathed by their coworkers but the company loved them. Ira's drudge jumped down from the panel with an unnecessary flourish as "Work Order Complete" flashed on Moss's display.

"You have to get up earlier than that to beat me," said an automated voice from Ira's drudge. The sound was unnaturally computerized as the company had never quite perfected neural voice output.

"You know that was my W.O., Ira," the same computerized voice said from Two's speaker. It didn't properly

convey the anger and jealousy he felt. Ira's drudge was painted in the same blue and yellow as his bike and Moss loathed how cool he thought it looked.

"Whatever, lame-name. You know I'm called Osiris out here," the drudge said, and Moss could hear the condescension even if it wasn't relayed. The dig at his drudge's name landed hard and he moved MOSS II fast toward Osiris.

"Your planned course of action is a violation of corporate policy and shall not be enacted," Moss heard in his mind's ear as Two ground to a halt. Laughter emitted from Osiris's speaker. It was an unnatural sound which always sent a chill down Moss's spine.

"Listen, friend," Osiris said as he strode toward Two with his metal head held high and an arm outstretched. "You're young. If you want to make it out here, you must do some things which piss people off. You want to be a saint? Have fun staying Level Two forever. I'm Level Six. I got a sweet paint job for my drudge, own my own company bike, and have a three-story hex.

"You think I care if I annoy you? You think it matters to me that Jenny screams at me because she can't complete an order as fast as me? Or that Burt lectures me about ethics?

"No. My life is great. The company loves me. I have everything I could want. So, take note kid: you want to make it in this world, you have to do what's best for *you,* regardless of the consequences."

Now it was Moss's turn to laugh. Just a slight, quiet chuckle. "What a sad way to live," he muttered to himself, but Ira heard it.

"When you log out tonight, look around and tell me who's sad," Osiris said as he mounted his bike. Moss didn't answer. His moment of superiority had passed, and he worried

that Ira was right. He had never done anything of note with his life. Nothing out of the ordinary or unexpected. Nothing even interesting. He wanted to log out, go sit and sulk alone in his hex. But no.

Ira was famous around the burb for this. Moss had never met the man or anyone who had met him, but everyone knew him. Word around the office was that there was one like him in every burb—someone who took advantage of the system in such a way to benefit themselves. People loved to grumble about him, stand around after work complaining about how he moved in and took their jobs, but it's how the company wanted it. They fostered the competition and rewarded employees like Ira.

For as annoying as Moss found it, there was truth to what he had said. Moss had almost no perks in his hex, he had an unadorned drudge, and still had very little saved. He was fine at his job, but not great and didn't aspire to be. He was content in his life, but that was it.

He snorted as he brought up the menu of available work orders. As he always did, he picked the next nearest job rather than the highest priority (and therefore highest value) job. Moss grimaced, Ira's words still ringing as he rode off. Moss felt a pang he couldn't quite identify.

"He's right," Moss said.

"You believe Osiris is correct?" Two inquired.

"Yes, bring up the full list of all work orders, regardless of availability," Moss said with a grin. Two did so and Moss looked at the display. Moss had watched Ira head northeast toward the road. He saw that the top priority job was in the same direction and had an engineer assigned. They were seven minutes away. If Ira stuck to the road, Moss thought he would arrive in five. He brought the job to the forefront.

"Chart the quickest path to this job, the direct route," Moss ordered.

"This job may be of higher difficulty than—" Two began but Moss cut him off, firing up his bike's engine.

"Just chart it!" he demanded.

"Of course," Two acquiesced, displaying a line directly to the work. The bike rocketed through the field of panels, the thrusters kicking up earth and rocks as he sped to the job.

"Any damage to your bike—" Two began, but Moss was too excited to let him finish.

"I know it. I'll make up for it in job completion," Moss announced. He kept an eye on the time as he weaved through the fields. The company docked pay for time spent without designating a work order, but Moss did not want to give Ira a heads up to his plan. He felt a thud and the bike bounced over a large rock that he had not been quick enough to avoid. But he smiled. He was making good time.

Soon the dot of the job appeared in his HUD. He was close. He saw the panel sparking in the distance and it drove him forward. He would stop for nothing. He saw neither Ira's drudge nor the assigned engineer. A devilish smile crossed his lips as he selected DESIGNATE JOB and turned his bike to come to a stop with a flourish at the base of the panel.

ACCEPT WORK ORDER.

His heart raced. The job was his.

Osiris pulled up a moment later. "Well played, kid," he conceded and Moss knew that somewhere the man was kicking himself.

"All's fair." Moss heard the bravado in Two's transmitted words. Osiris gave a conciliatory nod before fishtailing his bike in a plume of dust and speeding away to steal someone else's work. Moss beamed a moment before realizing

he now actually had to complete the repair. "All right, Two. Let's do this."

"Yes, sir," the drudge replied, and they got to work.

As he finished the complex job, he heard a pounding and shook his head, Two's robotic head moving back and forth in near unison.

"You hear that?" Moss asked.

"Negative," Two replied and Moss brought up a system check which ran instantly. SYSTEM NORMAL, the screen displayed. He heard the pounding again. "Could the sound be coming from your hex? There have been four reports of malfunctioning pipes on your floor in the past two weeks, according to records," Two helped.

"Could be. Go into Standby for a moment?" he asked and heard Two whir down.

He flipped the switch in his hand and blinked hard at being in the real world so quickly. His implant felt awkward. As his eyes adjusted, he heard the pounding one more time and realized it was coming from the door to his hex.

Doorbell, and the screen displayed the empty hallway in front of his door. He furrowed his brows, confused and bothered. He didn't understand how someone could be knocking on his door, as that was what he had decided it sounded like, but not be in the hall.

Moss heard the pounding through the heavy plastic door and muffled words. Nervous, he walked over and pressed OPEN. The door hissed up and before him stood an angry looking woman dressed in the most peculiar way Moss had ever seen.

"Take longer," she growled, and Moss just stared. She wore a white fishnet bodysuit which showed from within her tall, black leather boots up to her neck. From a studded black

leather belt hung a tartan skirt cut with slits and an ancient military style baltea—studded leather straps which served as groin protection. The ensemble was completed with a tattered leather jacket with small metal spikes running along the shoulders and down the arms with patches covering nearly every inch. Her neon pink microdyed hair shimmered with silver like a cascading waterfall. Black eyeliner smudged with sweat encircled impatiently expectant eyes.

"You gonna let me in?" She gestured for Moss to move inside before looking back and forth down the hall. "We don't have all day to stand here, are you ready to go?"

"You have the wrong person," Moss squeaked, positioning his body to keep her at the door. She was instantly the sexiest and most terrifying thing he had ever come in contact with. He questioned if he was in the midst of a lucid dream. This person could not be real. She wasn't actually standing before him. She rolled her eyes and shoved him into the hex, slamming a hand against the CLOSE button on the door frame.

"I don't have the wrong person," she said in a tone which made Moss feel as though he was stupid.

"Who—Who are you?" he forced from his mouth.

She answered his question with a question. "You're Moss right?"

"Yes," he said, utterly nonplussed.

"So, what's the fucking hold up?" she snarled. Moss looked around the room as though there would be cameras set up. He had seen shows on the Burb Network where the hosts would play pranks on unsuspecting employees. The woman seemed to watch his eyes.

"Are we being watched?" she accused more than asked.

He held up his hands and his voice shook. "What? No. I don't know."

"What's your problem? You don't seem ready to go at all, I don't see a bag and you're wearing." She grabbed his sleeve. "What are these, pajamas?" Moss's heart was racing, and he could feel sweat coating his body. He had never been so confounded in his life and this angry person was talking to him like he was someone else.

He found some courage buried within him.

"Look, I don't know who you are, what you think you're doing here, or who you think I am, but I am not the person you are looking for," he stated, trying to square his shoulders and look tough but even he knew he looked weak. It was the woman's turn to look confused.

"Chicken Thumbs never found you?" she asked and Moss didn't understand the question or know how to respond to it.

"What does that even mean?" he asked and the woman dropped her head, her shoulder length hair shimmering in front of her face.

"Shit," she uttered and looked back up at him sorrowfully. "Sit down."

CHAPTER 2

W ho are you?" Moss demanded in as tough a voice as he could muster.

"Ynna," she answered, turning her eyes on him. In them, he saw several lifetimes of age though she appeared to be only a few years his senior, if that. "Please, sit down," she said in a softer tone which made him all the more uneasy. He complied and sat in the single chair by the Foodier. "CT was going to fill you in on all this, but maybe he got caught." The word "caught" made Moss even more nervous and he unconsciously began bouncing his knee.

"What are you talking about?" he heard the resignation in his own voice as if he had accepted the defeat of pure confusion.

"Listen, Moss, you are part of something. Your parents—" Ynna began but was cut short.

"Alert!" a computerized voice crackled through the speaker in the room and Ynna's eyes went wide with terror. "You have been away from work for five minutes, employee. If you are experiencing medical distress, please enter your Dermidos and allow for a scan. ThutoCo values you and your health."

"The fuck?" Ynna asked.

"It's my shift. I can't just log out during work," he explained.

"Yikes," she mocked but Moss didn't understand. "Can you deal with that? We need a little time."

"Yeah, uh, okay," Moss mumbled as he stood. He walked over to his workspace and began entering the manual commands on the screen.

APPLICATION FOR EARLY BREAK.

A drop-down menu appeared, requiring a reason for the request.

PERSONAL TIME.

It was instantly approved. Moss had not used any personal time in years and had more than enough accrued to take the rest of the week off. Content to work during the day and watch the screen at night, he had never used a vacation day either. He often told people he wanted to get out and see the world, and he did. Theoretically. Something within him did want to experience what the wider world had to offer but he had become too content, too complacent to act on it.

He had used one sick day. It still haunted him—the one taint on an otherwise perfect record. But he was too sick to move from his bed and DocBot gave him such a heavy cocktail of drugs that Moss slept through nearly the whole day. He was fine by the following morning when he found out that most employees had spent the previous day the same way he had. The rumor was that some of the bacteria which made the land outside the cities poisonous to humans had gotten into the food, but Moss thought it doubtful.

He believed ThutoCo when they explained to the employees that the bacteria from the Prophet Root (which had saved and cursed humanity) had never made its way into the food distribution subsystems.

"Okay," he told Ynna. "We have time." He didn't know why he was accommodating all this. He could easily call security

silently and have this woman taken away. He couldn't understand why he didn't do it. It would be so easy. Be done with this entire moment so quickly. Make it a memory of that one time some weirdo showed up at his hex. He knew that with every passing moment, he could be getting himself into trouble. But he didn't send her away. He sat down and waited for her to speak. She did.

"Okay, Moss, here goes," she began, seeming to struggle to find the right way to explain things. "CT would have been able to explain this better. I was not supposed to, but whatever. You are one small cog here in a massive, *evil* industrial machine. But there are people outside who are working to expose ThutoCo to the world. We are trying to get information out, but we need help from within and that's why I am here. To help you help us."

Her crystal blue eyes stared into his, reading his reaction. He didn't understand what she meant. Employees complained about their jobs and the Iras of the world, but he had never heard the word evil ascribed to the company.

"We feed the world," he protested.

She rolled her eyes. "Sure."

"And off-world too!" he added, pointing a finger toward the ceiling to help his point.

"While that may be true, you also kill the world," she pointed out, clearly trying to suppress anger. Her eyes narrowed and her fingers dug into her knee.

"Some death is the price of all life," he parroted another company line. Ynna groaned, seeming to hate that she was even engaging in this conversation.

"Do you know how people live outside of this building? Have you ever even left it?" she pressed.

"No," Moss admitted, feeling ashamed of himself though he didn't understand why.

She looked at him with a mixture of sadness and pity. "Well, it's bad out there. You'll see tonight."

"What's tonight?" he asked nervously, not sure he wanted the answer. He was beginning to feel as though he was careening toward the edge of a cliff and while his knee bounced more than it ever had in his life, a curious spark of excitement was igniting a flame.

"Tonight, you take this to me at a bar in the city" and she extended a robotic hand out to him, the metal fingers unfurling like the legs of spiders to reveal a data chip. He stared at her hand, the crude exposed wires, gears and rusted bolts. He had never seen anything like it. Any cybernetics he had seen were near-perfect recreations of the human form.

The Relief Aides were nothing more than metal, silicone, and plastic wrapped in a polydimethylsiloxane skin, yet to touch and see them, they were as real to him as people. Her hand was more drudge than a person.

"What?" he asked. "Why would I take it? You take it."

She looked at him pityingly. "I can't take it. I barely got in here, there is no way I'm getting out with ThutoCo technology. But you can."

"Why would I?" he snapped, saying it before thinking.

"Because you're in this now," she said holding the chip toward him.

"No, I'm not, not yet. I don't know you or why you think I should be involved, but I'm not *in* anything," he stated, not sounding nearly as firm as he hoped.

She stared at him with steely determination. "You are."

"Maybe I'll just call security, give them whatever this is," he said as he picked the chip out of her hand.

"You could, but you won't," she said with cool confidence, knowing something he didn't.

"Why not?" he asked.

"Because it's not what your parents wanted," she stated, and Moss felt as though he had been pushed off a cliff.

"What?" he heard himself mutter. "My parents are dead."

"No shit," Ynna barked a laugh that sent a cold chill skittering down his spine. "But they were a part of this. Shit, they're basically the cause of this. And they wanted you to be also when the time was right. And the time will never be righter than now."

"You knew them?" Was all he could force from his lips. It had been so long since he had seen those flashlights in the night. So long since he had seen his parents.

"Yes," Ynna said softly and put a human hand on his. "They wanted this for you."

He knew it was the truth. He felt as though he should doubt her, but he knew. The fact that this strange person had known his parents made more sense to him than anything the ThutoCo representatives had told him. Thousands of questions poured into his mind at once. He wanted to sit this woman down and ask her everything about his parents, the company he worked for, and the outside world. He felt moved to be a part of whatever this was. Leave this place and never look back. He was jarred from this by another loud noise and flashing red lights.

"Security alert! Please remain in your hex and await further instruction," a synthesized voice commanded through the speaker in his room.

"Oh, shit, I thought I would have more time," Ynna said, terror plain across her face. "Meet me at the Long-Legged Spinners at 02:00 hours," she ordered and Moss realized he still held the chip in his hand.

"Here, let's wake you up." Ynna pressed her robotic hand to the implant point at the base of his skull, one of her eyes going

black and causing his vision to flicker. When she was finished with whatever she was doing to him, she darted across the room, pressed the metal hand on the door panel and was gone before Moss could even react. After a moment, he got his bearings and pursued her to the door which had shut instantly upon her departure. He pressed OPEN but the screen read, UNAVAILABLE AT THIS TIME. He was locked in the space amidst flashing red. He knew his life had changed.

CHAPTER 3

"After a minute, the flashing red light stopped, and the normal lighting returned. He looked down at the chip in his hand. It looked like any other, like the twenty or so assorted ones he had in the drawer next to his workstation. He flipped it over in his hand, contemplating what had just happened, and still not entirely believing it.

He had a headache. He knew he should log back into work but guessed that most people had probably logged out too when they heard the alert. Hundreds of miles away, in toxic fields, solar farms, and mines, drudges were standing as statues frozen in time—gargoyles of the technological age.

Moss rubbed the back of his neck. His implant bothered him more than ever. He looked at the clock display at his workstation. 10:23 a.m. There was still so much of the day left and he did not know what to do with himself. He was tempted to simply hand the chip over to security when they arrived, but he wasn't sure. He couldn't tell what he wanted to do anymore.

Call Gibbs, he thought, having programmed his friend's hex number such that he could simply place the call by name. "The employee you are trying to reach is currently experiencing a security alert. Do you wish to attempt an override? Your call

will be monitored for security purposes. ThutoCo takes the safety of its employees seriously." Moss ended the transmission and sat in silence.

He thought about Ynna. The anger, desperation, and intensity of her eyes. He wanted to see her again. He wanted to know what this was all about, but more than anything, he wanted to know more about his parents.

The panel on his door buzzed and Moss hurried to jam the chip into the drawer of chips.

PLEASE BE AWARE. BURBSEC ENTERING IN 5, 4, 3, 2, 1….

And the door slid open. Two BurbSec officers entered, covered head to toe in black fibermail mesh topped with gray plate armor. The ThutoCo logo was emblazoned on their shoulders and nothing more than their faces were exposed to let one know they were people rather than machines—though, with the helmets closed, they would be nearly indistinguishable. Kingfisher particle beam pistols hung on their belts, clicking ominously against their leg armor.

The first face which entered was that of a man Moss didn't recognize. Bearded, with suspicious eyes and a scar on his forehead, he looked around the room, analyzing everything. Issy followed behind and gave a quick wave to Moss. He hurried over and sidled up beside her.

"What's all this?" he whispered.

"We don't know much more than you: data breach. But we are doing a room-by-room check. It'll probably take all day," she told him and looked up at him with a small smile.

Retinal analysis, he heard in his mind's ear. It was like that of Issy's voice, but different and foreign, as though he was hearing her speak to him underwater. The realization of what this meant struck him.

He had not understood what Ynna had meant when she said, "wake you up," but it was now clear. She had hacked his implant, so he could now hear other's neural commands. More than the fact that she had set off a burb-wide security alert, the fact that he could do this truly meant that what he had experienced had been real.

But why had she done this? What was the point of him having this ability? And why was Issy scanning him while they spoke? He knew security officers had one eye replaced so they could run analysis while working, but he never expected his friend would use it on him. He was also surprised she would suspect him. In their years as friends, he had never done anything wrong, illegal or even slightly outside the rules.

"Everything all right?" she asked, more supportive than accusatory. Moss heard a man's voice, *scan for POI*. The male guard was using his eye to check for anything out of place. Moss's eyes darted around the room.

"Yeah, it's just—this is all intense," he answered truthfully, wondering what his eyes were telling her.

"It is," she agreed, a hint of excitement in her voice. "It's cra-cra-crazy!" she said, bumping him slightly with her shoulder and Moss smiled nervously.

"So, they haven't told you anything?" he asked, trying not to sound as though he was pumping her for information.

"Nah, as I said, it's all hush-hush," she whispered while her partner walked slowly around the room, scanning the space. With almost everything in the room having slid back into the walls, there was little for him to examine, though he made a show of it anyway.

"Gotcha," Moss answered as easily as he could muster and pressed a finger against his lips in a playful shush.

"But word this morning is that it was a big one," she said, and her partner almost imperceptibly cocked his head, obviously listening as he ran his fingertips over Moss's Foodier.

"Oh," Moss muttered, intensely watching her partner make his way around the room.

"When I was assigned this sector, I made sure we came here first so you could get back to work," she said but Moss was hardly listening as her partner neared Moss's workspace. "Moss?"

"Yeah," he answered and turned to look at her. He watched her pupil dilate mechanically. Could she tell how nervous he was? That he was hiding something? His heart raced. He could feel sweat rolling down his sides under his loose shirt and he wanted to ask why his friend suspected him but was acting so cavalier.

"I said I wanted to make sure you could go back to work," she said with a wink and for a moment, he forgot about everything else.

He laughed, and it sounded awkward even to himself as he said, "thanks."

"No problem. Some people are going to have to wait quite a while, and there is pretty much nothing you can do," she explained.

"I noticed," Moss said as the man pulled open his drawer to expose the pile of chips. His palms were damp, his breath short, and he nearly blurted out the truth. He did not. He simply swallowed hard as the guard looked up at him.

"What's all this?" He asked as he ran a gloved hand through the chips, causing them to roll and click around the drawer.

"Porn," Moss blurted without thinking.

"I'll bet it is!" Issy cried out laughing and gave him a light punch on the shoulder.

"At least he's honest," the guard said to Issy, picking up a chip thoughtfully before dropping it back in the drawer.

"Oh, he's nothing if not honest, Clam," she said, still chuckling. She whispered excitedly, "oh, Gibbs is gonna toast you for this one!"

"Ugh, I know," Moss replied with a hangdog look and sighed a deep relief as Clam closed the drawer. He couldn't believe the moment. He was hiding an intense terror for something he didn't understand and these two had no idea. He felt the weight of guilt on his chest. He was lying to the world, hiding something from the employer who raised him from a boy, from his best friend whose family had cared for him when his parents went away. He was exhilarated, too. He had pulled one over on everyone. In a few short moments, he had picked a side and gotten away with deception.

"My dad says 'hi' by the way," Issy added as Clam continued around the room. Moss felt as though, now that they had checked and not found anything in the one place something was hidden, they should be on their way. But he continued to sweep the room.

"Give him my love," Moss said, and he meant it. Vihaan had always been so kind to him, treating him almost as another child.

"I will," Issy said happily, shooting Moss the smile which had made him weak in the knees for years. "I won't mention the porno," she added with a wink and he felt that same guilt about the Relief Aide which he felt so often of late.

"All right," Clam said. "The kid's clean."

"Of course, he is," Issy said easily.

"If you're quite done flirting, you can check him off the list," he said, so matter-of-factly that it dumbfounded both of them.

"I wasn't flirting," Issy protested, turning a shade of pink he had not seen in what felt like an age and for the first time, Moss felt a glimmer of hope that she felt the same about him. *End analysis*, Moss heard, and it almost sounded hurried. Issy looked down to the screen on the forearm of her armor and made a note.

"Hex cleared, thank you for your cooperation. Employee, you have been awarded five Productivity Points," the voice announced through the speaker.

"All right let's get out of here," Clam gestured for the door before looking at Issy and pointing to the drawer. "With all that, who knows what he wants to do to you."

Issy was not caught off guard this time and said wryly, "oh, I know what he wants to do to me."

Moss nearly collapsed to the floor. What had that meant? She had never joked like that with him, always treating him like a brother.

"You two are wired," Clam said, looking down on both of them as though they were children.

"Dinner with the 'rent tonight?" Issy asked and Moss remembered that he was supposed to leave the burb for reasons he didn't understand.

"Maybe later in the week," he forced from his now intensely dry mouth, his tongue moving like cardboard.

"I'll hold you to that." She smirked and the two turned to leave.

Alone in his hex, an oppressive, near silent electric buzz closed in around Moss. Everything in the room emitted a sound

which he had never before noticed but which now seemed to press on his brain.

He sat in the middle of the room, pushing his hands on the plastic floor for support. He was exhausted. Not physically tired but psychologically drained. In back-to-back moments, his world had turned upside down. He crawled over to his workspace and called Gibbs again but got the same automated reply. He needed to talk to someone, let one train of thought leave his lips rather than having them all bang around in his head.

Shower. The small door at the side of his hex slid open and the water began to run at the preset temperature. He stripped, not bothering with the automated dressing arms and left his clothes crumpled on the floor. He stepped in, letting the water pour over his thin, muscular frame. Black hair matted over his closed eyes.

What was he going to do? He had lied to Issy, but it wasn't too late. He could call her back, tell her everything and help her earn that promotion Vihaan insisted she deserved. He could win her favor that way. Maybe she would see him differently then. Maybe she already did. Perhaps he would even get a promotion for his duty to the company or be jailed for his part. He could be dragged away, have his bounty sold to Carcer Corp, and stay locked away for the rest of his days. Once more, he needed to speak to someone.

Shower off. Dry. The water reduced quickly, the vent covers opened and warm air began swirling around the tight space. He stepped from the shower determined, put his work linens in the laundry chute manually, dressed in a clean outfit and headed toward the door, followed by the buzz in his head.

He stepped from the cold floor of his hex onto the soft carpet of the hallway, his light slip-on shoes sinking slightly into the ground. Pairs of security officers were entering and exiting hexes and he heard shouting as he moved down the hall. He

passed an open door and watched as two guards wrestled a heavyset naked man to the ground.

"Desist, employee," one of the guards shouted through a closed helmet. Moss started as the two forced his hands and the man screamed indistinct obscenities. He jiggled as he writhed against them. Moss could not move, transfixed by the scene before him.

He had never witnessed violence in his life. He had played at it in video games and watched it in movies, but this was completely foreign to him. It was ugly and brutal, and he hated to watch it but could not look away. One of the guards looked up and barked, *close* in his mind before the door slid shut.

With every passing moment, Moss became more convinced that the day was a lucid dream and he would soon awaken with no memory of any of this. He reached out a finger and ran it along the white wall, bright under the fluorescent lights. It was there. He tried to put it all from his mind and forced his legs to carry him toward the elevator.

It was a long way through the rows or hexes, dotted occasionally with restrooms, common rooms and gyms. At the center of the burb lay the elevators which looked out over an open space from which one could see all the floors of the structure. At the top was a massive skylight to let in the gray natural light and at the bottom, a shopping area and menagerie. The shopping space was for those employees who preferred browsing racks of items rather than picking something off a screen and having the item delivered to their hex.

The menagerie housed a clone of some long extinct animal which served as the mascot for the burb. 2152 had tigers, which yawned and lazed on heated rocks amidst plastic trees. Moss loved to sit and look at the animals, wondering absently about a time when the massive beasts roamed the earth. He

marveled at their impressive jaws and paws and couldn't believe that so weak a species as man could drive them to extinction.

He looked down at the tiny orange specks and called for the elevator which dropped quickly to his floor as the halls were largely void of people. Moss stepped in and rode to the top floor, his stomach turned. His body was so unaccustomed to the rapid movement that he was always left queasy during the ride.

The hexes at the top here were larger than those below, with glass-paneled walls looking into the office fronted apartments. People sat at desks with holoprojected monitors before them as Moss passed, hearing their commands: *data analysis, collate information, check drudge,* all rather innocuous but no less dumbfounding to Moss. He was wracked with guilt, ill at ease with the invasive nature of this newly unlocked skill.

He made his way to the office of Mr. Greene and knocked on the glass door. He watched as his mentor looked up and smiled, a hint of confusion on his normally stalwart face. Mr. Greene had hired Moss right out of school—though he had not placed high on his aptitude exams—and taken Moss under his wing, helping to guide him into his career as an engineer. Though he was still unsure what he was going to say, he knew he needed to say something to someone.

Allow entry, Moss heard Mr. Greene command his personal drudge, who complied wordlessly. Or thoughtlessly. Moss was unsure how even to categorize the machine. While the drudges in the field were hulking robots, designed to withstand the elements, the office variety were much more human in their design. Their form was that of a person, though skinless and mechanical, all polished plastic and metal. Their heads had a screen where the face would be. Most managers used it to display information, but others had a computer-generated human face display. Mr. Greene was one of the latter, preferring, as he said, "the human touch."

The machine approached the door which moved slightly back before sliding along the wall. "Good morning, Moss," the face of a handsome young man said in a near-perfect rendering of a human voice. Moss couldn't believe it was still morning. He felt as though a year had passed since he first heard the knocking on his door.

"Good morning, Erik," Moss replied in affected nonchalance.

"Hey, bud," Mr. Greene welcomed in his nasal, monotone voice, standing and waving Moss in. "You came without an appointment; this must be important." Moss moved over and sank into the comfortable chair opposite the older man. Mr. Greene was a third-generation employee. His grandparents helped establish Burb 2152. He had a picture of them mounted on the wall behind his desk, the young couple standing and smiling in front of the burb with a "Grand Opening" banner hanging over the door.

"They looked so happy," Moss mused, surprised he had said the words aloud. Mr. Greene turned in his chair to look at the picture as well.

"They were," he agreed. "Will and Linda Greene were pioneers of a new work style. They gave us what we have today. They may not have been trailblazers like the colonists, but they created a new world in a different way. At the time, you must understand, not everyone was enthusiastic about living in employer-provided housing, to say nothing of sending their children to employer-provided schools. Many needed convincing and my grandparents were among the first to help pitch people on the idea." He beamed with pride, as though he himself was the one who had the accomplishments.

"Trendsetters, definitely," Moss agreed, calming down slightly for the first time all morning, comforted by the small talk.

"My brother still lives in Hex One. It's been in our family since that day," he said, hooking a thumb at the picture.

"Neat," Moss said, looking at the photo of two happy people posing on opening day. The picture was rendered in black and white to give it an old-time appearance.

"What's up, Moss?" Mr. Greene asked, and Moss looked down at him. His beard was precisely manicured, his small brown eyes calculating behind rimless glasses.

"Something happened today," Moss started. *Begin security recording*, he heard in his mind and realized that Mr. Greene was now filming their conversation. It made him uncomfortable and he shifted uneasily in the chair. He had always counted Mr. Greene as an ally but now he was recording him. Moss swallowed hard and felt his leg begin to bounce again.

"What happened?" he led.

"Well," Moss stuttered, steeling himself to just tell him everything. "I don't even know how to describe it."

"You can tell me," Mr. Greene pressed with a hint of impatience in his voice.

"It's just—" Moss began before he heard, *security on standby*. Erik shifted into a slightly aggressive posture, its mechanical arms raising ever so slightly. Moss couldn't believe it. "Excuse me?" he blurted without thinking.

"Excuse you, what?" Mr. Greene said suspiciously, his eyes narrowing to slits. Moss was enraged. His hands were fists, shaking. This man, who he had counted on, trusted when he felt he couldn't trust anyone had called security on him. His rational mind screamed that any good manager would call security when a nervous employee came to them during a lockdown, but that voice was quashed by the fury of betrayal. The room felt tense, tight, like the oxygen was leaking out. Moss tried to keep a serene expression on his face.

"Excuse me for coming unannounced like this, it's just-"

"Just what?" Mr. Greene growled. All pretext of friendship was gone.

"Just, Ira stole another work order today and I think I need some vacation time," Moss said, deciding to keep his secret.

"Oh." Mr. Greene played at relaxing, but his body was still taut. "That's what you came here for? Moss, are you sure about that?"

Moss let his head drop. "Yeah."

"You don't need to come to your supervisor to register for vacation time, but I can certainly help you set it up since you are here." And while his tone had turned kind, Moss felt something just under the surface; lurking like a shark in the deep blue, ready to strike. "When were you hoping to take your days?"

"Tonight, well, tomorrow that is. That's why I came to see you since the system requires a week's advanced notice." Moss was impressed with himself that for a second time in the day, he had covered his tracks so quickly.

"I see," Mr. Greene said, sounding less dubious and more himself. "Ira really got to you?"

"He did. I think I just need a break," Moss answered as Mr. Greene opened his file, lifting his glasses to squint at the screen.

"You've never taken a vacation before," he observed. "Why now, just the Ira thing?"

"Yeah," Moss said.

"Not all the security action?" he fished, staring into Moss's eyes, gauging his reaction. Moss was disappointed that the man who he had trusted for so long seemed so suspicious of him, but he understood why. Mr. Greene had been a company man his whole life and valued ThutoCo above all else. He had tried to instill the same feelings in Moss, but they never quite took.

"Nah, I cleared that easily," Moss said, thinking about the flailing man he had passed.

"That's good to hear, albeit unsurprising," he said, and a gentle smile crossed his lips. "I can authorize vacation beginning the day after tomorrow."

"Oh, I'd really like to begin tomorrow," he pushed, unsure where the night would take him. Mr. Greene raised an eyebrow.

"Are you sure there isn't something you're not telling me," he asked in a way which bordered on insisting and Moss questioned if he should just say it. Be done with it rather than go along with this plan. But he was in it now and a determination to see through whatever this was overtook him. He would see Ynna again. He would bring her the chip and he would find out about his parents.

"Nope, just ready to lie on the beach for a few days," he lied and let a broad grin cross his lips.

"Going to hit up SeaDome?" Mr. Greene asked, looking at his screen and approving the vacation.

"I keep hearing how amazing it is. Maybe I'll take surfing lessons during the day and watch the fire dancers at night. I've never been in water other than my shower," he admitted.

"It is a good time," Mr. Greene agreed. "I take the husband there twice a year."

"You've mentioned, it's what inspired me to try it," Moss said and was surprised how easily the lies were coming to him. He had never once contemplated going to the SeaDome, even when Gibbs rather forcefully invited him.

"Good to hear I can impart some wisdom outside of work," he said, and Moss saw the word approved on the screen before he switched it to another. "Looks like you're closing in on Level Two."

Moss knew he was only at 78.64 percent. "Every day a little closer." He felt like he was still a long way off.

"You sure you wouldn't rather wait for your vacation until you hit Two? You unlock some good perks at the beach houses. You'll be stuck in a pretty small cabana at your current level." He looked up from under black eyebrows, head still tilted at the screen. Moss couldn't get a read on the situation. Mr. Greene had visibly dropped his guard but continued to press him in a way he was unaccustomed to.

"I'm not *that* close," Moss said in a joking tone, though he felt it was all too true.

"A couple of good months and you'll be there. I believe in you," he said, and Moss trusted him. "I've watched you come a long way since you were a boy. I see something in you. You have a spark, a drive which is rare, but sometimes…sometimes I wish you acted on it more." Moss nodded, thinking about how he stole that second work order with pride. "You have this untapped well and I just hope you find it."

"I think I'm beginning to," Moss said. "Anyway, this vacation will help to recharge my battery, get out of my head a bit" Moss said quietly, no less determined, but slightly guilty for the decision he had made. Mr. Greene was so supportive and here Moss was deceiving him.

He chuckled. "Well, no one ever said, 'I wish I had spent more time at the office' on their death bed."

Moss smiled and nodded. "Right," he agreed.

"You are approved for a week of vacation beginning tomorrow. Was there anything else? I would like to hear more about this Ira thing, but I don't really have all day," he said graciously.

"Nothing else, Mr. Greene, but thank you," Moss said as he backed toward the door, Erik moving alongside him.

"Make an appointment when you return and let's catch up," he said.

"I'd like that," Moss replied, wondering if he would have another conversation with Mr. Greene.

He left the office and returned to his hex. The floor was still abuzz with security. Moss quickly brought up the vacation menu at his workstation and booked himself a week's stay at the cheapest cabana he could find in SeaDome, expecting he would never step foot within it. Not wanting to stay confined within his mind for the rest of the day, he logged back in to work.

"Welcome back," Two said. "Was it the pipes?"

"Yes," Moss told his drudge. "It was the pipes."

CHAPTER 4

"We have time to complete one more work order before the end of shift," Two informed Moss.

"I think I would rather check you into a repair station for diagnostics before the night shift," Moss said. "I'll be off for a while and who knows how the others will treat you."

"This is an acceptable course of action," Two complied. "I see you rented a vacation house. You just wish to get away from work? You have never done so before."

"Yeah, it's time for me to see the world," Moss said with a smirk.

Two pointed his camera at the vast landscape of solar panels and prophet root. "The SeaDome seems a better option than this."

Moss chuckled. "No kidding."

"After the morning with Osiris, a burst pipe, and security checks, I can understand wanting a break," Two put in.

"Thanks, it's nice to know someone understands," he said, knowing that ThutoCo could access his conversations with Two at any point. He slowed the bike as they approached the massive hanger which served as the repair center. Drudges of every type moved about, fixing bikes and heavy machinery, moving debris and inputting data.

As he always did, Moss wondered about every person behind every drudge. He wondered if they were even in this burb, what they loved to eat and do and how they passed their time outside of work. These absent thoughts kept him occupied as he parked the bike and slid Two off before walking him to check in for repair. He brought up the menu and cued Two up for analysis before preparing to log out.

"Have a nice week, Moss," Two said as the logout initiated.

"Goodbye, Two," Moss said.

Logging out, he realized that work had been a welcome distraction but now he was alone with his thoughts once more. He opened the drawer and pulled out the chip. He could differentiate it as it had 0027 inscribed on the face. So much had happened today for this chip. He wondered if the security officers were even told if this is what they were looking for and decided that they were likely kept in the dark on that detail. Perhaps only the Security Chiefs were given all the information as Issy and Clam seemed to be doing a general sweep. Or perhaps his friendship had saved him?

He brought up a purchase menu to order some clothes suitable for the outside world when the screen was overtaken. INCOMING CALL. It was Gibbs, no doubt returning his calls now that the workday and security checks were done.

He answered the call, Gibbs wide face filling the screen before him, "Hey, man."

"Hey, I got an alert saying you called. What's up? I'm gonna hit up The Restaurant in a bit if you want to meet me," he offered, and it struck Moss how casual he was. His own world had changed so much in the day, it seemed weird that Gibbs was so normal, though of course, he had little reason to be otherwise.

"You mind stopping by my hex?" he asked.

Gibbs groaned. "You're not going to make me watch Skillz all night, are you?" he mocked into the camera, rolling his eyes dramatically.

"No," Moss said more seriously than he intended. His friend picked up on the tone. For as much as Gibbs could be foolish, more interested in chatting up girls than listening to his friends, he would always step up in a pinch. Moss knew he would walk through a minefield for him if he needed it.

"All right, I'll be by soon, but I'm bringing beer," he stated.

The idea of a drink was more appealing than it had ever been. "Perfect," Moss said.

"Oh," Gibbs said in astonishment. "Great."

Moss clicked him off and ordered black sneakers, denim pants and a jacket with the ThutoCo logo on the back and Burb 2152 on the breast. He wanted something more nondescript but there were no other options. The company always wanted its employees to be recognizable. After a minute, a voice came through the speaker.

"Incoming order," the voice said and the dumbwaiter next to the Foodier clicked and thudded before opening to reveal the perfectly folded clothes wrapped in plastic. *Dress me*, he commanded, and the arms unfolded from the ceiling as he stood. It was odd to him to use the neural commands now that he knew people could eavesdrop on them. Though he had always known there was a digital record of all such orders, it felt different to him now. The arms unwrapped and unfurled the clothes as others stripped him and within a moment he was dressed. *Screen cam*. He looked at himself on his screen. He

was a different person. He pulled on the cuffs of the jacket, admiring himself.

"Doorbell," the voice said through the speaker as Gibbs's image appeared in a box on the screen. *Allow entrance.* The door opened.

"What the heck?" Gibbs gasped as he strode in, a case of ThutoCo's inhouse BioBeer nestled under his arm.

"Yeah," Moss said, holding his arms out.

Gibbs looked him over and said in a mocking voice, "going somewhere?"

"Actually…" he trailed off, not sure what to say. *Living room.* The desk and chair which served as Moss's workspace folded down and slid into panels within the wall while another panel slid up and a couch with plastic wrapped cushions moved out. A large screen swung down from the ceiling and began playing as Moss said, "sit down." Gibbs shot him an incredulous look as the voice of Marisol Mae filled the room.

"Good evening, employee! In just thirty-seven short minutes, Burbz Haz Skillz will premiere—" *Mute.* The room fell silent, leaving just the buzz. Moss turned a grim face to Gibbs, who opened the case and tossed him a beer. Gibbs sat on the couch, which squeaked and deflated under his weight. He looked at Moss with a peculiar mixture of confusion and glee.

"What's going on?" A curious smile washed over his face. Moss did not know how to answer that question. He felt as though everything was "going on."

"I'm the security alert," he said, opening the beer and taking a sip and thinking himself rather cool. Gibbs burst into laughter before checking Moss's face and stopping.

"What?" he asked in what Moss thought was the most genuine bewilderment he had ever heard.

He smiled and took another sip. "I don't even know where to begin," he said finally. He ran his finger over the lip of the beer can, trying to put all that had happened into words. His whole life had been so simple, and the straight trajectory of his existence now felt askew.

"What do you mean? Why are you dressed like that? What are you talking about?" he squawked, sounding like Moss's brain. If felt good. Nice to be the one with some information.

"You can't tell anyone," he warned, his voice low and ominous. Gibbs nodded, putting his drink on the floor and leaning in.

"You know you can trust me." Moss knew nothing of the sort. In fact, he knew the very opposite, but at the moment, he didn't care.

"While I was working this morning, a girl—well, woman. I don't know. This person knocked on my door—"

Gibbs interrupted. "Was she hot?"

Moss let out an audible sigh.

"Unimportant," he said, knowing describing the girl would derail the conversation for hours.

"So, she was." Gibbs smirked and rubbed his hands together.

"Yes," Moss acquiesced so he could continue his story. "I let her in, and she gave me this." He held forth the chip.

"All right," Gibbs said quizzically, taking the chip and flipping it over. Realizing there was nothing special about it, he handed it back and picked up his drink.

"She said she knew my parents," Moss said and though he was excited at the prospect of learning more about them, sorrow coated his words.

"Really?" Gibbs asked, his eyes going wide. Moss almost never mentioned his parents and his friend seemed genuinely interested in this revelation.

"Yeah, and she asked me to meet her tonight," he explained.

Gibbs looked him over. "And you're going?" he asked incredulously. "*You*?"

"Yeah," Moss stated, holding his head high with a confidence he did not truly feel.

"Into the city?" Gibbs finished a beer and opened another, the crack and hiss of the can underlining his question.

"Yeah,'" Moss did the same.

"You'll be eaten alive," he said.

Moss replied half-heartedly, "I'll be okay."

"Moss," Gibbs said seriously. "I've been to the city. It's scary during the day but outright terrifying at night. I hardly wanted to walk around, and I was being led by an armed tour guide. The people outside of the burbs lead hard, cold, miserable lives and would be more than happy to cut your throat for that jacket. You have no idea what you are getting yourself into, no concept of the outside world, no reason for doing this except that some pretty girl mentioned your dad," Gibbs concluded. It stung, for Moss knew the truth of the words.

"I'm sick of this life, man. I do nothing, will do nothing. I don't know what this chip is, I don't know anything, sure, but it's something different," Moss argued.

"Something different may get you killed," Gibbs noted sadly.

"Death out there may be better than life in here," Moss said, trying to sound like a character from the superhero movies he so loved.

"Who are you?" Gibbs said, looking down to his beer can while running his forefinger along the rim.

"I don't know," Moss answered truthfully. "But I think it's time I find out."

"So, what's on the chip?" Gibbs asked.

"No idea, but clearly it's something important. Ynna suggested it could take down ThutoCo," Moss explained.

"Who?"

Moss sighed. "The girl."

Gibbs nodded. "Okay, but why?"

"She said the company was evil," Moss told him. Gibbs snorted.

"We employ half the country and feed all of it while providing necessary crops, textiles, and power from the toxic expanse! How is that evil?" Gibbs seemed personally hurt.

"I'm gonna find out," Moss said, and Gibbs swallowed down another whole beer.

"*We're* gonna find out," he corrected, extending a hand triumphantly.

"Nope," Moss said with a cold finality that took Gibbs aback. Moss had anticipated this offer. He had known Gibbs long enough to know that if there was an opportunity to get into trouble, Gibbs would be right there. But Moss did not want to jeopardize another life. He knew that his would never be the same, but he could protect his friend.

"What, you think you can protect me when this all comes out?" Gibbs said as though reading Moss's mind. "I'm safer out there with you than in here when they figure it out."

Moss puffed himself up, trying to sound more confident than he actually was. "They won't figure it out."

"Oh, yeah? The second you don't show up for work tomorrow, you're gonna be red flagged," Gibbs retorted, in his element playing devil's advocate.

"I took vacation time," Moss said with pride.

"During a security check?" He guffawed. "Nothing suspicious about that!"

"I had a good pretext!" Moss countered.

"Even if you had the best excuse in the world, the company is going to be suspicious. Count on it. If you don't think that they are going to cross check vacation time, or really, every statistic, you are crazy. Already, I can tell you don't have the mind for this." Gibbs folded his arms across his chest. "You are going to need me."

While Moss wanted to keep his friend out of all this, the idea of having a companion with him as he explored the city was appealing.

"Maybe…" he said, staring at the muted television. Marisol's mouth moved soundlessly. Gibbs stared at his friend. Neither spoke for a long moment. "What do you think she is like?" Moss finally put words to the question he pondered every morning.

Gibbs furrowed his brows. "What?"

"Marisol Mae, what do you think she is like in real life?"

"Moss," he sighed, his words coated in pity. "They are going to eat you alive out there."

The truth dawned on him. His combined terror and excitement had carried him this far but now he felt foolish and naïve. "Oh," he said.

Moss dropped his head as Gibbs said the words he already knew. "She isn't real. She's a CG construct."

46

"Right," Moss said, remembering all the times he imagined Marisol having breakfast, picking furnishings for her hex, and chatting with friends.

Gibbs looked him in the eyes and stated plainly, "you have to let me come with you."

"All right," Moss accepted.

"Good, now tell me everything."

Moss gave him a rundown of the entire day, leaving out only the part about Issy possibly flirting. Gibbs listened quietly, drinking and offering beers where necessary. When he concluded, Gibbs rubbed his face with both hands.

"If this woman is to be believed, your parents were working against the company from the inside," he said.

Moss nodded. "Yeah."

"You've never really talked about them," he coaxed.

"Mr. Greene told me they were killed by a malfunctioning drudge, but..." He trailed off.

"But what?"

"I have these memories, like when you wake up halfway through a dream. Flashlights in the night. Screams and promises. A hand being pulled away. I don't know. It's confusing. But when Ynna said she knew them, I believed her."

"You think they scrubbed your memory?" Gibbs asked, looking sorrowfully into Moss's eyes.

"I do now," he said. He tried to pull at those vague memories, tried to bring them to the front of his mind but he could not.

"That's messed up," Gibbs asserted. Moss simply nodded. "You think they hacked your implant? Listened in since you are the child of rabble-rousers?"

"I doubt it," Moss said softly.

"Why? Seems like the smart move."

"Maybe, but I was only twelve and if they scrubbed me, maybe they didn't think there was any reason to," he said, feeling empty.

He had often questioned his parent's sudden departure from his life, always felt that there was something more. The company line about a malfunctioning drudge had never quite added up to him.

There had been an undeniable truth in Ynna's words and, as more of the pieces came into place, his disgust with the company that had raised him was growing. He knew he needed more information, more answers.

"Plus, I guess security would have been on you if they knew you were visited," Gibbs said helpfully.

"True."

Gibbs shifted nervously, "And you can hear my thoughts?"

"No. I can hear only the orders. However, the system differentiates thoughts from commands, I'm hacked into that."

"So, no help in the outside world," he observed.

"People don't use neural commands in the city?" Moss asked.

Gibbs just laughed.

"Let's go to my hex and get some stuff. You'll understand when we reach the city; you are in for one hell of a rude awakening," he said, a devilish smile crossing his lips. "Say goodbye to everything you think you know."

Moss smirked and joked, "say goodbye to all your sick time."

CHAPTER 5

Drunk, Moss and Gibbs meandered down the now dimly lit hallway. Moss tried to look calm, but his hand gripped the chip in his pocket, slick with sweat. As they passed a group of young women in cocktail dresses, Gibbs stared, lacking any subtlety.

"Man, you see the twins this morning," he asked as though anyone had missed them.

"Yeah," Moss whispered as the girls looked back at them and rolled their eyes.

"I'm telling you, that night—" Gibbs began but Moss held up a hand to silence him.

"I know," he said impatiently. He didn't want to hear it again. His mind was split in so many ways, he couldn't bear to listen to Gibbs talk about sex again.

As they entered the hex, Moss looked around the space. Where he left his wall screens blank, using them for little more than his ocean sunrise in the morning, Gibbs utilized his to the fullest: modeled after a late twentieth-century college dorm room; two windows looked out over ivy-coated brick buildings and the spaces between were covered in posters. He switched them out regularly, always happy to lecture any visitors on the cultural significance of the image.

Three posters adorned the wall now, appropriately ripped and faded, the corners wrinkled as though adhered to the wall with sticky globs. Moss wondered how long his friend had spent altering the images to get them looking that way. An ecstatic Bob Marley grinned, surrounded by smoke from a large marijuana cigarette held in the middle of two fingers. Between the windows, the naked backsides of six women with Pink Floyd album covers painted on their backs, sat lounging by a pool. Lastly, to the right, was a black and red poster of a bearded man's face wearing a beret, the word "CHE" written in block letters.

"Pretty great, huh?" Gibbs asked as he pulled a beer from the pocket of his sagging pants.

"As ever," Moss complimented. Gibbs beamed with pride. He, like many in the burbs, was obsessed with the period just before the Neo Dark Age. Gibbs watched old movies and television shows and looked on those days with a reverence which Moss did not understand. He preferred the time in which he lived, the technology and ease of hex living. He did not romanticize some unobtainable past and found engaging in that kind of hyperbole useless. The fact that he did the very same thing with superheroes and fantasy adventures was completely lost on him.

Dresser, Gibbs thought, watching Moss's face.

"Yeah, I heard that," Moss answered the unasked question as the wall opened and a rack of hanging clothes and drawers slid out.

"So weird," Gibbs said, and Moss agreed as he heard, *Dress me for the city*. Moss turned his back as the arms folded down. Gibbs snorted a laugh.

"What?" Moss said over his shoulder.

"I just tested to make sure you couldn't hear my thoughts." Gibbs chuckled as the arms from his ceiling pulled a shirt over his wide frame.

"Oh, yeah?"

"Yeah," he answered easily. "Called you a massive prude for turning around so quickly."

"I'm just respecting your privacy," Moss defended.

"Whatever you say, prude," he mocked and for a brief moment, this all felt normal to Moss. Hanging out with Gibbs, getting ready to go out. Feeling reluctant and nervous while Gibbs excitedly made fun of him. It just felt like a weekend evening where he had somehow been convinced by his friend to go to a nightclub. The comfort of normalcy. But the moment passed as he rubbed his thumb along the side of the chip.

"What do you think it is?" Gibbs inquired.

"What?" Moss asked.

"The chip. What do you think it is? I mean, this company is so big, there are bound to be some bad apples, but I can't imagine what would be on that which could be so damning as to take down a company like this," he said.

"I have no clue. I'm honestly not sure Ynna did either."

"I guess we'll find out," he observed, and Moss heard him rummage through one of the drawers. Before he had time to turn around, he felt heavy plastic on his shoulder. He turned to see a Kingfisher stun blaster sitting next to his face.

"Why do you have this?" Moss asked, aghast, turning to see Gibbs holding one as well.

"Because the world is not a safe place." And while Moss knew the truth of his words, he had never experienced it. He reached for the weapon and held it in his palm, any sense of this being a normal moment evaporating entirely. It was

unnatural in his hand as he put his finger on the trigger. The battery displayed five full, green bars.

"Wow," he uttered as he turned to watch Gibbs stash his in the waist of a pair of loose-fitting blue jeans. He wore a simple black T-shirt over another shirt with long yellow sleeves peeking from underneath and a brimmed cap on his head, red curls poking out.

Moss tried to fit his weapon into a shallow pocket of his jacket, causing it to hang awkwardly to one side. Gibbs rolled his eyes and pulled the stunner from the pocket as he physically spun Moss back around and jammed the thing hard down the waist at his back. Moss let out a little shriek as the muzzle scraped his skin.

He huffed. "You want to be seen with that the day of a security breach?"

"I guess not," Moss said.

"You guess not?" Gibbs exclaimed. "Moss, you gotta screw your head on. I know you think you have this all figured out, but this is some major stuff we are engaged in here. We could be arrested or worse if we get caught. That chip in your pocket is tantamount to corporate treason. Following the trail of your parents may mean this is the last time you see your hex. The last day working with Two. The last time you see Issy. This is no small potatoes.

"The full weight of ThutoCo may come crashing down on you and you need to be ready. I can't imagine what would have come of you if you hadn't told me—if I hadn't offered to come along," he said, passion and pity making a cocktail which Moss could hardly stomach.

"I know, man. This is all just so much," Moss said, as deflated as he had ever heard his own voice.

"I don't mean to bust your chops, it's just that you don't seem to fully appreciate the magnitude of the situation," his friend said and put a reassuring hand on Moss's shoulder.

"I do, it's all just so new to me," he said, wishing he had stopped drinking after one beer. His already confused mind now drenched in a heavy fog.

"It's about to get a lot newer," Gibbs said and gave his shoulder a squeeze.

Moss asked. "Are we crazy?"

"Oh, yes." Gibbs nodded with a wicked smile. "So, let's go be crazy."

Gibbs threw on a backpack and ushered Moss out of the hex before he had time to doubt himself again. They made their way to the elevators and down to the first floor, trying not to stumble as they passed company shops full of people buying clothes, electronic toys and upgrades for their hexes. Employees sat around in coffee shops, bars and restaurants.

Most of the overheard conversations were about the security lockdown. Every person had their own theories as to what happened. The place was abuzz with nervous gossip. Moss felt superior to everyone, knowing the grand secret that was on everyone's lips. Gibbs watched all the idle chatter, making his peace with the idea of never stepping foot in the burb again.

Digital maps and projected arrows pointed the way toward the terminal and Moss couldn't help but smirk at the posters of smiling employees sitting on the white sand beach in SeaDome. The terminal walls were covered with alternating advertisements for the various Dome options: mountain climbing, winter wonderland, ancient ruins, and steamy jungles. All places Moss had heard mentioned and never been.

Light rail trains came and went with dizzying speed, hurrying employees and their luggage to the exotic destinations. The two followed the paths to the platform to Shuttle Bay Six, the nearest departure point. A train pulled in mere moments after they arrived, and they stepped aboard, found seats and lowered the safety bars over their shoulders. As the bars clicked into place, Moss was confined in a way he had never experienced and as the train pulled away from the station, the force of the movement made him instantly nauseated. As it glided silently forward, he felt as though his organs were being pressed against the inside of his skin, trying to force their way out of his body. He could feel his face flush and the tips of his fingers tingle. Looking around, no one else seemed the slightest bit bothered, mostly chatting with one another or watching the screens at the front and back of the compartment.

"I'm Marisol Mae and these are some of the vacation trends this season," the unreal woman said and, despite himself, Moss tried to picture her life off camera. It did not work anymore, and he just watched the display and tried to keep from vomiting.

"If you are in the mood for adventure, ThutoCo has you covered. Hop on a train to CastleDome. There you will be transported to a magical world where you can live out your fantasy of being a knight, maiden or even a King or Queen. Ride real horses, camp out under the stars or learn to fight with swords. You might even meet a dragon. You can have it all in CastleDome. Spots are limited so book your room now. Your adventure awaits.

"If you are more in the mood to relax this season, may I recommend—" and the screen paused as the train pulled slowly into the next station. Gibbs nudged Moss, who stood slowly on uneasy feet.

"You all right? Is it like the elevators?" he asked.

"Yeah, I don't know how you all stand it," he remarked.

"I suppose you just get used to it," he said, leading Moss off the train. "I have to stop here," he said, pointing at a restroom, and as the beer had caught up with Moss as well, he nodded his agreement. After a quick stop, Gibbs led Moss out of the tunnel up some stairs. The air turned cold as they ascended into the massive port with one open-air mall. Rain pounded the circular glass roof which reflected the light from the many screens indicating directions toward the hover-cabs. Moss followed his friend as a child follows their parent to the line for cabs and they cued behind a family. One kid lay slung upon his mom's shoulder while another kept slapping the tags on an upright luggage bag.

"Please stop that," the mother admonished, looking exhausted. "I want you to be good when we see your father."

It occurred to Moss for the first time that not everyone lived a life contained within the burb. His life had been so thoroughly contained, it surprised him that others lived differently, and once again, he wondered if he was too foolish to do what he was about to do.

Several green lights turned on near shuttles and they made their way toward an empty one, the doors opened and a screen with options lay in front of the seats. The shuttle was off yellow, with a red cherry light on top, a long bright light at its front and boosters all along its base. The heat coming off it was jarring, and Moss was uneasy stepping aboard the hovering vehicle. They seated themselves and entered the destination.

"This is not a recommended locale; may we suggest the shops at the Embarcadero?" a voice came through the speakers. Gibbs hit CANCEL and entered Long-Legged Spinners again.

"This is not a recommended locale; may we suggest the bars at Nueva Stonestown?"

Gibbs grumbled and went through the motions again.

"This is not a recommended locale; would you like to continue?" He pressed YES.

"Any damage taken by this vehicle will be added to your bill. Do you accept?"

ACCEPT and the cab jolted as it lifted further from the ground.

Moss and Gibbs left their fluorescent and white world for one of neon and black.

PART II

CHAPTER 6

The cab cleared the rim of the terminal and darkness filled the vehicle as thudding water hammered the roof and streaked the windows. For as sickening as the train had been, the smooth glide of the hover-cab didn't bother Moss at all. He looked out the window as the glistening white stacked circles of the burbs grew smaller. He was awestruck by how many there were, all connected by the light rail to one another as well as the terminals and domes.

"It's so big," Moss said, almost as though the thought just wanted to jump from his lips.

"That's what she said," Gibbs joked, and Moss groaned audibly as the cab banked and the complex disappeared from view.

Awestruck, he murmured, "I had no idea."

"The complex is massive. There are over one hundred burbs in the headlands. ThutoCo owns this entire district of the city, and there are complexes like this in almost every city around the world."

"How many cities are there?" Moss asked, never having thought about it before. B.A. City was all he had ever heard mentioned except when reading about the wars.

"No idea. I know there are three along the coast and a couple more to the east. I've never thought to ask," Gibbs explained. "Each city has its own local government but from what I hear, they are all pretty powerless. Intercontinental companies like ThutoCo pretty much make the rules."

Moss thought about it, running his hand over his chin absentmindedly. "I guess if you feed all the voters, you can pretty well control the people they vote for."

"Exactly," Gibbs agreed as the cab turned, and the city came into view.

"Woah," Moss said, astonished. Through the rain streamed window, he saw towers of stacked lights stretching over hills into the distance. An eerie glow pressed against the black night. Spotlight beams swayed back and forth over the seemingly endless series of rectangular skyscrapers. The orbital billboards, holoprojected figures and massive screens shone ads down upon the inhabitants. Moss stared as the lights of the city grew closer and he saw that most of the lights were coming from individual windows in the buildings. "How… how many people live here?" he asked in disbelief.

"This is only the tip of the iceberg. The city keeps going for fifty miles, with a population of fifty or one hundred million or something like that. Most people live in massive apartment buildings or just on the streets. The few elites left on this planet live at the tops of these buildings or in massive compounds all their own," he said, sounding to Moss as though he was repeating what some tour guide had told him.

He was astounded that so many people, so many lives existed so close to him and he had no idea of it before now. "That's incredible, the sheer size of it."

"Why do you think we have to grow so much p-root?" Gibbs asked, a note of mockery in his voice.

"It's unbelievable," he said, not paying Gibbs much mind. They flew over a massive, open-air night market. Seemingly endless rows of neon-lit, tarp-covered stalls with racks of clothes, smoking food stalls and cheap electronics stretched into the night. People milled about, unbothered by the rain. Moss watched their small forms move between stalls like the termites around the panels his drudge repaired. In an instant, it was behind them as they floated higher and into the city itself. Towers rose all around them as the cab moved between tunnels which connected the buildings and into a land of slow-moving traffic. HoloAds the size of the skyscrapers moved and flashed products.

Rings of condensation formed around the hands that Moss had pressed against the inside of the window as he gawked. He could not see the ground; the base of the city was so far from their elevated position. People were everywhere, in every window, smoking on balconies, having poolside drinks on the partially roofed plazas that connecting the buildings.

The cab stopped, red brake lights from the car in front flooding the space, shifting with the rain. Moss watched below as a drudge, dressed in a tuxedo, strode over to a group of people and offered them a plate of some food he did not recognize but which looked unmistakably fancy. One man picked something off the tray and popped it in his mouth before instantly spitting it back into his hand and throwing it at the drudge. The other people all laughed as he said something.

The red emptied from the car and they moved forward, both their heads snapping toward the front windshield as they pulled up to a stoplight which illuminated a green arrow pointing down and the cab dropped. Moss's stomach lurched and he felt all its contents sear the back of his throat. He cupped his hands over his mouth and swallowed hard as the cab slammed to a stop above the ground, sending the garbage that

littered the street flying in every direction. Gibbs was in no better shape as an electronic voice came through the speakers.

"You have reached your destination, please exit the vehicle rapidly, and have a nice day," it said as the two fumbled for their buckles. Gibbs stumbled from the cab like a drunk and Moss attempted to stand but struck the slick concrete, lights flashing up at him from the puddles. The sound of laughter, loud talking, and electric pounding music flooded his ears as rain pounded his back. He shivered as he vomited into the street. Gibbs came around to pull him up as the heat of the cab lifting skyward scorched his soaking body, steam gusting all around them. They both looked around to take in the scene and get their bearings.

"This way," Gibbs said, gesturing to a web of lights Moss could barely make out through the rain dripping down his face. He had never in his life been happier to have his friend by his side. He wiped his face and looked across the street to see the Long-Legged Spinner. The name was projected in moving letters on the façade above a huge spiderweb of neon red lights. Projected black widows skittered about the web. Windows faced the street, in which men and woman danced in suggestive lethargy.

"See the breasts on her?" Gibbs pointed as they crossed the street, but Moss had already noticed them. But the people in the windows were unnatural creatures. The women had massive, augmented breasts with waists so thin as to hardly contain a spine, legs so long as to be half their height and cartoonish eyes which stared into nothingness. The men were taller than any Moss had ever seen with long torsos containing too many abdominal muscles leading to humongous pecs and broad, strong shoulders. They sported permanent erections that they would point in the direction of passersby.

"Relief Aides?" Moss asked as they gaped from under an awning.

Gibbs shook his head. "No. They are genetically and surgically altered to meet the needs of... a specific clientele."

"Oh," Moss replied as he watched a woman absently gyrate in a glowing thong and pasties. "What are we doing?"

"Only one way to find out," Gibbs answered, though the question had been rhetorical.

They turned to walk toward the door but were stopped by a nearby group of people who had been leaning on motorcycles and smoking. Three men and a woman, all dressed in leather pants with military style jackets adorned with fearsome looking patches formed a wall before them.

"What do we have here?" The tall, broad leader of the crew asked threateningly.

The woman (on whose vest was written "prospect" rather than a name) wasted no time in excitedly answering. "Looks like a couple of fucking bubs," she snarled.

"Well, I'll be," the leader said as he moved toward them, fists clenched. He stared at the two of them unblinking, like a coiled snake about to strike. A man to his right pulled a short length of chain from a pocket and began wrapping it around his knuckles as the woman slid a dirty length of pipe from her belt.

"We don't want any trouble," Gibbs said, holding up hands still dripping from the rain. Moss was rooted to the spot, too terrified even to run. Every question he had about the decision to leave the burb was answered at that moment. Wet, sick and scared for his life, he was as miserable as he had ever been.

"Now, see, that was rude," the leader said to his crew. "He just implied that we was trouble."

Gibbs let out a shuddering breath and mumbled, "I didn't mean any offense."

"I think you did," the leader said as he moved closer, the words steaming from his mouth. "I think you meant we were trouble. And maybe we are," he added in a stage whisper.

"What do you want?" Gibbs cried as they closed in, boots crunching on the wet pavement. He had acted so tough in the burb but now that they were out in the real world, Moss realized his friend had been all bluster.

"We just want to have a little fun," he said, eyes flaring and teeth showing red in the light of the web. Moss, like a cornered animal, reached behind his back and produced the Kingfisher, pointing it at the woman and squeezing the trigger without thinking.

Time froze as all ten eyes tilted to watch the dart lodge itself in her neck. The woman looked confused for a moment before her body began to twitch uncontrollably, arms and legs vibrating as if trying to shake themselves loose from her torso. She crumpled to the ground as a wide smile crossed the leaders face. He began laughing uproariously and his goons followed suit.

"She was taken down by a fucking bub!" he hollered as he clapped a hand on one of the other men's back. After a moment, he stopped laughing and turned a deadly eye to Moss, shaking arm still outstretched. "That was a mistake."

Moss could not believe what he had just done. His mind screamed for him to run but his body did nothing. They stepped closer and Moss braced himself. He had never been hit. Never felt physical pain except when he twisted his ankle as a child. But his mother would not be able to pick him up and tell him it was okay this time. He might not even find out about his parents. All this could have been for nothing.

The leader wheeled his arm back.

White light. For just a moment. It blinded all of them and was accompanied by an electronic pop. Moss had never heard a sound like it before and he blinked his eyes back to the world. The leader furrowed his brows.

"What the fu—" he began but his jaw hung slack and smoke poured from the orifice. A perfect line bisected his face from the upper part of one cheek to the bottom of the other and the top half of his face slid ever so slightly to the side. His body fell to the street, sending half his head bouncing into the road before landing upright in a puddle, flared eyes still staring at Moss. Pumping blood from his body hissed as it was cauterized upon reaching what was left of his face. Gibbs shrieked, and the two remaining men turned to see a form emerge from the rain holding a wide, black, line-laser pistol in his left hand.

"You two best be moseying," he said to them, his sonorous voice like crushing gravel. They didn't need to be told a second time, on their bikes and roaring away into the night in an instant. The gruff man was on Moss and Gibbs in no time, holstering his pistol.

"You Moss?" he asked from under a dripping bulldogger hat.

Moss nodded. His mouth could barely be seen when he spoke, hidden by a scraggly beard like an unkempt garden of gray weeds. The whiskers seemed to meld into the ratty fur lining of the long gray duster he wore over what appeared to be a large hump protruding from his back. He looked at them with one narrow dark eye, the other being a black glass DigPlate. He appraised them and growled, "We have to go."

"We are meeting someone," Moss protested through trembling lips.

"Ynna, I know, but she's held up and Carcer Corp will be on us right quick," he informed them impatiently as he grabbed their jackets and manhandled them toward an alley. Just then, a soft buzz filled the air as two drones dropped from the dark sky above with scanners making grids on the street.

"Cocksuckers," the old man said as he released the two and slid the jacket from his shoulders. It exposed a metal box that was fused to his spine, part of it jutting through a slit carelessly cut in his vest. It was military grade headwear but if he had acquired it new, those days were long gone, rust and blood mixing where metal met flesh. He manipulated some commands on a cybermesh palmscreen and small flares fired from his back toward the drones, leaving streams of white smoke in their wake. The drones bobbed out of the way like fighter jets avoiding anti-aircraft fire as he continued to tap at his palm. "Got you," he muttered as the palmscreen flashed green before displaying a view from one of the drones which he controlled to fly directly into the other.

A firework of plastic and metal exploded above the street, causing cars to swerve and crunch into one another. The dancers in the windows watched as the drone carcasses rained onto the street below. People called out and screamed as the old man looked at the two and said, "let's go."

In a flash, he had picked his jacket off the ground and was off running, Moss and Gibbs following closely as he ducked into a trash-filled alley. They dodged bags, dumpsters, and what appeared to be sleeping people as he guided them into the dark, their way lighted by little more than seedy storefronts whose yellow light pushed out against the black. They reached the door to a cement building which stretched endlessly into sky and the old man pressed his soaking palm against a screen. The door beeped and stuttered open just enough for them to squeeze through. He manually closed it from the other side with a handle

crudely soldered to the door. "You idiots cost me a lot of hardware. You got the chip?" he panted.

"Y—Yes," Moss answered, holding forth the small item which had so changed his life.

He looked as though he was being offered a bag of cat shit. "I don't want it," he stated. Moss quickly shoved it back in his pocket.

"Who are you?" Gibbs asked.

The man groaned. "I could ask *you* the same thing," he said coldly, reaching into a pocket and producing an unlabeled, grimy bottle which he put to his lips. The smell of the alcohol filled the tiny space. The liquid trickled from the side of his mouth into his beard as he glugged. "They call me Burn," he said, holding the bottle to them. Moss shook his head, but Gibbs took a quick swig and winced.

"That'll wake you up in the morning, boy," Gibbs said before coughing. Burn smirked.

"Let's get upstairs and learn you," Burn said as he returned the bottle to his pocket and headed up the stairs. Faint sounds of scratching could be heard from within the apartments and a foul smell increased the higher they went.

They plodded up the stairs for what felt an eternity before reaching a landing with a boarded-up door. Burn pushed it open and led them down a carpeted hallway of flickering lights. Small white feathers danced underfoot and, as they passed an open door, it was made clear. The apartment was stacked with cages full of chickens quietly clucking and pecking about.

Burn turned over his shoulder to see their eyes. "Not everyone likes the vat stuff," he informed them as he ran his palm over what looked to be a misaligned brick. A wall panel creaked open and he ushered them into a small room, the sounds

of scratching coming in from all sides. Moss grimaced as he saw an old couch, more duct tape than fabric; a rusted electric oven with a single pan atop; a sink green with algae and a lamp which Burn turned on with a wave.

"Janitor's space from before these were the coops," he muttered as he pulled a chair off the wall and unfolded it, gesturing for the two to sit on the couch. They un-nestled some rats as they did, sending black creatures scurrying across the room. Moss yelped.

"We're going to have to toughen you up," Burn said, one unblinking eye staring at the two awkward kids on the couch. He lit a Longpork brand cigarette and sucked in a lingering drag. "You two know why you're here?" He exhaled, smoke spewing from mouth and nostrils.

"I was supposed to give that chip to Ynna," Moss said, sounding like a child asking about homework.

"So, no?" Burn stated more than asked.

"Not really. See, here's the thing, I don't really know what this is about or how I'm involved but she mentioned my parents and I want to know more and Gibbs here—you met Gibbs, right? Well, Gibbs here offered to come since I had never been to the city and so I said yes, even though now I think it would have been better for him to stay. I wanted to know about my parents because I don't really believe what I've been told about them. But now that I'm here and I saw a person get murdered—well, he deserved it for threatening me. Well, maybe not but I don't know, I was scared. But now that I'm here, I think maybe I should have just stayed home, too and ignored this whole thing." Burn held up a hand to silence him. Moss felt as though all his nerves were forcing themselves from his mouth.

"Guessing Thumbs never got to you?" he asked, raising the brow above his one natural eye.

"No," Moss answered, pressing his mouth shut after.

"Gibbs?" he asked, turning to face him and fixing a cold stare.

Gibbs puffed himself up and tried to sound confident. "Yes?"

"You understand what you're into?"

"Better than he does, I think," he said, hooking a thumb at Moss.

Burn appraised them and grumbled, "right, you boys are in it now."

"In what?" Moss pressed.

"All right," Burn said. "Here goes. You two work for a company that runs the world. There are several mega-corporations: Kingfisher, RePurp, Xuefeng Technologies, Carcer Corp, Dyeus Industries, Tomar, D2E, to name a few, but ThutoCo is the biggest. They control the food and the power, they sit at the head of the AIC." He took a drag and was about to continue when Gibbs put in.

"What's the AIC?"

Burn exhaled slowly, as if to calm himself. "You fucking bubs need to learn quick when to keep yer mouths shut. I was getting to it.

"The Amalgamated Interests Council is the worst kept secret in the corporate world. All the big companies meet to make sure they keep people spending a lot of money while making little. With monopolies in their various industries, they no longer fear one another, and they can work as one.

"The few times a company got uppity and tried to move on another's business, the Council sorted it. Scraps and subsidiaries folded into the rest. The mayors are little more than exalted marionettes, kowtowing to the Council's every whim. These 'representatives of the people' are Royal Families for all

intents. They all stay rich while we stay poor, slaves to greed. Anyone who had been left in the middle after the wars were sent to colonize the Great Black," he seemed to conclude, lighting another cigarette.

"But we aren't slaves, we are employees," Moss said, resenting the implication. He believed ThutoCo had lied about his parents but wasn't ready to hear what Burn was saying.

"That so?" Burn asked, smirking patronizingly.

"Yeah," Gibbs agreed. "We are paid."

Burn chuckled. "How much money you got, Moss?"

"I've saved over two hundred thousand DLI," he stated with pride.

"Would it surprise you to learn that's worth less than a thousand in real-world money? Couldn't afford a month in this room for that," Burn said through the smoke hanging under the brim of his hat. He pressed on his palm and projected the conversion rate. Moss and Gibbs sat in stunned silence, mouths agape. "It's why they give you a vacation stipend when you come into the city, so you never find out how truly broke you are. You try to quit, uproot your life and move out of the burb, you find out right quick that they have you over a barrel."

He stared at the numbers, his eyes wide and open for the first time. "Evil," Moss finally said. "Ynna called the company, 'evil' but…" he trailed off and slumped back, the water from his soaked clothes seeping into the fabric. It was hot in the building and he had been too distracted by the action to remember how wet he was, but at this moment, he felt drowned.

Burn gave him a pitying look. "But you didn't want to believe it."

"No," Moss acquiesced. He let out a deep breath as he turned over all the things he had learned in his mind.

"Neither did your parents," Burn told him, the statement like a thunderclap.

Moss looked at Burn, less surprised than he would have expected. "You knew them?"

"I did. They helped to start all this."

"All what?" Gibbs inquired before quickly covering his mouth with his hands, his inquisitive nature having gotten the better of him once more.

"We're getting to the meat of it now," Burn began, but the two young men said nothing this time. "I met your parents when they came to visit your grandmother. She and I served together and were living in the same government subsidized shithole. They were like you in a lot of ways, unaware of the world outside the burb, though your dad had lived in the real world until he was old enough to work for ThutoCo.

"That all changed when your father got promoted to Level Five. He started coming around less, leaving your mom to care for her mother-in-law. When he did show up, he looked scared, defeated. When Sandra—when your grandma passed, he couldn't even get the time off to attend her funeral.

"That was the breaking point. He got a pass to come into the city and tracked me down. He told me he suspected that the company was getting into some shadowy shit and he wanted help to get it out. I knew some people, so I obliged.

"As he got deeper, it seemed as though the company caught wind. He became paranoid, always looking out for the other shoe to drop. I guess they finally caught up with him because he dropped off. Never heard from him again until this month."

"What happened?" Gibbs blurted, enraptured.

Moss punched him hard on the shoulder. "Shut up!"

"Sorry," Gibbs said, rubbing the spot.

"You've got your grandma's fire kid, I'll tell ya that. Noticed it when you shot that biker. It was that killer instinct. You looked like a man possessed," Burn said, the ash from his cigarette bouncing precariously with the words. Moss agreed. That is how he had felt. His body had moved, had done the action almost independently from his mind. Moss had always known there was a little fire inside him, this instinct, but he had never truly felt it in action until that moment.

"What can you tell me about her?" Moss asked, snatching one question from the river rushing through his mind.

"Sandra? She was tough. Never took shit from no one and in the war—" He snorted a laugh. "Type of broad you thought was going to get you killed on the daily, but never got hit herself. Pulled me single-handedly from the line when I got shot in the back and recommended me for this." He knocked a knuckle on the box jutting from his spine.

"She wanted better for her son and encouraged him to move to the burb. I know it was hard for her to watch what happened to him. To see him become like the drudges he programmed. She loved your mom, too, her zest, her smarts. Your mom was a firebrand too, helped us a lot in those early days. She never lost that light, even when your father faded to black." Burn smiled far away, lost in memories.

"What happened a month ago?" Gibbs peeped, curiosity superseding fear.

"We got a message, preprogrammed," Burn said as he tapped at his palm again and a new projection appeared before them, rippling in the smoke. Moss's hands went numb as the face of his father appeared as a hazy apparition. He looked gaunt and nervous, drenched in sweat with deep bags under his eyes. It was a version of the man which Moss could not remember, but which clearly existed.

"Burn, I'm recording this during the Alpha stage and if you're receiving it before we talk, that means they got me. I've coded this message to be triggered and sent when phase one of testing begins. When that happens, a data chip here," a map of a server room appeared next to him, "will be uploaded with all the information and available for extraction. It will have everything you need to expose ThutoCo. It won't be easy to get and there is no one I can trust to get it out to you, so it'll be up to you.

"And Burn, if you're seeing this." His face turned grave. More serious than Moss had ever seen. "Get Moss out. Promise me. Get him out. Show him the truth. Don't let these bastards do to him what they did to me. Promise me," he pleaded. Moss's eyes grew wet, heart pounded against his ribs, fists clenched. He wanted to reach out. Hug his father one more time. Though, at this moment, he felt as though he had never known the man.

He heard the words before thinking them. "I'm out, dad."

CHAPTER 7

Gibbs put a damp arm around Moss, filling him with a warmth which the video had drained from him. The projection was over, leaving scratching and smoke.

"We're going to do it for him. Whatever's on that chip, we are going to show the world," Burn assured him.

Moss heard grim determination hard in his own voice. "Yes."

"The chip will be encrypted so we will need to get it into some capable hands," Burn stated.

"You can't do it?" Moss asked, looking at the palmscreen hopefully.

Burn answered with such finality as to make Moss feel instantly foolish. "No."

"I'm cold," Gibbs added and for the first time, Moss noticed that their clothes were lightly steaming in the warmth of the room.

"We will get you new clothes," Burn said. "It won't do much for you if those drones caught your faces but maybe it'll help with the Legion MC—those bikers are unforgiving. We have much to do and little time if the company is beginning testing."

"What are they doing?" Gibbs asked, seemingly despite himself.

Burn groaned. "If I knew—" he began but Gibbs cut in.

"Right, you wouldn't need the chip."

"Let's get you boys cleaned up, try to get that chip into the right hands before sunup," Burn said, standing and stamping out another cigarette, leaving another black spot on the already polka dotted floor.

"Where are we going?" Moss asked as he stood.

"Get you some new duds."

"Something with autodry?" Gibbs asked hopefully.

"We're not made of money, kid," he said and pulled his pistol, running a thumb over the battery display to check its life. "We are also going to need to get you two something with a little more bite."

"That was my first time firing a weapon," Moss put in.

"No shit." Burn rolled his eye. "You'll be learning a great many new skills before too long."

Moss felt a slight smile cross his lips. "Of that, I have no doubt."

I could eat," Gibbs added, almost pleading.

"You could stand to lose a few." Burn gestured to his gut. "But we'll get something in you."

"Anything but chicken," Moss joked, and Burn snorted a laugh.

"You couldn't afford it anyway," he said, muttering something under his breath and jamming his pistol away. "Let's go."

They left the room and made their way down the hall, passing an obese man wearing nothing except boots, gloves and a plastic leather apron. A hessian bag leaking bird scratch

bounced on his shoulder. He grunted in their direction, but no one spoke a word. Moss stole a glance over his shoulder at the man's fat, furry backside and, as he had so often with Marisol Mae, he wondered what that man's life was like.

At the bottom of the stairs, they stepped back into the rain. The pounding, ceaseless rain. Burn looked cautiously in both directions and led them down another alleyway. Every building they passed had stairs leading up and down to solid doors fronted with metal grates. Burn was moving them quickly, every step squishing water between Moss's toes. He was soaked through such that he felt as though he would never be warm again.

The aroma of food cooking over open flames filled their noses and light danced on the walls as the alley eventually opened to another market. Not dissimilar from the one they had passed flying in, this one seemed to stretch farther than he could see. It was built at the base of a crumbling freeway overpass which sheltered it from the rain. People had to push passed one another through the narrow spaces between the stalls as the actual paths were littered with rickshaws drawn by thin, miserable people with sunken faces.

A gaunt woman spoke to them from underneath the brim of a wide, triangular hat, signaling for them to take a ride. Burn waved her off and snarled something in a language Moss did not recognize.

He was uneasy as they moved through the crowds. There were so many people. More people in this one market than in all of Burb 2152. Gibbs was taking it all in too. Moss observed his friend watching the bustle, smelling the scents and inspecting the transactions. He seemed transfixed by the activity, staring as two women screamed at one another, hands waving and fingers pointing. Woks of vatmeat and vegetables sizzling as they were flipped and stirred. Shady characters

lifting cloths to reveal augmentations for sale, from single fingers or eyes all the way to legs or spines. It was all on offer.

Burn pulled a flap open on a stall and their eyes were met with a sea of clothing. Rows upon rows upon rows of racks. Tables stacked with hats. Shelves stuffed with shoes.

"Just pick some shit quick," Burn said, glancing around. Moss knew that the man's digiplate was doing most of the work, scanning the space and keeping a lookout. Moss pulled a black shirt from a rack, the long-forgotten name of a band called Pocket Fluff embossed on the front. He moved to a box of jackets and picked up a trench coat as well.

"This place is amazing," Gibbs said, happily rifling through shirts.

Moss chuckled and shook his head. "You *would* love this place."

"You are not wrong," he said, giddy with excitement. "Look at all this. Vintage doesn't even begin to describe it. Like time stood still. It's awesome!"

Moss tried to internalize some amount of his friend's enthusiasm but failed. "You realize two groups of people want us dead, to say nothing of ThutoCo?"

"I'm not too worried with him around," Gibbs said, pointing at Burn but not looking up from the racks of shirts.

"He just killed a man," Moss hissed, those eyes from the puddle still staring at him in his mind.

"Good, jerk deserved it. Who knows what they had planned for us. I'm just relieved we hooked up with him so quickly. Who knows if that chick ever made it to meet with us," Gibbs said.

"Ynna," Moss replied and pushed through a narrow passage between the racks to Burn who was standing near the entrance. "Have you heard from Ynna?"

"Huh?" Burn asked, looking lazily up from the bottle he was nursing. "I have a call out. We'll know more once we meet up with the others. But don't worry, she knows what she's doing. That idiot, Chicken Thumbs on the other hand. Bet you anything he stepped right in it."

"He was supposed to talk with me first, right?" Moss asked.

"We gave him the fucking easiest job. Said he was ready for the big time. Guess he learned."

"You think he's dead?" Moss gulped.

"Maybe," Burn replied in an unsettlingly cavalier tone. He was so flippant about the potential death. Uninterested in the fate of a person Moss took to be Burn's friend. He had never met anyone like that. In the burb, death was inevitable (though delayed for many) and taken very seriously. Until today, death had been little more than a vague notion. When he had been told of his parents' death, he had been too young to fully understand it. But out here, with Burn, life seemed cheap. It was a difficult notion to shake.

"You worried about him?" he asked bluntly but there was something in his tone which left Moss feeling mocked.

Moss couldn't help but answer honestly. "If he died trying to find me, then yes."

"You bubs really are like children," Burn said. "If he got himself killed, *he* got himself killed. Weren't your fault, nor mine. Just his and whoever pulled the trigger."

Moss did not answer, just mulled the words over. "Now get some clothes, we don't have all fucking night to stand around here jawing. And tell Chubs he's got five minutes before he finds a boot in his anus."

He ran over to Gibbs who turned on him with a grin, holding up a white shirt frilled at the front and along the sleeves.

"But I don't wanna be a pirate," he said in mock imitation of something which Moss did not understand.

"Burn says we have to hurry," he said, his tone conveying the message clearly. Gibbs hustled to pull a flannel shirt off the rack before moving on toward heavy jackets, Moss right behind. Within a few minutes, they both had armfuls of attire and were standing before Burn who brought them over to an ancient man sitting in a plastic chair behind a cluttered counter, his face blue with the light of an ancient, decrepit television. He wearily rang up the items before Burn spoke.

"They are going to change in the flaps, you torch what they leave." The old man nodded, appearing neither to have listened nor heard. In a flash, Burn sent a cigarette butt rocketing toward the old man who had just time enough to slap at the embers as they burst upon his chest. He cursed at Burn who simply repeated, "torch what we leave."

"Yes, yes," the old man grumbled, as Burn ran his palm past a small scanner to pay. "Go change," Burn ordered and the two pushed into cramped stalls with a cloth hanging from copper rings which scraped across a steel bar. They stripped slowly out of the clothes which clung to them. With nothing to dry themselves, they put the new items on their damp flesh, shivering all the while. Moss noticed a small camera pointing into the changing area and grimaced.

"Creep," he said to no one in particular.

"I see it too," he heard from the adjacent stall. "I always assumed the hexes had cameras too, despite the company's claims." That thought had never occurred to Moss, who had always taken ThutoCo at their word. The idea unnerved him greatly.

"You think?"

"Yeah, probably. What we've learned tonight only bolsters that notion."

"You may be right," Moss had to concede, remembering Issy's claim that she knew what he wanted to do with her and feeling the pang of guilt once more. He imagined a group of security officers laughing at him and calling her over to watch as he awkwardly defiled his friend. Her imagined face in horror as she was made to stare at the sordid incident.

"You about ready?" Gibbs asked as Moss pulled the bulky, water-resistant jacket over his shoulders.

"Yes," he answered, sliding open the curtain. He took one last look at the sopping pile of burb clothes and headed for Burn who was still arguing with the man behind the counter.

He led them from the shop toward a section thick with smoke. Crude fires lit with charcoal heated a sea of pots and skillets. They made their way to a young man, covered in sliding tattoos, who looked lazily up at them. He wore a tattered, oversized Comph brand wifebeater with the company logo on the front nearly faded to oblivion. The pockets of his baggy pants were filled to bursting and Moss could not even venture a guess as to what was in them.

The kid seemed utterly disinterested in their very presence. "Help you?" he asked, glassy-eyed.

"Three meat bowls with everything," Burn ordered, tapping on his palmscreen.

"Three?" he repeated as he grasped for bowls.

"Three," Burn hissed as the kid lay them out in what felt like a frame-by-frame video.

He heaped noodles into the bowls. "Soup?" he asked, the word as lethargic as his movements.

"Everything," Burn said, not looking up as the kid ladled in steaming broth.

"Shoots?" he asked.

Moss began to fret for the young man's safety as Burn raised an eyebrow and seethed, "Everything!"

The kid was unfazed, topping the bowl with shoots. "You said meat, right?" Moss held a delicate hand over Burn's hard, calloused hands reaching toward his pistol. The action surprised him as he was scared of the man. But he was even more scared of what would happen if he coldcocked the kid.

"Don't fucking touch me," Burn warned but his tone was betrayed by a peculiar smile.

"He's not worth what will come," Moss said, retracting a trembling hand, still surprised with himself. Since leaving the burb, it was as if instinct had replaced logic.

"Yes, meat," Gibbs said to the kid who had taken no notice of the scene unfolding before him. Moss marveled as he heaped meat onto the bowls. This young man had no idea how close he came to a world of pain, or worse. A tattoo of a woman riding a nuclear bomb winked at Moss as the cook reached for sauce before looking up with a questioning look.

Moss shouted, "add the sauce!"

"Whatever, asshole." The young man pouted and there was no stopping Burn this time. He grabbed the kid by his scruffy black hair.

Now he was paying attention.

"Your fucking generation," he said to Moss as though it were his fault before turning on the cook. "Listen, fuckwit, when you have a customer before you, that is your whole fucking world. You hear me?"

"I hear you," he said with venom coated in terror.

Burn released the kid and threw an ancient cash chip at him. "It's more than you deserve," he snarled and scooped up a bowl and two sticks from a jar. The two followed suit.

"Prick," Gibbs added before trotting after Burn. "I've never said that to someone before," he whispered to Moss.

Moss shook his head, his heart racing. That brief interaction was more intense than just about anything he had experienced in the burbs. Gibbs had a little smirk on his face. Moss scoffed, "I can't believe how much you are enjoying all this."

"You only get one go, Moss. We may not have much longer, given all this. I'm gonna experience it, live it while I can. Those bikers come back and," he snapped his fingers. "It could all be over. So, I'm gonna eat, drink, buy clothes, shoot guns, do whatever."

Moss knew there was truth to what he said. A hard, unfathomable truth. "You should take a page, live while you're living," Gibbs concluded with a wink.

Moss nodded and considered the words as the three sat in what he imagined was once a park. A large plaza with cement benches covered in small spikes to prevent sleeping, fire pits and lighted posters under a tall overpass that was shaking under the weight of cars. People sat about eating, talking and sleeping while others made rounds, performing tricks or playing music with open hands. The beggars stayed well clear of them, Burn obviously not giving the impression of generosity.

A small, enclosed playground sat off to one side, packed with unattended children. The gates, structures and fencing were all branded with Opperistic Wealth Network logos. The company had undoubtedly donated the small space to curry favor with the citizenry. Moss had noticed that almost every building, structure or piece of beautification bore one corporate logo or another.

As they sat in silence, eating and slurping, a cat wandered over. One of its hind legs was a crude but functional mechanical version. The cat leisurely circled, mewing for

scraps, the robotic leg working in perfect harmony with the others.

Moss cocked his head at the animal as it clicked around his leg, nuzzling and beginning to purr. "Who would put that on a stray?"

"Who cares?" Burn replied, finishing his meal.

"Just seems like an odd use of the parts," he noted, watching the little critter as it made its way to Gibb's feet, popping its little head up one pant leg. Moss dropped a small scrap of meat from his bowl to the ground, immediately getting the animal's attention. It sprang over and began licking at the imitation meat.

Burn snorted. "Feed him and he's likely to follow you around forever."

"I'll take all the friends I can," Moss joked without thinking.

"Friends and followers ain't the same," Burn pointed out, but Moss was hardly listening, fixated on the movement of the small animal. It was so similar to the way the tiger in the burb moved, skulking and lapping at the proffered meat. The rusted metal against the dirty orange fur made it hard to distinguish the leg in certain lights as the cat moved. Moss smiled, forgetting for a brief moment where he was and what he was doing.

"Shit." Burn groaned and both Moss and Gibbs looked up to see six people coming around a corner into the plaza. They wore the unmistakable vests of bikers with the same horizontal sword emblem they had seen earlier that night. Moss turned to Burn who appeared to be calculating his next move. "We have to get the fuck outta here."

"Oh, no," Moss squeaked and leaped to his feet.

"Slow up," Burn hissed. "These lot may not know what you look like, so let's move out slow." He stood as he sent a message on his palm. They all turned away and began making their way back toward the narrow walkway. People bustled quietly and a couple moved to sit on the vacated bench. Moss felt the throbbing of his heart and stole a glance over his shoulder. One biker caught his eye.

"I think they see us," Moss whispered in a tremulous voice. His feet began to move more quickly though he tried to hold his pace.

"We're fine," Burn whispered but Moss could see he was unsure and had his hand buried in his jacket. They were nearing the street, the sea of people in which to get lost a mere ten paces before them.

Pop.

The sound of gunfire was unmistakable, and the screaming began immediately. Burn was pushing them through the running bodies as he pulled his Kingfisher from its holster and turned his plated eye back just long enough to get a shot off. The white light filled the space and a different scream echoed behind them—not one of fear, but anger and pain.

As they entered the fleeing throng, Moss stole a glance back to see a man grasping at seared flesh, feeling for an arm that lay next to him on the street. The beam had sliced him from collar bone to ribs. Moss stared at the man a moment longer than he should and tripped as another shot rang out, moving the already fleeing people faster.

"Moss," he heard his friend utter as he turned to see the crimson seeping into the white squares of the flannel on his left arm. He was staring into Moss's eyes as he ran, a vacant look on his face.

Moss would never forget the fear and grim understanding he witnessed from his friend at that moment. Gibbs clutched at the wound. The blood began to trickle from between his fingers, slowly filling the creases at the skin of his joints. He was panting as his flesh turned pale.

"Gibbs got shot," Moss yelled to Burn through the crowd. The old man grumbled an inaudible response.

Moss hooked himself under his friend's other arm, helping to take some of the increasing weight. Another shot fired at a distance exploded a streetlamp overhead, showering glass down on the crowd. More shouts and shots could be heard as drones dropped from above and zipped toward the perusing thugs, scanning as they moved. Burn lowered his head as they passed, blue lines skimming over the brim of his hat. Moss held his free hand over his face, pleased that he was already shielding himself from falling debris.

"This way," Burn shouted as he ducked into a doorway and kicked the entire door off rusted hinges, a muffled hiss and gulp emanating from the back implant. "We can get to them this way. The buildings are connected."

"All right," Moss said, looking at Gibbs who was hardly conscious, eyes bloodshot and glassy under dark bags. Climbing the stairs was slow going and Burn eventually took over carrying Gibbs. They reached a landing and made their way down a long hallway of doors, Gibbs all the time dripping on the patchy carpeted floor. Wailing music grew louder as they moved toward a set of open doors with people partying back and forth between apartments, red plastic cups to match the red faces. The revelers seemed utterly disinterested in the three as they passed.

"Dude's messed up," one announced drunkenly, cheap beer dripping from his mutton-chopped face. "You should get him to a vet."

A girl by his side slapped him playfully, before nearly falling and grabbing his arm. "You mean a doctor!" she shrieked through laughter.

The drunken kid joined in the merriment. "I know, right?" he said.

The three kept moving.

"We're taking him to a hospital?" Moss pressed.

"We'll get him patched," Burn answered, impatient as they reached a walkway between buildings. "Places get quieter farther in."

Moving through the endless sea of apartment doors and hallways became increasingly frustrating as Gibbs sank deeper and deeper, hardly clutching the wound any longer.

"How you doin', kid?" Burn asked.

Always one to joke under duress, Gibbs rasped, "been better."

"Sounds about right," Burn nodded. "Just about there."

"I always like to make an entrance," Gibbs sputtered just before his body contorted and he sprayed vomit on the peeling papered wall, pieces of undigested noodle sliding slowly to the ground. Burn ran his palm over a screen next to a door and it opened—revealing an empty room. Four wood paneled walls with linoleum floors.

Nothing. Moss turned to yell at Burn, who was rapidly tapping at his palm with the fingers from the same hand. Just then the back wall was no longer wood panel but a blank screen with a door that slid open. Though he had looked at wall screens like this his whole life, he had never considered that they could be used for clandestine purposes.

"Woah," he uttered.

"Cheap trick, but keeps RENTec Building Associates from asking questions," Burn said as he heaved Gibbs toward the open door.

"Trick can't be that cheap," Moss noted, trying desperately to distract himself from the fact that his friend was dying.

"We inherited it from an off-the-books porno studio we," and his tone shifted, "helped to relocate."

"Ah," Moss said, pretending to understand the implication but unsure what exactly he meant. He followed Burn up a narrow staircase with hardly enough room to drag Gibbs up. An impenetrable looking door with machine gun turret and camera awaited them.

"Let us in," Burn ordered into the camera, immediately followed by an electronic click and the sound of someone shifting heavy metal.

CHAPTER 8

They crashed through the door and were greeted by staring eyes and pointed weapons. Seeing the situation, a thin, dark, meticulously clean man in a checkered suit rushed over to Gibbs. He was devoid of any hair and wore lemon yellow gloves with matching tie.

"He's been hit," Burn announced as he and the thin man helped Gibbs onto a couch. The man began scanning Gibbs, taking vitals and putting bots to work. "Legion's on our ass and Carcer'll be swarming," Burn added.

A beefy, Asian man holding a classic revolver asked, "they see you?"

"Kid was smart, covered his face and the other was slumped," Burn explained.

"Good," the man said as he hurried over to pick up Gibbs.

For a safehouse tucked in between tenement apartments, the space was rather large, though nearly all of it was full of equipment and computers. Cords and power cables snaked around the floors, up the walls and were even taped to the ceiling where many hung slack—the tape having failed under the weight.

Another person eyed them suspiciously from a bank of cots. They were little more than metal frames with canvas bolted to the wall on one side and held flat by rusted chains on the other.

"I need a couple of reloads," Burn said to the person on the cots, who jumped down despondently, eyeing Moss the whole time.

Moss stared at the slight frame, nondescript baggy clothes, facial features which Moss considered both masculine and feminine and those angry eyes. While one side of their head was shaved, the long hair which cascaded down the other was dyed jet black with white stripes. With thick, black tribal tattoos cascading down one arm and tanned skin, they looked to Moss like a Pacific Islander, though he had never met someone from there before. He desperately wanted to say something, justify his presence, but could not muster the words. His mouth simply fell open.

A plump, pale, Caucasian girl with tattoos covering her face approached him. Bisected at the nose her face was striped with what Moss took to be code and the other half, hieroglyphs. She wore a maroon shirt, black leather skirt with purple lipstick and eye shadow.

"Rosetta," she said, extending a hand, inked in a language Moss did not recognize. He shook it but before he could speak, she asked, "you Moss?"

"Yeah," he said, looking over her shoulder as Gibbs received an injection.

"You have something for me?" she asked kindly, as though speaking to a lost child.

Moss hesitated. "Um..."

"She's the one to give it to, she's our breaker" Burn announced as he peeled his jacket from his shoulders. Moss

pulled the data chip from his pocket and handed it over. He felt as if his entire purpose in this had already come to a close, and that he had got his friend shot for nothing.

"Thanks," Rosetta said with a broad smile before turning and scurrying over to a computer sitting on a desk cluttered with repair supplies, paper coffee cups and action figures. She inserted the chip into a reader and began working. Burn sat on a couch as the work commenced on his implant.

Moss stood, not knowing what to do. Feeling utterly useless, he made his way across the room to where the man in the suit was pecking at a screen, programming a handheld medical assist bot to remove the bullet in Gibbs' arm. The large man turned at his approach, holding up his hands to stop Moss.

"Your friend is going to be fine," he said with a hint of a drawl. "But let Grimy do his thing."

"Thank you both," Moss said, his sincerity not lost on the man who towered over him.

"It's what we do," the man said. He wore tight black pants, through which Moss could see the outline of his large penis and a purple mesh tank top through which the words "100% BEEF" was tattooed across his broad chest.

He caught the look. "I'm all man," he said, continuing when he saw Moss's confusion. "No augments, no implants, nothing. Don't take stims, don't smoke, don't drink coffee, nothing. Parents had me au natural. I was born in a bathtub—all human ever since. Don't judge all you folks with your robo-parts, just ain't for me," he concluded, clearly having given this speech many times before.

He ushered Moss to the remaining couch, and they sat. "You get sick a lot?" Moss asked, having always been told that people without genetic inoculations rarely survived past infancy.

"Used to. Got called, 'sniffles' as a kid cause'a how much I got sick. But now? Never. My body handles that shit. Nothing you can do in a lab which the human body can't do better."

"Not Sniffles anymore?" Moss sheepishly joked.

"Oh, no! They call me Ferocious Stan on account of my short temper," he said and took Moss's hand in one of his strong, massive paws before giving it an introductory shake.

"You don't mind the name?"

Stan grinned. "Nope. I know how I get. Comes in handy in a scrape."

"I'm Moss," he said, and just as with MOSS II, he wished he had come up with a better nickname.

"Like lichen?" Stan asked with a cocked eyebrow.

Moss smiled slightly. "You know, I've never heard that one before."

"Got a ferocious wit too," Stan said with a wink. Moss chuckled.

"Does it make it difficult to do things?" Moss asked, genuinely curious. They were so dependent on technology in the burbs that he could not imagine living without.

"Being tech-free? Yeah," Stan admitted. "I carry an old-style phone I program like a palmscreen, but it does make life harder sometimes."

Moss liked the young man, feeling at ease talking with him, but it struck him that he only seemed a few years older than he was. Ynna too. Looking around the room, the whole lot of them seemed to be under thirty.

Watching his eye, Stan asked, "what you see?"

"You're all... well... young," he observed.

"You got that right," Stan said with an infectious smile. "We are. Not all groups are like us. Some are older, been at this

for years, but others..." he trailed off, examining his compatriots. "Sandra brought us all together. Each one of us was on an—well, let's just say an unideal path. She took us in, gave us homes and showed us we could be part of something."

"What?" Moss asked, wanting to know everything about both his grandmother and the purpose she lay before them.

"You've only been away from the burbs a few hours?" Stan asked.

Moss felt as though he was admitting some secret shame. "Yeah."

"Well, it'll be hard for you to see, but you've been part of some bad shit for a long time. We all know your family wanted you out, but it may be a while before you understand why we do what we do."

Once more, Moss felt like a child. A memory flashed for a brief moment: his father saying, "this is tall talk," before ushering him from the room. His father, this man who he no longer felt he knew at all, and about whom so much had been made, had made him feel then just as he did now.

"I'm beginning to understand," Moss said, but even to himself, the words sounded shallow.

Stan put one of the giant hands on his shoulder. "I'm sure." It was a kindness and it was not lost on Moss. This man, this self-described ferocious man was being so nice to Moss, and it meant a lot to him. Moss was overwhelmed and scared-for himself and for his friend who was wheezing in the corner. He had made it here on instinct but now felt as though he could pass out from the weight of it all.

But Stan was making it a little easier. The small gesture of a conversation was enough to keep him going.

He looked up at the massive man and asked, "what was Sandra—what was my grandmother like?"

Stan chuckled, himself lost in memories. He smiled and pounded his fist against his palm for effect. "Hard. Not the type of person you wanted to run into in a dark alley. But under her ass-kicking, ball-busting exterior was a good woman. She helped me when I was lost. Lighted a way in dark days.

"You see, I played ball in school, helped me to get big and tough rather than sick. I got good. Real good. Even got a contract from the Miners Football Club. But as happens, I tore my ACL."

Stan wasn't looking at Moss as he recounted the story, he seemed to be reliving it through the telling. "Easy fix right?" he continued. "But I didn't want the drugs or the mesh where my body should be. So, I tried rehab. Old fashioned stretch and lift rehab. But my body never quite came back." He hung his head in the miserable memory. "I got cut. I got mad. Living with rage the way some live with booze. Couldn't get right. Started fights just to finish them. Sometimes they finished me though."

He fell silent for a moment before Moss saw a slight glint in his eye. "Then I met her. She showed me that I could still make an impact in this world. As I said, she did that for all of us."

"I didn't really know her," Moss said, wishing more than anything that he had. "Turns out there was a lot I didn't know about my family."

"That's hard. I still spend every Sunday night with my family," he said, not considering his words. "Sorry," he adjusted.

"It's all right," Moss said. "I think I'll get to know them better by getting to know you all better."

"Right," Stan agreed with a smile. "Let me make introductions." Moss glanced around the room as Stan pointed. No one took note. "You met Rosetta on the way in, she's better with computers than most."

"Okay," Moss said.

"Working on Burn's back is my partner and love of my life, Judy. Former Carcer fixer. Before you ask some dumb-fuck bub question, the pronoun is 'they.' You follow?" Moss did and had no interest in finding the ferocity, so he turned the conversation.

"Everyone has a role?" he asked.

"Exactly, just like in your video games," Stan said knowingly. He was more right than he understood. Growing up playing games together, Issy, Gibbs, and Moss had always built purposeful squads with Issy playing as a tank class, Gibbs as a healer and Moss picking up a more leadership role: putting more points in charisma or intelligence, depending on the game.

Breaking Moss out of his thoughts, Stan continued, "Most groups of us try to have enough diverse skills to get us out of a jam."

"Makes sense," Moss said.

"Now, over there," he said, and pointed to the man in the suit. "That's Grimy." They both looked at Grimy as he watched the bot delicately remove the bullet while simultaneously clearing blood away and adding cream. The mechanical arms and tendrils worked in perfect fluid motion— a meticulous ballet of healing.

Stan tore his gaze away first and took up the conversation again, "Grimy does most of our patch work. Former vet. Veterinarian, that is. Not the other one. Not like Sandra. I don't think he'd hold up too good in a fight." Moss

couldn't help but think about the drunks they passed who made a similar distinction.

Moss questioned, "he's called Grimy ironically?"

Stan tapped a finger to his nose. "The man's fastidious. Never seen a person who likes things so clean. He says he "likes things a certain way", but I think he's a little crazy," he said loudly enough for all to hear.

Grimy looked over his shoulder at them. "Laugh now but I'm sure you'll be happy when you do not get an infection." He scowled. His voice was deeper than Moss had presumed based on appearance.

Stan laughed. "Guess you got that right." Moss chuckled and was surprised by how light the mood was in the room. A group of young people fighting a giant company who no doubt had bounties on all of them, with one-person bleeding out in the corner and another who had recently killed a person getting repaired, and none of them seemed bothered. "When we get synched to our network, you'll meet Seti, our Aussie eye in the sky. Never seen her outside of VR but she keeps tabs on the goings-on. Helps keep Carcer out of our face."

"Oh," Moss said and caught himself looking up before shaking his head of the foolishness.

"And you know Burn." Stan pointed to the man in question. Burn was engaged in a hushed conversation with Judy.

"Right," Moss said before adding politely, "seems nice."

Stan laughed and whispered, making sure Burn was not listening. "No, he doesn't, but I'd rather be led by a competent asshole than a kind idiot."

"Sure," Moss agreed, thankful for everything Burn had done for him so far. "What about Ynna and Chicken Thumbs?"

Stan's face grew dark.

"Right," he said, hanging his head. "Ynna is a jack of all trades. Tough like Sandra, clever as Burn and skilled as Rosetta and Judy."

Moss smirked. "But not as strong as you?"

"Nah, no one is," he said with a bright grin. "She comes close, though."

"I notice you didn't include me in that list," Grimy put in. "As, no one compares to me."

"You just ain't good enough at anything to count," Stan fired back. "Little bots of yours do all the real work."

Grimy dramatically put his hands to his chest. "My delicate psyche," he mocked before turning serious. "While you may think modern medicine is simply dropping a bot, human guidance is still paramount to the success of any operation."

Moss offered, "like us with our drudges."

"Precisely," Grimy said with a tip-of-the-hat gesture. "I'll be interested to hear how you describe our illustrious Chicken Thumbs," he said to Stan, who shook his head and turned to look at Moss.

"Here's the thing about CT," he began, considering his words. "He wants it. He wants to be good, and he works hard to help. He's not naturally gifted the way some people here are, not some wonderkid who was in vet school while most kids his age were drawing with crayons." He shot Grimy a withering look. "He's just a normal guy who wants to help. I admire him for that. He and I both worked hard and now we are part of something."

Grimy snorted a laugh and Moss found that he was hardly listening, more concerned at that moment about his friend covered in blood on the couch. He took solace that Gibbs

looked better now, rhythmically breathing while the bot skittered over his body, checking for further injuries.

Moss felt the weight of guilt upon him. He had been so distracted by the people in the room, the stories of his family and his own role that he had nearly forgotten that his closest friend had been shot for coming along. For helping when there was no reason for him to have come along. He could feel his eyes well up as the overwhelming shame took over. The two men took no note and Grimy said, "the difference, Stanley, is that with your hard work you became something more than you were. Chicken Thumbs may want for greatness, but his capacity is limited."

Stan shot the man a broad, winning smile. "I think he's gonna surprise us all."

"Assuming he's still alive," Grimy stated, before noticing Moss's look. He glanced down at Gibbs. "He's going to be fine," he said. "This is a rather mild injury, all things considered."

Moss had to force words from his lips, his voice cracking as he spoke. "He got shot for me."

"Maybe you shouldn't have fucking brought him," Judy scolded, and the words found their way like an arrow into Moss's soul.

Moss looked at them meekly. "I tried to stop him."

"The kid's friend got shot Jude, cut him some fucking slack," Stan defended.

"Someone here needs to speak the truth," Judy said, eyes narrowing at Moss.

Grimy gestured to Gibbs. "Don't you think he's had enough truth for one day?"

"He's going to need to toughen up quick and all this coddling isn't helping matters," Judy argued, Moss watched the scene unfold, wide-eyed and miserable.

"Yeah, but—" Stan began.

"Enough," Burn bellowed, rising to his feet. "Judy, let's you and I go for a drink. Stan, get Moss set up on a cot."

"Maybe read him a bedtime story too, hon," Judy mocked as the door opened and they exited hurriedly.

"I'm not," Moss began, ire rising within him. "I'm not a fucking child!"

"I know." Stan nodded and smiled in a pitying way that made Moss feel worse.

Moss turned to the powerful man, affecting as tough a tone as he could muster. "Tomorrow, can you teach me to fight?"

"Not really how it works," Stan said. "Learning to fight takes years of training and conditioning, you don't simply watch me punch a guy and mimic it."

"Teach me to shoot then," Moss pleaded, and Stan nodded.

"All right, but you should get some rest. If we get this decrypted, we may need your help sooner than later," Stan told him. Moss nodded and stood, not making his way straight to a cot, but to Gibbs. He watched his friend lay there, doing nothing.

But he was alive.

"I'm sorry," he said, not for his friend, but for himself. He gritted his teeth. This would not happen again. He would learn to fight, to protect himself and those he cared for.

He turned back and slumped onto a cot. The room was bright and loud and completely unlike where he normally slept. And yet, he did.

CHAPTER 9

Moss opened his eyes, rubbed his implant and for a moment, wondered where the sound of the sea was. The rotted wood which greeted his vision reminded him. He was not in his hex. Not in his burb. He was somewhere else altogether, doing something which he didn't understand, for reasons he was only beginning to see clearly.

He rolled over and the room was dark and mostly quiet. Rosetta still faced the bank of screens, transfixed in her work. Gibbs snored quietly and there was an impression of a body in the cot above him, sinking low over his head. He blinked and a coffee mug appeared before him, steaming with an unmistakable aroma. Moss had never tried the stuff before, but his head hurt and nothing else was normal, so he figured to give it a shot. He reached out and grabbed the mug as he realized it was Judy who was offering.

"Thanks," he whispered as the steam from the mug filled his nostrils. He had always enjoyed the smell of coffee when he had passed the cafes but never enough to walk in.

"No problem," Judy said. "Sorry about before. Not a great first impression."

"Nope," Moss agreed, and Judy laughed, zebra hair falling in front of their face. Moss noticed all the freckles Judy had, never having taken the time before to observe.

"It's simply that I don't know you and don't know why everyone is so quick to trust you just because of who your family is."

"Fair enough," Moss said and meant it. He knew these people had no reason to trust him yet and did not really begrudge them for saying so, though he did not like it either. "It's a two-way street. I don't know any of you people either and I pretty much have to just go with it, also. I mean, I'm pretty sure I gave up my whole life for this just because someone told me they knew my parents."

"I hadn't thought about what you gave up to be here, or what you risked. I am sorry," Judy repeated, and Moss wondered what Burn had said to inspire this turnaround. "Maybe we can both learn to trust each other—together?"

"I'd like that," Moss said and extended a hand, which Judy shook.

"You ever have coffee before?"

"Nope. Am I going to like it?"

"Probably not, it's… well, it's an acquired taste," Judy said, their brown eyes kind for the first time since they met.

Moss smiled and asked, "you ever met anyone from the burbs before?"

"Nope. Am I going to like it?" Judy parroted and they both chuckled quietly.

Moss took a sip of the dark brown liquid and winced. The hot brown liquid tasted disgusting to him. "Where do you acquire that taste?" he joked, but before Judy could answer, Burn stepped into the light.

"You two about done mending fences?"

Judy said, "yes," and Moss nodded.

"Good," he said. "Could be a long da—" he began and cut his words short, pressing a finger to his ear. Rosetta turned from the streams of data on her screens and Judy cocked an ear. "Getting this?" Burn asked Rosetta, who nodded, causing all the piercings in her head to bounce.

"What is it?" Moss whispered, but the cots above him were already beginning to shift.

"Burn, you want me to piece him or unlock him?" Rosetta asked, holding up a physical earpiece.

"Just unlock him, the thing's in there already," Burn answered, pointing at Moss and indicating for him to move. He stood and hustled over to Rosetta, making sure to avoid all the cables between them.

"I'm gonna connect with your implant," Rosetta said. Her tone was still kind, but tired.

"Sure," Moss said. "Long night?"

She smirked. "Yeah, ThutoCo usually doesn't make it too hard but this chip you brought is some deep data. It'll be a while before I get anywhere. This implant on the other hand," she said and pointed to the base of his head. He noticed then the cybernetic fingertips under a layer of the same skin mesh which were used in Relief Aides. She tapped on her keyboard. Moss watched as she got a lock to his implant.

"How much can they do?" he asked, marveling at the ease with which they kept hacking it.

"A lot," she answered easily, not paying much attention to him. The screen flashed.

DOWNLOAD COMPLETE.

UPLOAD COMPLETE.

INSTALLATION COMPLETE.

"DETRITUS SIXTEEN" LINK ESTABLISHED.

DIAGNOSTICS COMPLETE.

Hey, new guy. Moss heard the Australian accented voice in his mind.

"Hi," he said aloud, causing chuckles all around.

"You can think responses, just like the commands to your room back home," Rosetta clarified.

Oh, he thought, and Rosetta shot him a thumbs-up.

"You can all hear my thoughts now?" He asked but realized the answer as the words left his lips. Rosetta chuckled.

"No, just the ones designated for us. The implant translates your brainwaves the same way as before, you just have a new feature unlocked."

"Right," Moss said and turned to Grimy. "How's Gibbs?"

"Still recovering well," he answered.

Now that I have all of you, Seti interrupted. *I got an encoded message from Ynna. It came in garbled and I won't bother playing it for you. Suffice it to say, I heard the word captured and she hasn't checked in since.* No one spoke as everyone processed the information.

Seti broke the silence with a joke. *Am I to assume you are all making grim faces at each other?*

Yes, Burn said. *We will work on a plan to get her out.*

Seti said, *I'll let you know if I hear anything else.*

Thanks, Rosetta replied.

"Moss," Burn said, and all eyes turned to him. "Where would someone be taken if they were arrested in the burb?"

"Carcer Corp has an auxiliary holding between the burbs where our security officers take people for transfer," Moss answered, happy Issy had explained procedures in excruciating detail while she was at BurbSec Academy. He remembered the late nights in her hex, flipping cards with detail after detail of

ThutoCo security. He had never thought it would actually be relevant for his life.

"Think we can get in easily?" Burn asked.

Moss shook his head before admitting, "I have no idea, though, really." Looking around the room, he added, "I guess if anyone can, it would probably be you guys."

"*Us* guys," Stan clarified, looking right at Moss, who could feel his hand begin to shake.

Seti, can you get us schematics? Judy asked.

Already on it, Seti answered and a projection of the facility appeared in the center of the room, a perfect, full-color digital rendering. Flanked by burbs on all sides, the octagonal structure of gray metal and concrete was ominous. Brick walls with barbed wire lay only a few meters before chain-link fences. A guard tower overlooked the structure with floodlights and scanners. Drones circled like vultures overhead and Moss squinted to see two guards in their intimidating gray and red armor playing on palmscreens.

Moss gasped. "Is this live?"

Sure is, Seti said in an unapologetically braggadocios tone.

"Stan, I want you to get some equipment with Moss while Judy and I workshop a plan," Burn announced.

"Got it, coach," Stan said with a wry smile as everyone began to move about the room.

"Actually," Moss said, and everyone stopped dead. All eyes on him once more, he swallowed and said, "I think I know someone who can help us with this."

Judy scowled as Burn asked, "who's that?"

With all the eyes now on him, he stammered, "my friend, well, one of my closest friends. I mean we grew up together, not that we were close in any other way. Not that I would be opposed

to that. I just mean a friend of mine. I should clarify: her parents helped raise me after mine… well, anyway, she works in security and may be able to help us."

"What did you have in mind?" Burn asked.

"Why are you humoring this?" Judy hissed. "We don't need another fucking bub involved, we already have this bonus sack of potatoes." Judy hooked a thumb at Gibbs. "We don't need more. Every ThutoCo employee we bring in puts us at higher risk."

"That may be, but we are up against it and an inside man may be just what we need," Burn stated and, though Judy seemed to sulk, no more was said. Silence oppressed the room for a moment.

"I was thinking she could take some of you guys prisoner or something and you could break Ynna out from the inside," Moss offered, thinking himself very clever until the laughter began.

Burn was not laughing. "It's a good idea, kid." His patronizing tone was not lost on Moss. "But that only works in the movies. If we got taken in, we would be stripped, databased, have our weapons taken, our implants shut off and would be in as bad a spot as Ynna."

"Your plan just means more of us imprisoned," Judy piled on.

Moss hung his head in shame. "Sorry."

"Don't be," Burn said. "I'll want you to contact your friend and see if they can't help us out, just not in the way you suggested."

"The way you coddle him is amazing." Judy snorted, reminding Moss much more of the night before than the person he woke up to.

"The only one getting coddled right now is you," Burn said with a threatening finger pointed square at Judy. "I know you're all bent out of shape cuz your friend's in peril, but you need to inflict this attitude on Carcer and not those fixing to help."

"Fine," Judy conceded accompanied by a dramatic eye roll.

"Stan, take him to a café and to get kitted. Make contact with the friend if you can but keep him safe. Get back by sundown because we want to get to Ynna before they transfer her to a proper facility and things get a whole lot worse."

"I got you," Stan said and headed for the door with Moss dogging his steps. He was relieved to be leaving the room, though it put him ill at ease to leave Gibbs with strangers, no matter how well they knew his family. Gibbs was the brother Moss never had and more and more, his real family were people he never knew. The crotchety old grandmother who sent him a present once a year for his birthday was some rebel leader bringing young people together for a cause. His father who got home just in time to say good night was a corporate spy trying to take down the company that raised him. He still didn't even know his mother's role in all this, and, given everything, he wasn't sure he wanted to.

Gibbs had been there for him. Had been a friend when he needed one most. Issy and her family had taken him in, helped him to sort his life out when things were most dire. Moss shook his head, trying to banish the guilt from his mind. One of his friends had been shot for him and he was about to ask the other to betray the people she most trusted for some person Moss hardly knew.

"What am I doing?" he heard himself ask aloud when he and Stan were out in the anteroom.

He hoped Stan had not heard but he turned to face Moss. "You're doing good in a bad world," he put plainly. "I can't imagine what this is like for you—waking up to a normal world

one day and an upside down one the next. Must be hard. Brutal. But you seem like a good man and you're going to help people. We don't know what's on that chip, but your dad wanted us to get it out. That means it's some bad stuff. And you're helping with that. You're making your dad proud," he said with such genuine kindness that Moss wanted to fall to the floor.

"Thank you," he said.

"And your friend's gonna be all right and he'll help too," Stan added for good measure. "And look, before we head out, sorry about Judy."

Moss looked to the floor and halfheartedly offered, "it's okay."

"It isn't, and Judy knows it isn't. What you have to understand is that it's been a tough road."

"Oh," Moss said. "Because of the," and he waved his hands vaguely around his genitals.

Stan shook his head with a deep pity before taking a breath and looking at Moss seriously. "Nah, mostly because of some other shit. Shit back on The Big Island, but sure, sometimes all the talk of a post-gender world is just that: talk. Judy has never once been handed anything or been treated fair.

"Technology the way it is, we can all be more than human. We are born more than human. Concocted and altered in a lab. Born with nanotech, implants and altered. You can buy yourself into whatever you want to be. But if your heart knows you weren't born the way you need, some assholes have a problem."

"It's not only gender though," Moss pointed out. "I'm sure you know better than anyone that some people have a problem with the tech, too."

Stan nodded. "Got that right. I may not want to alter my body, but I don't judge those that do. Those pristiners, like my

parents, railing against science? It's all just fear," he concluded. Moss nodded his understanding.

"As someone who doesn't do it, you must have some reservations about the human modifications though?" Moss asked and a corner of Stan's lip curled up.

"My relationship with it is complicated, sure, but I can separate my feelings about what I want for myself from those which others want for themselves. Not that it doesn't go the other way, too. Many who meet me think I must have a problem with them simply because I don't want the tech for myself. It's a vicious cycle, man."

Listening to Stan, Moss knew that he had so much to learn about the world. His world, where neural implants were a prerequisite for employment, was so different from what Stan and Judy saw outside the burbs. There were deep shades of gray in everything and complicated nuance that Moss would have to examine.

"But with Judy," Stan continued and though he was simply justifying their behavior, Moss could hear the undying love in the man's voice. "Sometimes that anger at an unfair world comes out in ways it shouldn't. Doesn't make it right. But hopefully, it helps you to understand."

"It does," Moss said, still feeling sorrier for himself than caring about anyone else.

"Let's get you some new toys and talk to this girl that's got you all out of sorts." Stan smirked as he turned to lead Moss from the room.

Moss felt the blood rush to his face despite himself. "It's just—" he began but decided to let the issue drop.

They exited the tenement building onto a bustling street, mobbed with people on the sidewalks, cars in the street and

overhead. The rain was replaced by a thick gray fog hanging in the sky, dulling the colors to a pale hue. Stan had thrown a purple hoodie with the words Miners FC emblazoned on the back over his mesh shirt with a cap to match.

"This way," Stan said as he began pushing through the people who Moss now realized were all moving toward a train station at the end of the block—an imposing, artistic spiraled glass building with a towering adjoining parking structure.

Train times and directions were displayed on screens facing out toward the street, the helpful information intermittently replaced with commercials for new model cars, drudge personal assistants, and quick travel to other cities. Moss watched, expecting frustration from travelers when the information they required yielded to commercials, but he saw only conceit.

The people moved wordlessly passed them, staring at their palms or lenscreens, lost in earpieces or direct neural messaging. Moss followed beyond banks of storefronts for several blocks before they stopped in front of an antique bookshop with paper books in the window. Fire danced from a gas metal base above the door with the words "Fahrenheit 415" written in scorched, bent rebar before the flames.

"Four one five is the old-time area code for this district. Clever, eh?" Stan asked.

"Yeah," Moss agreed as the guilt returned, knowing that Gibbs would have loved it. A bell chimed as they stepped through the door and an ancient woman looked up from the book she read with latex-gloved hands. They were surrounded on all sides by bookcases and the walls were lined with tattered pages.

"Stanley," the woman greeted.

"Chu," he said back, and she smiled, wrinkling her round face.

"I presume you are not here for literary pursuits?" she asked as she shuffled from her chair with the aid of an ornate wooden cane carved to look like a Chinese dragon, the open mouth flattening into a surface for the palm of her hand. She wore a simple brown cloak which hung down to wooden shoes, strapped across her feet.

Stan smirked. "Can't say that we are."

"To the back then," Chu said as she moved slowly to a pristine copy of *The Price of a Life* in a glass case. Moss recognized the book as it was the first in the series which inspired the founder of ThutoCo to name his company for the fantasy Empire in which the story took place.

Chu produced a remote and key from the folds of the cloak and pressed a large button, shuttering the windows to the outside world before she opened the case with the small key. The room now lit by nothing more than a small gas lamp on the desk at which she had been sitting, she fumbled behind the book before pressing another button. A click could be heard from the wall behind and Chu moved over to push hard on a bookcase which slid a few meters backward.

"Any rooms in this city not have hidden compartments?" Moss joked.

"Not in the circles we run in." Stan smiled. "Ready?"

"Yes," Moss said and followed him around the bookshelf to a room padded with noise insulation foam and broad counters on either side. A young man looked up from the pornography he was watching on an old screen and waved a hand of greeting to Stan. The man had short horns protruding from his head.

It was like nothing Moss had ever seen, the slight bone points sticking through the skin. He knew the vanity bioaugments were common, but he had never seen them before in real life. ThutoCo had strict policies and any augmentations had to

increase productivity or were not allowed. Moss also understood these types of things to be very expensive and if this kid had them, he had to be wealthy.

Chu peeked from around the corner and yelled at him in a language Moss took to be a Chinese dialect. The horned kid yelled back and waved her away as the bookshelf slid back into place, securing them in the tight corridor room. Moss couldn't help but watch as ejaculate exploded onto a woman's face on the screen and the young man turned fully around to face them, one hand concealed under the counter.

He narrowed his eyes at Stan. "You always come at the worst time."

"If this is how you work, I doubt there is ever a good time," Stan shot back.

"Got a problem with how I work, maybe you buy guns somewhere else," he said in a tone which Moss could not discern. Stan held his hands up, conciliatorily as a new scene began on the screen.

"You got the best shit, jack off whenever you want," Stan said in a similarly uncomfortable way. "We just want to get the kid here some gear."

"What you have in mind?" the young man asked as he stood to reveal he wore nothing more than a long, stained shirt hanging down to mid-thigh with a noticeable protrusion at the front.

There was another protrusion in the back: the kid had a long slender tail of flesh which swayed and flicked as he walked. Moss grimaced and, for a brief moment, just wanted to be back in his hex talking to MOSS II.

"Something easy," Stan said.

"Bullets, laser, icer, plasma, sonic, needle, line, beam, eddi, phaser, saucer?"

Stan rolled his eyes and laughed. "Those last two were made up!"

The kid laughed and put his hands in the air, raising the hem line of the shirt. "Caught me. Serious, what you want?"

"Kingfisher Dual-Beam Flip," Stan said, and the man peered under the long metal counter before reaching under and producing the pistol, setting it heavily on the counter with a clang which died in the walls. Gray metal and plastic with the trademark long-billed bird logo along its face. Battery magazine loaded into the base of the grip. A slender metal switch lay atop the pistol's trigger.

"You point, you squeeze," the man said to Moss as he handed a box of batteries to Stan. "Flip down, you toast."

"We can try it in the back?" Stan asked.

"Sure. You want pig?"

Stan shook the question off, "No need to waste a clone. Dummy's fine."

The young man stepped from the counter, his shirt bunched in his crack as he opened another door at the rear of the room. He waved them in and closed the door behind them. Moss and Stan stood in the tight space and Stan handed over the weapon. It was much heavier than what they had taken from the burbs. The room was similarly insulated, with a wood table at the front facing a figure which was once made to look like a person, but which was shredded down to the pole set into the cement floor.

"Point and squeeze," Stan repeated, and Moss lifted the weapon, remembering the biker's convulsions the last time he had pointed a gun.

He inadvertently closed his eyes as he pulled back on the trigger. He smelled the white smoke which spat from the barrel just as an explosion of electricity blasted the blackened wall

behind the dummy. The minimal recoil startled Moss and Stan let out a light chuckle. "All right, you have a few things to learn."

He helped Moss with posture, showed him how to hold his arms, square his shoulders and, "most importantly, to keep those eyes open." They spent the better part of an hour practicing before Stan finally had Moss flip the switch.

"Doing this will mean more kick for you but more stopping power, too. It'll make short work of a drudge and even shorter work of a person. You follow?"

"Yeah," Moss said. "But I don't want to make 'short work' of a person."

"I know you don't, but you may have to," Stan soothed.

Moss set the weapon down with a heavy thud and sighed. "These Carcer Corp people, they're just people, too. They took a job and probably have families and kids and stuff and I'm sure I can't kill them just for taking an 'evil' job."

"That's a fair point, but you'll feel different when they got a barrel pointed at you," Stan said, his voice hard and unyielding.

"Maybe," Moss considered.

"Trust me, they have no qualms about sending you to an early grave. You should try to leave that delicate heart here, now."

"Shouldn't we be better than them?" Moss argued, his internal debate finding its voice.

"We are," Stan said, his clear eyes leaving no doubt as to his belief. "Now point and squeeze."

CHAPTER 10

"After buying the weapon, holsters and Dermidos nanomesh bodysuits to disrupt drones and cameras, Moss and Stan made their way from the bookstore. They headed toward a large stone building which had served as a place of prayer for some long-forgotten religious sect in the past and was now dedicated to computers and digital escapism.

They ascended the steps through tall wooden doors with huge metal knockers set into the center. Oval-shaped stained-glass windows showed multicolored images of people interacting with different types of computers. Each pane displayed prices for hourly rent and cast odd light into the room. Banks of computers sat on either side of a long red carpet leading to a drudge behind a podium. They passed CerebralSync and VR sets on one side and traditional computers on the other, the clientele appearing to Moss as the types who would prefer a no-questions-asked establishment.

"Greetings and salutations, sirs!" the drudge loudly greeted as they approached. Cameras set into the head where eyes would be and a hinged metal plate for a mouth which moved in imperfect synchronization as it spoke.

"Private traceless traditional," Stan said, not making small talk with the machine.

"Please scan your palm for prepayment," the drudge replied. Stan produced a small screen from his pocket and held it up for the robot to communicate with. "Thank you. Booth three," the drudge said, and they made their way to a grouping of small stalls near the entrance doors. They stepped into the box labeled three and slid closed a red velvet curtain. Moss could feel Stan's hot, tea scented breath on his neck as he slid a keyboard toward himself and looked at the screen, watching sheets of information pass before he was met by a blank screen.

"This'll be secure. You can log into your ThutoCo account," Stan instructed.

"Right," Moss said as he typed his login. His mail was mostly empty: a productivity report from the previous day, a forwarded ad for upgrading SeaDome and a message from Issy. He opened it, uncomfortable with Stan reading over his shoulder.

"Didn't see you or Gibbs at the gym this morning, just wanted to make sure you're okay. Call me when you can, I have the day off," was all it read. He was curious if she had stopped by the hex, too and found him not at home.

"You can call her," Stan said. "She won't be able to see you though." Moss did so, replying to her message with a call. She answered before the first ring tone.

"Hey, Moss," she said excitedly, looking into the camera and furrowing her brows when she didn't see him.

"Hey, Is," he said in as normal a voice as he could muster but, even to his own ears, he sounded off.

She looked into the camera with a knowing smile. "So, you left the burb?"

"What? Um, yeah," Moss answered.

"Friends of your parents finally found you?" she asked, and though her big eyes brought Moss more comfort than anyone,

the question threw him for a loop. Stan tapped him on the shoulder and shook his head.

"What do you mean?" Moss asked and Issy rolled her eyes playfully. She picked up the small camera mounted on her desk and showed him the room.

"I'm alone. The line isn't tapped. I've been waiting for this for a long time, Moss," she said, and Moss didn't need Stan's guidance this time.

"What?" Moss said.

"I'm sorry," she replied, and he could hear the truth in her voice. "I've known for a long time. Our parents were friends, it's why it was so important for us to help you all those years, but my dad told me the truth. He told me that one day you would probably run off," she explained, her eyes downcast.

Moss couldn't believe what he was hearing. It was another surprise in a long list of surprises. Issy was the one person he trusted most in the world and it turned out that she, too, had kept things from him. "Why?" he murmured.

"Dad told me so I wouldn't get—" she trailed off.

"No, why didn't he tell me? Vihaan is like a father to me," Moss said, his voice rising. He felt as though he was the only person who didn't know what had been going on. His parents had a network of people working with them and friends who they trusted, but not him. Moss had been alone in the dark.

"If you had known, you might have tried to do something." Her justification sounded like a plea for Moss to understand.

"I might have," Moss admitted, and she smiled a sad, grateful smile.

"Are you ever going to come back?" Issy asked, leaning in toward the camera and looking hopeful. Looking into her big,

beautiful eyes in that moment, his anger and confusion drained away.

"Yes," he answered, a steely determination entering his voice. "Issy, I need your help."

"Sure!" she said before catching her excitement. "What can I do?"

"Ask if she can meet you in the Forum at 22:00," Stan whispered right into Moss's ear. He instinctively shied away from the closeness. He repeated the instructions to Issy.

"Yes, of course," she said.

"Be in uniform," Moss added, without needing to be told.

"Oh," Issy said, the sound of surprise in her voice for the first time. She recovered quickly, "Sure, whatever you need. You know you can trust me." She looked miserably at the screen and added, "I really hope you know you can trust me," and Moss nodded, knowing she could not see it.

"See you tonight," he said. "And thanks, Is."

"See you tonight," she parroted and though they had only been parted a day, he missed her.

TRANSMISSION COMPLETE.

"Can you?" Stan said.

"Pardon?"

"Trust her," he clarified.

Without hesitation, Moss said, "yes."

"You sure? Even though she knows what's up?" he asked.

"You trust Judy?" Moss asked. It came off a little harsher than he intended, but the doubt of one of his closest friends irked him.

"Fair enough," he said. "You just seemed a little rattled by some of what she said, so I wanted to be sure. Either way, I'll have your back tonight just in case."

"Good," Moss said and meant it. Even though he trusted Issy more than just about anyone, the idea of trust was a confusing mess in his mind at the moment. In a way he didn't fully understand, he trusted Stan more than most of the people he had known his whole life.

Stan got a big grin on his face. "Hungry?"

"Sure," Moss said, not convinced of the answer. He knew he needed to eat but the desire was not there.

"Great, I know a place near here. And guess what?" Stan asked with a smile which implied he was setting up a joke.

"What?" Moss indulged.

"No hidden compartments." He laughed mildly.

Moss smiled. "Good, if I have to pass through two doors, I'm just gonna kick your ass," he joked with a mock punch of Stan's solid bicep.

"Oh, I'll bet you would," Stan hooted back as they left the stall. Moss took one more look around the building as they left, this hallowed structure, once a place of worship, now devoted to technology.

They exited and Stan led him to a restaurant whose windows had been rented out to a department store nearby. Screens flashed videos of people pretending to laugh and cavort while in pristine versions of the fashion of the day.

"Cursed Earth Pizza" was written in spray paint above the door. The smell of warming bread and melting cheese filled Moss's nose as they entered and his stomach let him know that he was hungrier than he had thought, grumbling audibly.

"That's right," Stan said, pointing to Moss's gut. "All-natural ingredients. Almost impossible to get these days. City farmed. Why it's so expensive."

"I see," Moss said, never having given any thought to where his food came from. The place was empty. Cherry red

topped barstools sat before counters which lined the walls of the room. Light forms on screens in the windows shifted and morphed on the checkered floor.

"Stanley," the lanky man behind the counter shouted with a wave. "You brought a new friend. Where's Ynna and that sweet ass of hers?"

Stan chortled, "tell *her* that and she'll put you through the fucking wall."

"Don't I know it," he said and the two slapped palms jovially, though Moss noticed Stan slide his hand into his pocket to hide something passed in the exchange. "You want two sunrise slices?"

"Yessir," Stan answered quickly and the man at the counter pressed some buttons on his palm. "Catch the game last night?"

"Nah. Caught it in reruns, but I was up all night with this sweet slice," he said, eyes growing wide with the excitement of telling his story. He let out a long dog whistle and continued, "You ever been with a woman with a tickler installed down there? Hoo, boy, it's a whole new world!"

"I'll bet," Stan said with unconvincing affected excitement.

"All right, go sit with your friend," the man behind the counter said, waving Stan off. The two sat side by side in silence for a moment.

Moss looked at Stan and winked theatrically. "I think shady handoffs count as a back room."

"Saw that, did you?" Stan smirked. "Our group sometimes needs some relief and the pizza isn't the only all-natural thing they sell here, get me?"

"I do, but I'm guessing you don't take the stuff?"

"You got that right!" Stan said. "But I'm happy to pick it up if it helps.

Moss smiled. "That's nice."

"I know I am," Stan announced, twisting Moss's words. "As I said, we all have a role. It's not just for when we go on runs, but in the down time, too. I spend more time out in the city grabbing shit because I'm comfortable here. Rosetta doesn't like people, Grimy annoys them, Judy hates them, and Burn doesn't play well with others."

Moss snorted a laugh, thinking of the kid at the noodle shop, "So I've seen. And you said there were more groups like you- like us?"

"Yeah," Stan nodded, his eyes drifting up to a screen in the corner showing sport highlights. "Small pockets of groups with the same goal: trying to free people from the shackles of the big companies who own their lives." His eyes flicked down and he pointed to a passerby. "All these folks go about their days indebted. Bought and paid for. We seek to free them whether they know they need it or not."

"People like me," Moss pointed out. He thought about all the people he had ever known, all the other citizens of the burbs who had never—and would never—leave. It had been him only a short while earlier, content to live out his life in his tiny fishbowl. Now that he had stepped foot outside, he wanted to see more.

"Exactly. Though you are a bit of a special case," Stan noted.

"Right," Moss replied bashfully. "But you never meet these other groups?" he asked, wanting to learn as much as he could while Stan was being so forthright.

"Met a few but we keep separated so companies like Carcer can't take down the whole if they take down a part." As he explained, he lifted an outstretched hand and bent down one

finger and wiggled the others. "A couple of times we have worked with another squad on a raid or something but that's about it. I heard all the crews came together once for some massive job but it's probably not true. Can't even imagine the type of thing that would bring all us weirdos together- would be really neat to see though."

Moss nodded, beginning to understand.

Stan continued, "folks like Seti help us all to pull in the same direction, unite the different crews."

"She gives you orders?" Moss asked. Stan chuckled and shook his head.

"Nah. It's not like that. She gives suggestions, options. Lets us know when there are moves to be made. Ultimately, we do our own thing."

"Anyone do too much of their own thing?" Moss asked.

"Ah, yeah. Some groups have tried to take on too much. Got cocky. Thought they were all-stars. They learned quick though." A grave expression darkened his face as he spoke. "Carcer comes with a couple of Wardens. Blast in with DOA bounties," he trailed off, the light of the ads shifting on his eyes as he stared into nothing.

Moss understood. "You used to run with another crew?"

"It's—" he began before two slices of pizza were set before them, interrupting his thought. Lightly sauced on thin dough with cheese oozing down the sides, caused the paper plates to become translucent. Moss's jaw tingled at the smell of it. He blew the steam off just the way he did at home, but he could hardly contain his excitement over the food. "Gotta let it cool," Stan warned.

"I know," he whined, staring at the piece with near ravenous desire. After a moment, Stan peeled his piece from the plate and took a bite with exaggerated enjoyment. Moss followed

his lead and though it burned his mouth a little, it was the best piece of food he had put in his mouth.

"Oh, man," he murmured through a full mouth. "I could get used to this."

"You're gonna have to," Stan reminded him.

"How do you learn to cook like this?" Moss asked.

"Pizza University," Stan stated in an obvious joke. "I mean, there *are* culinary schools and stuff, but this place has been here for generations. Parents hand this down to children and so on and so on. It's a family legacy." Moss considered his words as he delightedly took another bite.

"Moss, can I ask you something?"

"Sure," he said absently, so focused on the pizza that he was paying attention to little else.

"You and your friend—the one from the couch—you guys think you can handle this life? I mean, you didn't ask for any of it, didn't choose to do it, it's being thrust upon you."

Moss paused a moment, trying to put the confusing jumble of thoughts into words. "I don't know, Stan. It's all happened so fast. What I've seen, what I've learned. It's so much. I want to make my parents proud, and some part of me feels connected to what you are doing in a way I cannot quite parse. I mean, one day ago I was sitting in my hex and two days ago, I thought that was going to be my whole life. To give it all up. To quit and never look back. I don't know. And Gibbs... he offered to come, and I knew I would need him. But to see him shot. Drag him through a city I don't know to help people we've never met. It's hard." He hung his head with the thought.

"I know the guilt," Stan said softly. "You have to turn it into fuel, let it motivate you."

"I don't want to live a life guided by revenge," Moss said, more honestly than he expected.

"It's not revenge," Stan began.

Moss held up a hand. "Don't tell me it's justice."

"I won't," Stan said, falling silent.

Moss grinned, happy he had been right. "But you were going to?"

"Maybe," Stan smiled, raising an implicit eyebrow. Moss smiled, too. He liked Stan.

"It feels different with you guys," he waxed. "Different from the people in the burbs, I mean."

"Yeah," Stan agreed. "That's because, even though you lived with them, they were ultimately your coworkers."

"Oh," Moss said, before admitting, "I had never thought of it like that."

Stan looked at Moss sadly, once again like a little kid who was in over his head. "Sorry."

"It's just another truth I was too simple to see," Moss confessed, more to himself than to Stan. "Though I suppose it's true for you, too."

Stan snorted, "I had never thought of it like that."

"I suppose it's a little different," Moss added, and Stan nodded.

Both their heads cocked as they heard it. Engines roaring up the street. Unmistakable. Moss's heart began to race as he saw Stan's posture tighten. The first motorcycle zoomed by the window ad and Moss squinted to see the back of the vest. Stan let out a deep sigh as Moss saw a round shield with skull emblem and the words "HOPLITE MC" written above.

"Not the Legion," Stan said, as relieved as Moss while the bikes streamed passed them. "You were good at target practice but I'm not sure we could take on a gang, just the two of us."

"Probably not," Moss agreed, seeing a fire in Stan's eyes which had never been there before. He understood then that the ferocity lay just below the calm exterior of the massive man.

Nervously, he asked, "how many are there?"

"Bike gangs? A lot," Stan snarled derisively. "Gangs in general, really. These assholes are just the loudest. You have to understand—out here, there are a lot of things people want but can't get. The gangs can provide. People need justice but can't afford a Carcer Corp bounty? Gangs can provide. A lot of people need protection," Stan spread his hands flat.

"Gangs can provide," Moss filled in.

Stan sighed, a low, tired exhalation. "In the burbs, they give you everything you think you need so you never ask for much. Out here, there's a glut of nonsense people think they want, and someone is always out to take advantage. The big companies take most of what people have and the street thugs take what's left."

CHAPTER 11

Moss sat on a cot, listening to the group bicker about schematics and schemes when he heard a low murmur from the couch. He sprang over to Gibbs's side, his friend's bloodshot eyes blinking to focus.

"Hey, man," Moss whispered.

"Hey, Moss," Gibbs said, his voice low and wobbly. "Where are we?" His eyes scanned the room, eyebrows furrowed in confusion.

"Burn took us to a safehouse," Moss said, feeling slight guilt that at the moment he felt cool using the term, "safehouse."

"Burn?" Gibbs said before clarity flashed in his eyes. "Right, we left the burb. We take down ThutoCo yet? Become enemies of the state?" A weak smile broke out on his dry lips.

"Not quite yet, but it's moving that direction." Moss smiled. "How you feeling?"

Gibbs smiled weakly. "'Tis but a scratch."

"You got shot," Moss told him, and his friend rolled his eyes dramatically.

"I know. It actually doesn't hurt," Gibbs informed him.

"That's great. Grimy here got you patched." Moss gestured over his shoulder and watched as Gibbs appraised the man.

"Name's ironic, eh? Clever," he said sarcastically, bringing smiles to the mouths of all except Grimy.

"Oh, another one of *those*," the doctor said. "Can I put him back under?"

"Kid got shot so's we could have that chip," Burn said and Grimy shook his head.

"So, what's next?" Gibbs said. "Save the damsel in distress?"

"Ooh, I like him, a bit of a firecracker," Stan announced with a smile, and Judy punched him on the shoulder, and he played at an injury.

"She's no fucking damsel," Judy announced but without the previous harshness.

Stan turned and kissed Judy on the forehead. "Don't I know it."

"Pain in my ass," they retorted and the two began to kiss, moving quickly to a passion which carried them to a cot.

"Get a room," Grimy said, holding his hand to his chest in offense.

Judy said through pressed, wet lips, "this is a room,"

"Into the stairwell then," Burn ordered the couple whose clothes were already beginning to come off. They shuffled awkwardly through the door, no longer focused on anything around them and Stan kicked it closed behind them. "You two ready to hear a plan?"

Gibbs leaned forward laboriously, and Moss said, "Yes."

"Bring up the display," Burn said, and the image of the building appeared in the room once more. "Moss, you and Stan will go meet your friend and hope she can get you in without incident. We're putting a lot of faith in her and if she wants out when all is said and done, we'll take her. If things go sideways,

Stan has orders I hope you'll understand." He paused, waiting on Moss.

Moss nodded and said in the same tone he always used with Mr. Greene, "I understand."

"Good. Things do turn, Rosetta, Judy and I'll be standing by with Dronepacks to drop in and lend a hand," Burn explained.

"Don't let things turn new guy," Rosetta warned from the desk without turning to look at them. "I don't really dig firefights."

Moss's stomach turned. He had never been responsible for more than keeping a drudge from getting dented and now lives would be depending on him. He nodded nervously.

"Seti will be keeping an eye out but she's got lots of irons in the fire so Bullet Hole, here." Burn pointed to Gibbs. "You'll be watching the live feed and can call 'em as you see 'em."

"I veto that nickname," Gibbs said weakly. "But I'm happy to help."

"Good." Burn nodded and lit a cigarette, instantly mixing the smell of smoke into that of stale body odor. "Grimy'll be with you just in case but he'll duck out if things get hairy."

"Don't let things get hairy," Rosetta half-joked, clearly amused by her own repetition.

Burn snorted. "That's enough."

"Sorry," Rosetta said. "I'm getting close here."

"Tell me," Burn ordered. Rosetta clicked away for a moment longer and turned.

"I got it decrypted," she said, turning tired eyes to Moss. "It's clear your dad did not want this to be figured out by laymen. But I found myself at a password protected portion."

Gibbs piped up. "Did you try," and here he put on a low, British accent, "mellon?"

Rosetta chuckled, "cute."

"That's enough from the peanut gallery," Burn said harshly, and Gibbs sank back into the couch.

"It just says 'goodnight,'" Rosetta said. Moss smiled. His father had left a riddle which only he could solve. For the first time, Moss felt that he had value in the group. It would be him who helped crack this code. It would be him who connected them with Issy so they could free their friend. He now meant more in the world than he ever had.

"Try, Mossy," he said with pride. His father had always called him that. Even as he aged and begged him not to, he always did.

"I did already," Rosetta said plainly, clearly trying not to sound patronizing. "The computer is also trying millions of word combinations every nanosecond."

"Oh," Moss said. He supposed it shouldn't have been that easy, but he had wanted desperately to get it right on his first try. He thought about his father: tucking him in, kissing him goodnight. More often, as Moss got older, his father would open the door to his small part of the hex, standing and looking at his son. Moss would sometimes wake up but wouldn't say anything. He would simply crack an eye, see his dad, and fall back to sleep.

Moss could hear the thinly veiled disappointment in his friend's voice as Gibbs said, "you'll figure it out."

"You've got time," Burn added. "Just not all that much time."

Moss plopped down onto one of the couches and thought it over. After a while, Stan and Judy returned, sweaty and stinking of sex. They joined in, trying to workshop the

riddle with Moss as the sun began to set. Time passed with Rosetta clicking away at the ancient keyboard and seeing ACCESS DENIED again and again.

"We have to get started," Burn announced after many fruitless hours and the tone in the room shifted. They produced weapons from tattered steamer trunks, and everyone began getting ready in silence. An undeniable tension seeped into every corner of the small space as they prepared and before too long, Stan turned to Moss.

"Ready?" he asked, seeming to know the answer before he heard it.

"Yes," Moss answered unconvincingly.

"You'll be fine," Burn assured him before whispering something to Stan.

"Don't get killed," Judy said to Stan before turning to Moss. "Don't you get him killed."

The full weight of the moment landed on Moss's already terrified and heavy heart. He walked over and knelt by Gibbs.

"You going to be okay, here?" Moss asked.

"Yeah. It'll be just like when we played Ancient Command in virtual, you know? I'll be calling out orders from on high and you and Issy will be on the ground getting things done." Gibbs and Moss smiled at the childhood memory. They had spent so many afternoons playing that game. At twelve years old, they were one of the best teams in the burb. It was the first video game they had played together, and it had bonded them forever. Moss thought back to when, after several rounds of the game, their small band of hardened digital soldiers trounced an army five times their size. The defeated sixteen-year-olds spent the next week trying to figure out who had

defeated them. Moss, Gibbs, and Issy hiding from the wrath of the older children.

"It's just like that." Moss smiled. He began to whisper, "Issy knew everything. She knew all about all of this."

"She always knew *everything*, Moss," Gibbs said with a knowing smirk and Moss was disappointed that Gibbs was not surprised.

"We can trust her, right?" Moss asked, stealing a glance over his shoulder to Judy.

"If there is anyone in this world you can trust, it's Issy," Gibbs said without hesitation.

"Why didn't she tell me?" Moss asked. A mixture of heartbreak and anger welled up in him as he thought about it.

"Same reason you didn't want me to come: a misguided attempt at protection," Gibbs said.

"I wasn't wrong, you did get shot," Moss argued kindly.

"So, you keep saying." Gibbs smirked. "If it weren't for the blood loss, I'd already be back on my feet. And anyway, chicks dig scars."

Moss grabbed his friend's hand, once again grateful that he had offered to come. "I'll see you soon," Moss said.

"I'll see you on the other side of the war," Gibbs sing-songed.

Moss couldn't help but chuckle, shaking his head. "I wish I could do that."

"What?"

"Stay so calm in spite of everything," he explained.

Gibbs smiled. "It's a gift."

"I just feel like I have so much to learn. I didn't prepare for this at all. I don't know how I could have. I mean, I probably just wasn't ready, but now I feel like I'm going to be playing catch-up forever," Moss said.

"You'll get there," his friend assured him. "They will help you."

Moss looked around the room. He knew there was so much he could glean from all of them, so much they could impart to him. He nodded and stood. "Thanks, Gibbs," he said. "Let's do this."

Sitting with Stan in the cab, slowly flying back toward the burbs, Moss watched the rain streak the windows once more. The seat shifted underneath him as he bounced his knee nervously.

"It feels like a million years," he said, turning to look at Stan who was also staring out his window.

"Since you left?" Stan asked, his breath fogging the window with each word.

Moss nodded, shifting slightly and feeling the spring in the cushion of the ancient cab groan. "Yes."

"I'm sure it does," Stan said. "Make you wish we had never come into your life?"

Moss was surprised that he didn't have to think about the question. "No," he said. "I'm happy you did. I've been confused and terrified since the moment Ynna knocked on my door. I've come to realize much of what I thought my life had been was a lie and come to know that my family were not the people I thought I knew. But, despite everything, I'm actually happy. In some way, this feels more like the life I was supposed to live."

"It is," Stan said. He seemed more absent than Moss was used to. In a short time, he had become accustomed to Stan's gregarious energy but now, he seemed distracted.

"Everything all right?" Moss asked, causing Stan to blink hard and turn.

It was an obvious lie when he murmured, "yes."

"I mean, I know we only just met, but—" he began but Stan cut him off.

"It's not that," he said. "It's my pregame ritual. Right before a mission, I think about everything that could go wrong. But also, everything that can go right. Try to think about every eventuality, possibility. Coaches always tried to instill that in us, but your grandma helped to teach me to look at the whole board, you know?"

"Yeah," Moss replied. "You miss it? Sports I mean?"

Stan worried at some crust on his pant leg. "Not really. I was never in it for the fame or nothin'. I loved the sport and being part of a team, and though the sport has changed, I'm on a pretty great team now."

Moss cocked an eyebrow, "No part of you was in it for the fame?" Stan chuckled.

"I'm not saying I hated it." He winked, sounding more like himself. "First time's the hardest."

Moss let out a grim chuckle. "Nice thing is, if I botch it, I'll be dead and won't care so much."

"Could be captured," Stan noted. Moss's hands went numb. The thought of being killed scared him but the idea of being captured, tortured and questioned about something he did not fully understand terrified him much more. He had tried to rationalize all of this, make it seem like some abstract or not real event. But as the burbs grew closer outside the window the reality of what he was doing was undeniable. Fear began to grip him as he felt his heart rate and breathing quicken.

A massive hand landed on his shoulder. "You'll be fine," Stan said and as Moss looked up, something in Stans' eyes made him feel like the words were true. Moss breathed in

deeply just before the first-generation cab they had hired shuddered and began to drop to the landing pad.

It hissed to the ground, vibrating and jerking as it landed. The door clanged open and they stepped out. As he put his foot to the ground, Moss realized that he hadn't been made sick by the descent. He smiled.

"I will be fine," he told Stan.

The landing pads were on a raised platform off the side of the Forum, a place which served as a meeting spot between the burbs where friends could eat and shop and feel as though they had left home without the discomfort of actually doing so. A large plaza of decorative marble with a fountain and holo-projected trees was flanked on all sides by restaurants, cafes, boutique shops, and travel agencies. Relief Aides stood like statues outside the bars, ready for rental by inebriated employees.

Stan's eyes scanned around the space. He turned to Moss. "Know where we meet your friend?"

"Yeah," Moss said, pointing to Naan Scents Restaurant. Issy had invited Moss to join her family there for dinner on occasion and, though he had never taken her up on the offer, he figured she would be there. They made their way to the restaurant as the smells of spices and curry filled their nostrils. The scent instantly brought back memories of eating dinners Vihaan cooked for them in his hex.

"We may live here now, but it's important to remember where you come from. These are the tastes of your home, though you may never go there," he had told his daughter before setting the plates in front of them, and though Moss had infrequently joined them for dinner, the smell in the Forum made him feel that he was home.

Issy waved to them from the window, a half-eaten plate of biryani set before her. Confusion coursed through him as he looked at her. Her jet-black hair pulled into a bun, beautiful brown skin showing from under her armor and bright chestnut eyes smiling at him. His heart began to race once more, though this time not for fear of what lay ahead.

Stan smiled and half mocked, "I get it now."

"You saw her before," Moss reminded him.

"It's different in person," Stan told him. He was right. Though it had only been two days, seeing her again now stirred something within him. She stood as they entered and sprang into his arms, her armor clattering. She stepped back and looked him in the eyes.

"Are you all right?" she asked as though they had been parted for years.

"I am," Moss said. "You?"

"I'm fine. How did you take the news? How did you find out? I'm sorry I didn't tell you." She looked so apologetic Moss could hardly stand it.

"I found out from the person we are here to help," Moss explained. "And I'm fine. It's okay that you didn't tell me, I know you were doing what you thought was best. How much do you know about them?"

Stan cleared his throat theatrically and the two turned. Issy nodded in understanding and turned to the middle-aged man with thinning hair behind the counter. "Kunil, turn the music up and stir a pot... in the back."

He hurriedly followed the command and disappeared into the kitchen. The room became filled with synthesized sitar and a woman singing slowly. Moss had never heard Issy act as a BurbSec officer before and was impressed by the effect.

She appraised Stan and asked Moss, "who's your friend?"

"Stan," Moss introduced as the large man intentionally loomed over her.

"Issy," she said, extending a hand and smiling in a way that indicated that she was unimpressed by his attempt to intimidate her.

"Ferocious Stan," he corrected in a tone more threatening than friendly. Issy wrinkled her nose at Moss almost imperceptibly as they shook.

"We can talk here?" Stan clarified, looking suspiciously around the room.

"Yes," Issy answered. "Family friend and I'm off duty."

"Good," Stan said.

"What do you boys need from me?" she asked, forgoing small talk. Stan opened his mouth to speak but Moss beat him to it.

"Is, before we begin you need to understand something," he said, and both stared at him in shock.

"Yeah?" Issy said.

He cleared his throat to buy time and averted his eyes. "This is a big ask. You help us now; you may be giving up your whole life."

"Oh," she said sullenly, looking down and shifting one foot as she thought.

"She helps us, Burn says we can take her on," Stan announced to Moss. Then he turned to Issy. "Sorry," he corrected. "Hate it when people talk about me like I'm not in the room. *You* help, you can come with us."

"Thank you," she said, not looking up. Moss could hear the internal struggle in two short words and worried as to what

she, and Stan, were thinking at the moment. Leaving had been hard for him though he left little behind except for comfort. It would be much different for Issy. She had a life that she had worked for, a job she was good at and a life she enjoyed. She had her dad and friends. Asking her to risk all that for him made him feel sick.

"You can say no," Moss offered, in that moment hoping she would. She turned such sad eyes upon him that he nearly demanded she went back to her hex.

"I'll help," she said. "For you." Moss did not know what to make of that. "I left you in the dark for so long," she said by way of justification though Moss did not know if the words were for him or for herself.

"You don't have to," he told her. "You could just... just, walk away."

She thought on his words as Stan shifted with impatience under the bright, fluorescent lights.

"I'll help," she announced once more. "What do you need?"

"Can you get us into the Carcer Corp facility where they transfer prisoners from BurbSec?" Moss asked.

"Yeah," she answered. "I know there has been activity, it's what everyone is talking about since the lockdown."

Stan asked, "you have access to the cells?"

"Sure, I have to be able to put people there myself," she explained. "Though, of course, I never have."

"It's all traceable," Stan reminded her unnecessarily. "Once we are inside, we'll deal with the Carcer guards."

"When you say, 'deal with?'" Issy asked, worry covering her face.

"I mean *deal with*," Stan intoned in such a way as to leave no doubt. Issy nodded her understanding. "Gonna finish that?" Stan asked, pointing to the plate of spiced rice.

"What? No," Issy answered, nonplussed. She pushed the plate of food to Stan and handed him the fork which he took graciously.

"Energy, man," Stan justified to Moss as he sat. "Split it?"

"No," Moss answered, too struck by the shift to say anything else. Stan sat and worked at the food voraciously.

"Safe to say your life has changed," Issy joked nervously, pulling a piece of sleeve which stuck out from under the wrist of her armor and rubbing it between her thumb and forefinger.

"You are not wrong," Moss said, wearing a weak smile. He could not even begin to tell her how much his life had changed.

"Where's Gibbs?" she asked. "He came with you, right?"

The guilt hung on his every word. "I'll tell you later."

CHAPTER 12

They strode through the Forum, a BurbSec officer and two obvious city dwellers turning more than a few heads. Issy led them to a corridor between two buildings as Stan snickered.

"What?" Moss asked.

Stan smirked. "You catch the name of that bar?"

"Lewd and Lascivious," Moss answered with a shrug. He had never been but knew Gibbs would go there with some of his coworkers from time to time.

"Yeah." Stan laughed. "A sports bar with girls in hot pants dancing on the tables? You fucking bubs don't even know the meaning of lewd and lascivious."

Having seen the Long-Legged Spinners, even from the outside, Moss had to agree and began to speak before Issy hissed, "will you two hush up!"

They approached a concrete pillbox with the BurbSec seal painted on a thick metal door. *Entry Code Six Ten,* Moss heard her command in his mind and the barcode on her name tag was scanned before the door hissed open.

"There's a lot of these side entrances so the average employee doesn't see people being dragged very far," Issy explained as she led them down concrete steps whose yellow paint had been worn off over time. Lightbulbs in metal cages

illuminated the corridor which seemed to stretch on as far as Moss could see. They walked a while before Issy spoke again. "Ferocious Stan," she began respectfully. "You should take the lead here, there will be a guard stationed as we round the next corner."

"Right," he said and stepped in front of them, cracking his knuckles with dramatic flair. They stepped past a line of demarcation spray painted on the floor, the blue beehive shield logo of BurbSec on the near side and the handcuffed scorpion pincer emblem of the Carcer Corporation on the other.

"Thank you, Is," Moss said.

She turned sorrowful eyes on him as he heard her neural command, *Security Order 19*.

That was it.

He wasn't surprised, only disappointed.

"Listen, Moss," she began, but his hand was already reaching for the weapon at his side. It was not instinct as it had been with the biker. It was a calculated move.

He knew how much he had asked of her, how much she would have had to give up to help them. He also knew how much it would help her BurbSec career if she stopped them. He had hoped that she wouldn't betray them but he understood why she had.

His heart broke as he pressed his thumbnail against the switch, ensuring it was set to non-lethal. Her eyes went wide with disbelief as his he raised the weapon, pointing to the break in her armor at the shoulder. He knew the wiring would distribute the shock; Stan had taught him as much. The lights in the hallway turned red and she had time to say, "No," as he pulled the trigger.

Stan wheeled back around with his revolver aimed as an overhead speaker blared, "Security alert." The world was immediately flooded in red light.

Moss found himself saying, "I'm sorry," as the shock hit his oldest friend, who crumpled instantly into his arms. His eyes burned and his face contorted in anger, disappointment, and fear. He lay her down and turned to look at Stan with his weapon pointed at them.

Moss snarled, "it's dealt with." Stan lowered his weapon.

"I'm sorry." But Stan's words hardly registered.

"Me-fucking-too," Moss exclaimed, his words muffled in his own ears, drowned out by the alarms.

"We have to move," Stan ordered.

"I know it," he said through gritted teeth, his last conversation with Gibbs replaying in his mind. He looked at Issy, her shallow breaths causing her armor to rise and fall ever so slightly. He pulled the name tag from her armor and wiped the tears from his face as he stood, accepting that he could trust no one but himself in this world.

"Let's do something good," he told Stan and they hurried down the hallway. A guard turned to meet them at an open door at the end of the hall and Stan brought the butt of his weapon down so hard on the man his helmet shattered, sending him crashing to the floor. Moss held his weapon forward as they continued down more corridors.

We've been compromised, meet us at the front for extraction, Moss heard Stan command in his mind.

Already en route, Judy answered. Moss had watched this version of events play out on the hologram and knew they would make their way to the holding cells before leaving through the front door where the rest of the crew would be waiting. Time was paramount now as Carcer would be mobilizing men and drudges to converge on this location.

Two more guards awaited them around the next corner. One knelt, opening a box containing an auto-assembling turret.

Stan's weapon boomed in the contained space and the man on the ground was sprayed with the blood of his cohort as Moss pulled his own trigger with fury, the first few shots spraying electric blue all over his armor before finding a gap. He convulsed violently and crunched against the ground before he had a chance to activate the turret. Blood pooled dark crimson on to the hard floor and Moss stared a moment at the two men— one living, one forever dead.

Once a month in the burb, handlers made a special show of putting chickens in with 2152's mascot tiger. Employees would gather to watch the beasts stalk the helpless birds before turning them into plumes of feathers and viscera. Next to Stan, moving toward their destination, Moss felt a kinship with the animals. He could not wait for the next guards, his finger poised on his trigger. All sympathy he had felt for them lay two hallways back, taking shallow breaths.

He nearly pulled the trigger once more as the two stepped through another door to the holding cells and figures appeared before them, standing over the bodies of six guards. He had to blink hard to catch his brain up to what he was seeing.

Ynna stood poised with an autorifle pointed directly at them, a naked man cowering behind her. One windowless cell door was open and faced a bank of computer monitors displaying images from inside the cells and around the facility, where guards were hurrying into position. The feed from the outside of the structure showed no activity except the guards, though Moss knew that was about to change.

"What the fuck are you two doing here?" she shouted at them over the sounds of the alarm.

"Of course," Stan said, getting a read of the moment Moss did not understand.

"We are here to rescue you," Moss explained but Stan was already shaking his head at the words.

Ynna laughed as she reloaded her rifle. "Aww, my dipshits in shining armor."

"This him?" the man asked as he pulled some clothes for himself out of a security guard's locker and began to dress hurriedly, having to try several times before feeding his arm into one of the sleeves. Ynna was still dressed the way Moss had seen her when they had met and what Stan had realized now dawned on him too. Her garbled message had not said that she was captured but that she was going on the rescue mission herself.

"Chicken Thumbs?" Moss asked the Caucasian man who appeared to be in his late twenties, was slightly overweight and bore the fresh purpling yellow bruises of someone who had recently been asked some aggressive questions by Carcer Corp jailers.

"The one and only," Chicken Thumbs said, spreading his arms wide. His body moved with jerky, uneven motions as he reached down to pick up one of the guns from the floor. "Good thing you all got here when you did, I was a few hours away from a one-way trip to Carcer City."

"Hey fuckwits," Ynna interrupted. "People are coming to kill us so perhaps we can save the introductions and platitudes for later?"

"Yeah," Stan agreed as gunfire illuminated one of the screens. "Cavalry's here."

They stepped over the bodies as they moved back into the passageways. Lighted exit signs guided their way and they heard yelling from around another corner. Stan and Ynna led the way with the other two dogging their steps. Ynna peeked around the corner.

"Three more," she announced. "With a turret."

"I'll take the left?" Stan asked and Ynna rolled her eyes and shot him a devilish grin as she pulled the pin from a heat-seeking grenade.

She sent it bounding down the hallway, small pins firing out one after another to seek the bodies of the guards. They heard, "Shit," before a white light and loud explosive bang filled the space.

No sooner than it happened did Ynna and Stan round the corner, the autorifle and revolver singing their songs of death in unison. Moss and Chicken Thumbs followed but were left useless. Where he had felt like a hunter moments before, Moss was instantly relegated to a support role with the two now leading them. Though he didn't want to kill, neither did he want to do nothing.

"It's not much further," Ynna told them as they stepped through the gore. "There will be a lot more at the front so you two asshats may have to actually do something."

Her words stung but Moss simply nodded. Chicken Thumbs stepped through the blood and slipped, splaying his legs before he splashed to the ground. "Ew," he said as he tried to right himself, sliding again and landing face first into more of the warm, sticky red liquid.

"You may have to find a new job," Ynna said, shaking her head with disgust as he stood, his clothes clinging to his body. Trying to wipe the blood from his eyes simply smeared it more around his pudgy face. The guilt Moss had felt about bringing Issy—the person who betrayed them to the authorities—was somewhat diminished in the face of CT's seeming ineptitude.

As they moved further, Stan sidled up to Moss. "Quit hugging the wall like that," he said, pulling Moss toward the center. "One of those turrets starts firing, lots of bullets will slide along and make short work of your side."

"Oh, okay," Moss said weakly, realizing once again how truly far he was from being the tiger. "Thanks," he said. "For everything."

"I got you," Stan smiled. "Just remember, you got an important place in all this."

Moss would remember that moment for the rest of his days.

They all huddled as they neared another corner.

"Lucky ThutoCo doesn't like straight lines," Chicken Thumbs observed.

"Idiot, they are trying to make blind spots and choke points. There are going to be a lot of bodies around this," Ynna said, not masking her derision.

"Wish you had saved that grenade," Stan said, wiping the sweat from his brow.

"Stanley, sometimes it's like you don't know me at all," Ynna said with a crooked smile, producing another grenade from beneath her jacket. "Once this hits, we all pop out and lay it down."

"Right," Moss said, making circles with his thumb on the side of his weapon.

"Let's see if you're worth all this trouble," Ynna added, making Moss more resolute. He was going to prove his worth to them, show them that he wasn't just some useless bub.

"Isn't there some cover we can use?" Chicken Thumbs pleaded, his words running counter to his grim visage.

"Do you see any fucking cover, CT?" Ynna asked. "We have to get the fuck out of here."

Ynna pulled the pin and tossed the grenade. The guards sounded prepared this time, hollering, "incoming!" The narrow corridor was filled with light and sound once more and bullets and beams filled the small space as they stepped around the

corner. It seemed to happen faster than Moss's mind could compute as he pulled the trigger of his weapon, sending blast after blast into the group of seven guards.

They fired at the group who crouched behind mobile auto-folding metal walls. Chunks of wall and ceiling exploded and rained down, filling the space with rocks and dust as Stan bobbed and weaved toward the group. Moss watched as the only guard who had not lowered his visor looked in shock as the massive man kicked the shield, sending two flying backward.

Ynna and Moss let loose a barrage as the other guards turned to watch their compatriots. Moss hit one in the helmet, seeing the REGNAD display within the visor. Ynna's rifle made short work of two more while one man seemed to be merely cowering in terror.

A loud crack sent chills down Moss's spine as Stan spun the head of one guard to face backward. The other guard on the ground leveled his weapon at the same time as Stan stood. The guard fired a shot which grazed Stan's shoulder as he moved down the hall. Enraged, Stan pounced and knocked the gun loose before bringing a fist down on the guard's unprotected face. Blood cascaded as he hit the man again and again with a rage Moss had never before witnessed.

Moss turned too slowly as the last remaining guard took aim and fired with a trembling hand. Simultaneously, a shot rang out from behind him, killing the guard as Moss's vision went white with pain. He looked down to see his shoe split open, blood and smoke pouring out. Moss collapsed in pain as Ynna made sure the guards were no longer a threat. She turned to see Moss clutching his foot.

"Shit," she muttered as she made her way to him. "You all right?"

"Got shot," Moss told her, though he knew she was aware. He had never known pain, never experienced anything

like the firefight he had just witnessed. The VR games he had played, simulating modern war, were nothing like the carnage before him and the simulated gunshots nothing like the excruciating feeling emanating from his foot.

Ynna offered him a hand and pulled him to his feet. She produced a small tube from her pocket and pressed a button with her thumb as she placed it against his neck. The stim injector worked instantly, subsiding the pain and making Moss feel as though he could burst through the front door and take on Carcer Corp himself.

"Thank you," he said genuinely.

"No worries, still more to do. Can you walk?" She asked, her fierce eyes looking right into his.

"Yeah," he said and stamped the foot which produced a squishing sound but no longer pained him. He looked down to examine the wounded appendage and realized a good chunk of the side was gone. He knew it was the drugs which caused him not to care but he wasn't bothered by that fact either.

Clear up top. Rosetta's working on the front door for y'all but we'll have company shortly, Burn related.

Got two squads headed your way, Gibbs informed them.

Burn added, *they'll be on us right quick.*

We're clear and headed to you, Ynna told them. She reloaded her autorifle and said aloud, "Let's move."

As Stan had predicted, Moss felt little remorse as he stepped over the people who would have been happy to kill him and had shot his foot. The metallic scent of blood mixed with acrid smoke, gunpowder, dust, seared flesh and plastic filled his nose. He watched Stan rise to his feet, his eyes dark like that of a shark and his posture twisted predatorily. Splatter gleamed against his pale skin; his mesh ripped where the guard had thrashed against him.

"I was an engineer," Moss thought aloud.

"In a past life," Ynna replied, the barrel of her rifle still seeping a trail of smoke. She knelt and quickly wrapped his foot in a roll of bandage Moss had not even seen her produce.

"Got that right," Moss agreed and one side of Ynna's mouth turned upward slightly.

"To the front," Stan ordered, his light affability replaced with a coldness to match his appearance.

"Still can't believe you thought I needed rescuing," Ynna mocked as the group made their way up the hallway toward the front of the structure. Moss marveled at the size and scope of the tunnels which led to such a small building.

"Communication was shit, got bad intel, made a call," Stan stated.

"You must be real fun at parties," Moss joked as though speaking to Gibbs rather than a murderous pseudo stranger.

Stan snarled. "Like you've ever been to a fucking party."

"Cut him some slack, first time he's been doped, no doubt," Ynna defended.

Stan snorted. "And people wonder why I don't touch the stuff," he said under his breath, but loud enough to be heard.

"I like regular Stan more," Moss couldn't help but joke. Stan spun on him and scruffed him by the shirt, lifting him so his toes just touched the ground.

"Ferocious Stan is all that's keeping you and Chicken Shit alive," he hissed into Moss's face.

"I hate that nickname," Chicken Thumbs said, cutting the tension.

"Gibbs used a veto on his," Moss joked as Stan lowered him to the ground wearing a face of disgust which Moss ignored.

Chicken Thumbs raised an eyebrow. "Who's Gibbs?"

"Hey, dingbats, can we get the fuck out of here before Stan does Carcer's job for them?" Ynna said as she began to walk again.

The hallway opened into a large anteroom with security office on one side, large glass windows looking into the space. A huge metal door, large enough for a truck to be backed into, was set into the concrete. A solitary guard squatted at a panel next to the door, attempting to counter whatever Rosetta was doing on the other side. Stan was on him before he knew what hit him, slamming the man's face so hard into the door that his helmet cracked and visor split.

"Saved us a bullet." Chicken Thumbs shrugged as Moss watched the body slump. Moss noted how little protection the armor offered. He wondered if it served more to give them an intimidating appearance than to actually protect them. He decided he would wait to ask, the initial rush of the drugs having worn off.

Thanks, guys, Rosetta said. *I'll get it now.*

An eerie calm descended as they waited for the door to open, Stan pacing impatiently and Ynna checking and reloading her weapon.

"How'd they get you?" Moss asked Chicken Thumbs to fill the silence, his voice reverberating down the hall.

The young man chuckled miserably. "On my way to meet you, I was stopped by BurbSec. Tried to talk my way out of it the way I've seen her do a hundred times, but they didn't buy it," he explained.

"You were probably shaking like a fucking leaf and sweating like a stuck pig," Ynna chided.

"Yeah, I stick out like a sore—" he began, his voice rising with the joke.

"Don't you fucking say it, Bloodbath," Ynna interrupted, but Chicken Thumbs smirked anyway.

Got it, Rosetta informed them as the massive door thumped and began to slide open, revealing her working at a panel on the outside. Burn and Judy had their backs to them, pointing weapons to the sky. Moss took a breath of the clean air as it poured into the hallway. It smelled like the rain.

No sooner than Moss had taken the one free breath than the dark sky became dotted with approaching Carcer guards, the flashing red lights from their drones announcing their arrival. Moss knew what happened next unfolded in mere seconds but the stim slowed time as the action began.

Burn sent a line into the air, one guard's legs falling to the earth as his upper half went careening into a building in an explosion which shook the structure. Judy sprayed the sky with what amounted to fireworks, the bursts of cascading sparks causing more guards to recalculate their descent. Two were able to land, firing shots which scattered Judy and Burn. Ynna and Stan ran out into the open, the autorifle screaming shots which felled one of the guards. The other paused just long enough to point in the direction of Moss who lifted his weapon in what felt like slow motion.

He heard the pop of the weapon in the distance and felt the blood spray his face. He gritted his teeth and he felt his thumb move as Rosetta's head jerked to the wall in a crimson splat. He pulled the trigger and felt the recoil this time as the blue electric streamed toward the man, blasting open his armor. The second shot exploded his chest open in a mixture of smoke and carnage.

He knew what he had done.

He knew he had ended a life.

After all his protestations, Stan had been right. He felt no guilt for the man, only sorrow for Rosetta, the woman he had

assured this wouldn't happen. Weapons fired and alarms rang out as he knelt next to her body, red streaks pouring down over the tattoos on her neck.

"No!" Ynna shouted as she ran back and over to Rosetta. She clutched the body for just a moment, her face angry and inconsolable. She turned and looked at him with eyes that pierced his soul before darting back into the fray, screaming a war cry.

As one Carcer officer landed, she grabbed the muzzle of his weapon immediately, pulling him stumbling forward. She spun him to face the oncoming fire from one of his allies, and he was riddled with bullets meant for Ynna. She was covered in blood as she returned fire, making innumerable men pay for the death of her friend.

Moss could not move. He was immobilized by all of it. Seeing a new friend die. Killing someone. It was all too much. Two days earlier he had been an engineer, a cog in the machine, a nobody. Now he was something else. Something he couldn't even identify.

He looked down at Rosetta's body, feeling like he might throw up.

"I'm so sorry," he whispered to her. Her blank eyes stared into space.

Chicken Thumbs pulled him to his feet. As he stood, he saw one more Carcer officer take aim and Moss felt his arm move lethargically. Exhaustion, terror and regret was keeping his body from obeying his brain. He simply watched in stunned silence as the man pointed his weapon directly at him, poised to fire death.

The officer's head exploded, blood spraying into the lighted night sky. Moss turned slightly to see Judy, weapon smoking in hand, give a slight nod.

Second round closing in, Gibbs informed them as they hurried to Burn and Judy.

"Here," Burn said as he strapped a dronepack to Moss, metal arms wrapping themselves around his torso, clipping together to form a booster at his chest. "It'll get you out of here."

Judy screamed something at him and spit on the ground, but he was too sorrowful to hear or care about the insult. The slight engine on his back whirred to life.

Sticks in the wind, Seti ordered and Moss lifted into the sky. All the members of the group flew in different directions as Moss's stomach lurched. In the solitude of the night sky, he was left with his thoughts. Issy's face as she realized he was going to shoot her replayed in his mind before becoming Rosetta. The sound of the alarm. The blood. Stan prowling. Being shot. The drugs. The sizzle of the guard's chest. It was too much to bear. More had happened in the last hour than in Moss's previous nineteen years.

The drone shifted and buckled in the wind.

A thunderclap.

Light misting rain like hundreds of people spitting in his face before opening up, giving way to heavy rain. Every drop slapping him as if the world knew the enormity of what he had just experienced. The lights from the city grew in the distance as the burbs disappeared.

He turned his head as if to hide from it all and retched into the darkness.

CHAPTER 13

"Moss landed in a puddle, people turning to look at him in surprise, their eyes wide and mouths agape. Personal pack drones were expensive and required an even more costly registration and license. They were therefore uncommon, particularly with people as bedraggled as Moss appeared.

He slumped to the ground, crawling under an awning in front of a twenty-four-hour palmscreen repair shop. The ride had sapped any remaining strength and he leaned against the glass storefront, wrapping his arms around his knees.

A hand appeared in his vision.

"Let's go home," he heard Ynna say.

The word "home" rang false. He didn't feel as if he had a home anywhere in the world. He listened to the thumping of the rain on the awning. "Moss," Ynna said, her voice soft, almost sweet. He looked up, her wet hair glowing, her eyes big and kind. "Shit happens. We all know the risk."

She paused a moment, choking down emotions. "She knew the risk."

The words fell heavy on him and Ynna tried to recover. "You did good, but we have to go. That gauze had clotting gel but that foot's gonna be a problem if we don't get you some proper help."

He nodded, happy it was she who found him. Her jacket opened slightly as she helped him to his feet, exposing her bare breast through the mesh bodysuit. The curvature was a welcomed distraction, albeit fleeting. He couldn't tell if she didn't notice or didn't care as his eyes wandered up to her face.

In a weak voice, he said, "okay, we can go."

"I know it," she replied, obviously resenting the implication.

Not knowing what else to say, he muttered, "sorry."

"Let's go," she commanded.

They walked the lighted streets, both completely soaked through. Moss hated the feeling, the wetness bothering him more than the foot leaving dark streaks in the puddles. They weaved through neon-lit streets and alleys, the darkness and rain doing nothing to deter the denizens of the city from going about their business.

"This is all a pretty rude awakening for you?" Ynna asked, pulling her hair back with her hands to wring it out and get it out of her eyes.

"Yeah," Moss answered, needing to constantly steady himself with a hand on her shoulder. "I just wish I had known." The admission pained him.

"Why?" Ynna asked, and the question surprised him.

"I could have—I don't know—I could have prepared," he fumbled, wiping water from his face.

"You think anything in the burbs could have prepared you for tonight?"

Looking around the unfamiliar streets, cold faces and dangerous streets, he sullenly admitted, "no."

"ThutoCo doesn't teach classes on fighting the power," she joked with a slight smile.

He joined her in the smile and added, "fighting the power one-oh-one."

"Right," she chuckled and cupped her hands to her mouth, blowing into them for warmth. "You will get used to it, to all of it."

"I'm not sure I want to," he told her, feeling at ease with her as he had with Stan. He understood why his family liked this crew.

"I get that," she sympathized. "But important things require sacrifice—in every meaning of that word."

"Sure," he agreed. "But I imagine you've had your whole life to ready yourself for that, I've had three days."

"I didn't have my whole life," Ynna began but trailed off. Moss didn't speak, hoping she would continue to talk. She did.

"I was a normal kid. Came from money, really. If you can believe it. Dad kicked me and mom out when he realized Relief Aide's don't talk back. He had the kind of connections which meant the law would work in his favor.

"Child support, alimony, all the mandatory minimum. Cut us out of his life with little more than a couple of bucks being transferred from some forgotten account once a month. We made do the best we could. Mom waited tables and I fell in with the kind of kids who know how to make a quick buck. Those kids made me smart, tough, taught me how to survive. I needed it, too. Mom got killed in a holdup: drunk asshole wanted to steal a pie. A fucking pie! Cook wanted to play at being a hero and mom tried to step in, some good it did her."

"You try to go back to your dad?" Moss asked.

"Tried. But he had as much interest in being a father as I did in kowtowing to the prick who had thrown mom out. So, I got the urchins together and we robbed him. Foolish kid idea, I

161

know it now. He had the money to get a bounty on us and I learned how Carcer does things.

"When I got out, my former friends wanted nothing to do with me, blamed me for bringing the heat down on them. I was alone. So, I got smart. Learned how to hack, steal. Learned what trucks the big companies wouldn't miss. I had a fence wrapped around my finger so I could get the best deals.

"But he got wise when I wouldn't put out and made a threat. I wasn't gonna whore and when he figured that out, he finked. Got some thugs to try and learn me.

"I gave as good as I got at first, but it was four against one and eventually they got the better of me," she said. She paused a moment, seeming lost in thought and Moss wondered how much of the story was true. She had seemed so tough to him and he had a hard time picturing anyone being able to take her on.

They trudged forward, the constant rain pounding Moss down, making it harder for them to move. She squinted at him. "Grimy found me broken and bruised as he came out of a haberdashery—as you would expect. But you might not expect that he took pity on me, bringing me to a safe house to get patched."

She smiled then with a glint in her eye. The same glint which Stan had when he was telling Moss about his past. "That's when I met Burn and Sandra. They honed my skills. Showed me that what I was good at could be put to use. That I could do some good in this grim fucking world.

"I wanted to help. I craved it. I wanted the men like my father, the people who valued money above all things to pay for their greed, to see that the people they treated as little more than drudges were real, could have power all their own.

"This cause, however you see it, that your family helped shape, means everything to me. To all of us. To Rosetta."

She let the name hang, eyes downcast. Moss didn't know how long they had known each other or what their relationship had been, but he could tell she was taking the loss hard.

"You ever go back for the fence?" Moss asked, not wanting to dwell on the death for which he blamed himself. Ynna's head dipped slightly with the shame of it.

"Yes," she said. "I went back for him with my new skills and a few augments. I released a fury on him I didn't realize was in me, but—" she fell silent once more. Moss matched the silence as they stood before the apartment complex, not entering. "I had never seen Burn so disappointed."

"Really? He seems like the type who wouldn't mind," Moss said and Ynna shook her head.

"No, he said petty revenge was beneath us. He explained that we were part of something bigger and to risk getting caught over a personal vendetta was just hogwash."

"I can see that," Moss said as they entered the building.

"Point being, I may have had more than a few days, but not really my whole life to prepare," she concluded. Moss let out a little chuckle.

"Fair enough," Moss said, gripping the banister hard to ascend the stairs.

When they entered the hidden apartment, Grimy rushed over, seeing the blood seeping from Moss's foot. He gestured for Moss to move to a couch.

"Joined the club?" Gibbs mocked in a whisper, glancing toward Stan laying on one of the cots, one massive bloody paw hanging over the edge.

"Couldn't let you have all the fun," Moss said with a pained smile as he moved through the room, blood and water dripping and pooling on the floor.

Gibbs couldn't hide the sorrow on his face. "You all right?"

"Yeah," Moss forced, pulling the soaking trench coat from his body with great effort.

"Liar," Gibbs said, and one corner of his mouth turned up.

Moss chuckled. "Yeah."

"If you two could keep the prattling to a minimum," Burn said from a dark corner, gripping a bottle, his face momentarily illuminated by the flare of a cigarette.

"Sorry," Gibbs said. Moss had not even noticed him.

"Don't mind him," Grimy said as he cut away at the wet bandage. "He gets morose after a job. After a loss like that."

"He has every right to be miserable," Moss said quietly. "You all do."

Grimy didn't look at him, didn't give any reaction and Moss stared at the cables dangling on the ceiling. Dust covered their tops and spider webs undulated slowly. "This is pretty bad," he heard Grimy say, though he didn't look down. "I can patch it but it may be better to take him to see the Ferrier."

Moss glanced over as Burn rose and entered his field of vision. He could barely make out the old man's grizzled face under the brim of his hat. "You want an upgrade?"

"What?" Moss asked.

He pointed a finger at Moss's legs. "New foot, maybe two for good measure."

"He's more machine now than man," Gibbs said in a tone Moss recognized as an impression.

"Um—" Moss began to answer but the door to the apartment slammed open.

Judy snarled, rocketing toward Moss. "You piece of shit!"

Ynna moved between them quickly, holding up a hand.

"What?" she asked though Judy's angry eyes were fixed on Moss.

"His fucking girlfriend got Rosetta killed. I told you we couldn't trust them," Judy said, pointing an accusing finger at Burn.

Ynna kept shifting and moving to try and hold her friend's wild eyes. "What do you mean?"

"Stan said the other bub set off the alarms!" Judy hissed.

"No," Ynna said, the word ringing out like a shot and Moss's face wrinkled with confusion.

"What would you know about it?" Judy seethed.

"More than you, I was in the fucking room, Jude!" Ynna said, her voice raising. "A guard pressed the alarm button before I could take them all down."

"What?" Moss asked in horror, guilt coursing through him. Judy stopped to listen as well, taking a deep breath. Stan peered over from his cot.

"I couldn't get them all down in time and one set off the alarm when I got to CT. I watched him press the button myself. About the same time though, the cell doors unlocked. When I saw you guys, I assumed it was you who hacked the doors," Ynna explained as Moss's hands went numb.

"No," Moss uttered.

He didn't want to believe it, couldn't believe it. Visions of Issy's face as he raised the weapon played in his head. *He* had betrayed *her*, not the other way around. He had shot her. To protect her, he tried to rationalize. Stan wouldn't have given her time to explain as soon as the alarm had gone off. He would have killed her. Gibbs moved laboriously over to Moss.

"So, what happened?" he asked as Judy and Ynna continued to bicker. Moss explained the series of events as he had seen them. "You did what you thought was right," Gibbs assured him, but his words lacked conviction.

"She'll never forgive me," Moss whimpered. "She shouldn't."

"She will," Gibbs said. "She knows you."

"I don't," Moss said, all the guilt and confusion he had felt in the past few days finding a home in two words.

Burn, who had been watching the whole thing unfold in silence, turned and spoke to Moss again. "Let's get you to the Ferrier," he said.

"That would be best," Grimy agreed and Moss wondered if he meant for medical reasons or to get him out of there. Moss knew he had been listening while pretending to focus solely on his foot. He knew that even after Ynna's defense of the situation, they would blame him for Rosetta's death. Even Ynna, who was being kind to Moss about it, was very obviously upset and trying to hide her feelings.

"Yeah," Moss agreed, more interested in leaving the room than the prospect of cybernetics. They left the room in a hurry.

"I know what you are thinking, young'un," Burn began, and Moss listened in sullen silence. "We needed to come. You must understand that. The second that button was pressed, Ynna was up a creek and if we hadn't come, we'd have lost two instead of one.

"You're gonna feel the pangs of guilt, I know it, but Ynna and Chicken Thumbs are breathing now because we came. Carcer moved when that button got hit. You made a tough call and it was the right one so don't sit in sorrow."

Moss felt the truth of his words. He knew Burn was right but the image of Rosetta dead, stared at him every time he closed his eyes.

"And your friend," Burn added. "You shot her to save her. Timing fucked you, no getting around it. But I'll work with you to get her out, if'n she still wants it."

"Thank you," Moss said, taking some small solace in that idea. He imagined her waking up, feeling the betrayal Moss had felt when he thought she turned on the alarms.

"One leg, or two?" Burn asked and though Moss knew it was a tactic for distracting him, he was grateful.

"Just the one, I think," he answered.

"All right," he said, hailing a cab electronically which descended out of the rain almost as soon as it was ordered.

Moss was leery as they moved toward the vehicle. "Is it safe to fly so soon?"

"Should be," Burn answered. "Lots of traffic at night and we are heading away from where we came," he explained.

"That's good." Moss breathed a sigh of relief.

"Not all good news," Burn said, lighting a cigarette in the confinement of the cab as it took off. "We all wore scrambling outfits to hide from the cameras but ThutoCo techs will be working with the footage. They'll figure it was us before too long and they'll set a new bounty. It'll be harder to make our next move."

Moss nodded. He knew his life had changed, knew he had killed a person, become a criminal, but the reality of spending his whole life on the run and looking over his shoulder terrified him.

"Why didn't they warn me?" Moss asked and when Burn didn't answer, he continued. "My parents, my grandma, someone? They could have left me a message somewhere so I

167

could know what to do, what my place is. I feel like I didn't know any of them at all—like I'm chasing shadows. No, worse: like I'm chasing shadows in a dream. I mean, my dad left you a message but not me, that's hard."

Burn turned to look at him through the eerie smoke. "I say he didn't leave you a message?"

"No, but I just assumed," Moss started but Burn held up a hand, ash cascading down his hand.

"You assume and you prattle, but I need you to listen and hear," Burn said. "You got caught up in this and it's been moving fast. It won't always be that way and in the downtime, you need to be smart, watch the world, wait for opportunities. You have a long way to go and I'll help you get there, everyone back there will. Even Judy, despite how they treat you now. This crew, we are a family."

Moss nodded. "I've already begun to see that."

"Now, you want to see what your dad said?" Burn asked, his one eye piercing Moss.

"Yes, please," Moss answered, trying to sound calm unsuccessfully.

"All right," Burn said. "You want me to project it here? Means you won't have privacy from me."

"You haven't watched it?" Moss's eyes went wide.

Burn snorted. "Weren't mine to watch."

"It's okay," Moss told him, so happy to know that there was a video that he didn't care who saw it. Burn tapped at his palm and once again, the face of Moss's father was before him.

"Hey Mossy," he said, turning from the camera bashfully. He was much younger and less frazzled than in the other videos. "Seems trite to say this but I guess if you're watching this it means they got me. I'm sure you have a million and one questions and they will all be answered in due time. But

know that your mom, grandma, and I have always been proud of you and know you will continue to make us proud.

"If you are watching this, it also means you got out and found Burn. He may seem like an asshole, but he is a good man and will help you any way he can."

At this, Burn smiled almost imperceptibly under his beard. Moss had never heard his father swear and it was unnatural to Moss's ears, but he smiled too.

"He and your grandma helped me get free and it brings me great joy to think that they have done the same for you.

"ThutoCo is evil, kiddo. You may be grappling with that but trust me when I say it. More than making willing slaves of their employees, they have plans to do worse and I'm helping them. That's why I need to do what I'm doing now and why you need to find a different life. The corporate path you left behind was helping to oppress the world and working with Burn can help to free the world instead.

"I wish I could have told you this in person, that I could have explained it to you and helped you to adjust, but I'm too deep and you are still so young. I look at you now and I can't bring myself to corrupt you with the truth. I hope you understand and don't hate me for it."

"I don't," Moss whispered, his eyes full as his father kept talking.

"We are just trying to do what's best for you. I really hope you understand that now. If you still have questions about what you are now part of, ask Burn. He is here for you since I can't be... I love you," he said, tears streaming down his face. "I hope you never have to see this, but we will meet again."

The transmission ended and Moss could not speak. He had needed that, and it had come at just the right moment. For the first time since Ynna knocked on his door, he was comfortable with his decision to leave the burb and help these

people. The way his father had spoken about Burn made Moss feel as if he knew him, too. He let out a long breath, not able to recall the last one he took.

"Thank you," he said and Burn nodded.

"You have questions for me?" he asked.

"I'm sure I will have more, but can you tell me about ThutoCo? I know the history they teach us, but I feel as though I need to understand more," Moss said. It was clear to him that everyone, including his father, hated the company, but Moss had been brought up by it and needed to understand more.

"What do you know now?" Burn asked.

"What they taught us? Well, the company was founded by Wesley Greyson and named for a fantasy novel he loved. The startup did agricultural genetics and some robotics," Moss began, trying to remember what he had been told in his Company History class. Burn lit another cigarette and the smoke instantly filled the space.

Moss continued, "They created a plant which was supposed to be able to feed the world and was, therefore, given the name Prophet Root. It replaced many traditional crops around the world but eventually, a bacterium spread over the plant. Treated, it was still edible, but it killed all the farmers, caused The Great Pandemic and drove all of the survivors into the cities where they had started to set up perimeters to keep the spread at bay."

As he spoke, he tried to read Burn's face, tried to get a sense of whether anything he had been told was true. Burn was unreadable though, his face like a blank screen. Moss kept talking, watching the older man. "ThutoCo built the burbs and drudges to give people an opportunity to stay employed and do work outside the city walls from safety."

"That's the gist of it?" Burn asked and turned slightly so Moss was reflected in the plate which covered one of the man's eye sockets.

"Yes," Moss answered, shifting uncomfortably as though he was giving a presentation for which he hadn't studied.

"Nothing about the wars? The relationship with the colonies?" Burn pressed, sounding annoyed before sending two plumes of smoke from his nostrils.

"Not about the wars, but the colonies, sure. I know we produce so much p-root to send off-world in exchange for what they mine," he said.

"All right," Burn said. "Well, what they tell you ain't too far from the truth. Sin of omission more like. You ever question why they can stop the spread with misters and treat the root to be ate, but it still ain't safe to leave the cities? Or the fact that prophet can't be grown off world? Or how about that they had the burbs all built up and ready to go before the bacteria?"

"I hadn't thought about any of that," Moss admitted. "What does it mean?"

"Means ThutoCo knew what they were doing. They wanted to drive everyone into the cities, into their waiting arms. Drive them all off the land so the whole planet could be one big, corporate farm for them. When the old government tried to stop them, they greased enough palms to get B.A. City to succeed. And once they did, every city followed suit, leaving nothing but bought-and-paid-for local governments. ThutoCo and the rest of the AIC now owned a country and all the people within. And since no one can leave, we all get taxed so stupid we have nothing left."

Moss couldn't believe how easy he made it sound. How sad the whole thing was. "And the wars?" he asked, wanting to know the whole truth now.

171

"Ah, well, as happens with these things, not everyone was happy with the monopoly. Andreas City had walls and misters built but not the infrastructure to take on all the displaced people. They cried out for jobs and wanted the land claimed by B.A. City. So, they tried to take it and all of us who didn't work for ThutoCo were pressed into service by the city government," Burn explained. Moss knew there had been wars between the cities but was never given context for it. He looked out the window at the massive, endless city below, thinking of all the people who had been affected by the corporate greed.

"But ThutoCo must have had drudges built, why not just send them?" Moss asked. Burn shook his head.

Burn scoffed and waved a hand. "Our lives didn't cost them anything."

"Oh," Moss said, taking in the full implication of the words.

"So, we fought, and we died, and many of us vowed to fight back when we were discharged. A few of us are," he stated. Moss thought about all the different people brought together for this one cause: an athlete, a ThutoCo employee, a rich kid turned street urchin, a former soldier and now, him. He felt that he wanted to be a part of this. Not just for his father, but for himself; to help the people. He smiled for what felt like the first time in an age.

The cab began to descend into a part of the city not made of glass and concrete.

CHAPTER 14

Landing on a patch of dirt, Burn and Moss exited the cab in a district very different from the one they had left. Ancient drywall and stucco homes topped with corrugated metal layers surrounded them on all sides and above. Scaffolding held more homes aloft, above the street. Fused metal and rust joined together like twisted branches. People moved about within, going about their normal business and once more, Moss realized how truly massive this city was.

Enormous banks of floodlights served as streetlights. Strings of electrical cable pulled like loose yarn from a ball hung low overhead hissing and popping while unattended governmental keys rattled from unchecked lockboxes.

Many of the homes had their front walls knocked out, gaping like angry mouths and serving as storefronts. People milled about and Moss could not tell who was working and who was shopping. Everyone seemed to maintain a sense of personal style though the clothes were tattered or thinned from too much wear.

He was relieved that it was not raining here but the air was thick, brown smog sitting heavily. It burned his nostrils and mouth to breath.

"Old Oak," Burn announced. "This part of the city is cheap and largely unchecked by Carcer. Ecosystem and economy all its own out here. Where most of my brethren from the war ended up. Artists, writers, anyone with an independent spirit, too," Burn said, gesturing to the open spaces. Many served as small art studios filled with paintings, renderings, and what Moss took to be furniture—though it mostly seemed to be form over function.

"Why not hide out here?" Moss thought aloud.

"We have places here, too, but better to be where the action is. This is where we come to lay real low," he said as they walked. Whatever Grimy had done seemed to have worked and Moss was able to walk without much pain. "We have to make a pit stop quick on the way to get you fixed," Burn told him.

"All right," Moss said as they strode forward. He was about to ask a question when his mind was flooded.

Moss! We know you love girls and we have them! Whatever your taste, we have just the gal for you! Moss pressed his hands to his ears, but the booming sound didn't stop. Burn turned to speak, his mouth moving wordlessly under the sound of the ad. *We've got fat ones, skinny ones, enhanced or natural. Something for all tastes at Bonk City! Just one hundred meters from your next left!*

It stopped and Moss tried to shake the sound from his mind. Burn pointed to a glass oval in a chain-link cage. "That get you?"

"What?" Moss asked.

"HackAd," Burn said. "They are illegal, but no one cares to stop them out here."

"So, what? That thing hacks my implant and targets an ad?" Moss asked though he knew the answer.

"You got it. Lots of folks have neural implants of one sort or another, so this type of advertising is popular. People

174

who live here say you eventually tune it out, but we'll get you some blockware."

"Thanks," Moss said. For his whole life, the implant did nothing more than sync him to MOSS II and his hex but now he was growing to hate it. He didn't like hearing others' commands, communicating without speaking or the idea that his very mind could be hacked. He blinked and saw Rosetta again, the last person to work his implant and, for the briefest moment, he wished to go back to his old life.

Burn seemed to read his mind. He placed a wrinkled, vascular hand on Moss's shoulder and squeezed. "Remember what your dad said."

"That you're an asshole?" Moss joked as an attempt to shift his mind. Burn snorted a laugh.

"Yeah, that," he said with a smile and they continued to walk. The knocked-out houses gave way to a commercial area with proper storefronts, still piled with makeshift homes atop. They turned to enter the Talisman Saloon, an old western style bar with swinging half doors leading into a faux wood paneled room.

A tall woman with a bright smile worked behind the bar next to a drudge in a cowboy hat. The wait staff were all nude with wild, unkempt hair and covered nearly head to toe in tattoos. They seemed unbothered by their own nudity though Moss felt the need to avert his eyes.

"Burn!" Moss heard shouted from behind the bar and he turned to see the woman moving toward them, bright eyes set into a dark face. Her long hair of tight dreadlocks swayed as she moved, and she wore a fur-lined leather vest buttoned only to her cleavage. "How the hell you doing, you old so-and-so?"

Burn waved a dismissive acknowledgment. "Heya, Jo." He held up two fingers and she set two shot glasses on the bar before her.

175

"Haven't seen you in an age," she said. "And you brought a friend."

"Getting him some new shoes," Burn told her, and she tapped a finger to her nose before pouring whiskey loosely into the glasses, a small amount spilling on to the bar. Burn gulped down the shots in quick succession and turned to Moss. "Shot."

"No, thanks," Moss said.

"Weren't asking," he clarified, and Jo refilled the glasses, not bothering with a new one. Burn handed Moss the drink which he took down in one swallow before his stomach lurched and he nearly gagged the liquid back up. He coughed and felt the effect instantly, slamming his hand on the bar.

"Thanks," he wheezed to no one in particular.

"We are here to see your boy," Burn told her, sliding his glass across the bar for a refill.

"Oh," Jo said, a hint of disappointment in her voice. "Take him, more like?"

"More like," Burn repeated.

Jo frowned and asked, "what happened to the girl?"

"Worm food," Burn said, and Moss grimaced at the callousness. His head was swimming and he felt sick but gulped hard and watched the two in silence. Jo refilled Burn's cup.

"Willis goes with you, I expect you to keep the worms from him," Jo said, pointing a threatening finger at Burn. They were speaking casually but Moss could hear the fear in her words.

Burn nodded slightly. "Do my best."

"Do better than your best. You owe me," she stated as she put the whiskey bottle to her lips. "And keep the language to a minimum. I don't want him back in here talking all salty."

"Yes, ma'am," Burn replied, tipping his hat slightly with thumb and forefinger. When she finished her chug, she pointed toward the back of the bar.

"He's got a workshop just past the potty," Jo said sullenly. Burn gave her a sideways look with his one human eye, and she shot, "Oh, give me a break. I have a fucking three-year-old, too."

"Right," Burn said and put a hand on Moss's back to lead him through the bar. Patrons sat in plastic chairs printed to look like wood at circular tables of the same material and took no notice of the two—all of them drinking in silence, staring at the wall-mounted screens, palmscreens, lenscreens or, most often, the staff.

They walked down a hallway of paintings of cowboys and bison, past a bathroom to a narrow doorway with stringed beads as a door. Burn parted the beads to reveal a young man hunched over circuitry with a soldering iron in one hand, large goggles over his eyes and a cigarette dangling from his lips. His skin was as dark as his mother's and he was similarly dreadlocked. When he turned to face them and pulled the mask off, he was her spitting image. His eyes had been upgraded and glimmered an unnatural blue. To Moss, he looked like a child.

"Remember me?" Burn asked, tipping his hat up slightly to reveal more of his face.

"Of course, Mr. Burn," Willis said hurriedly. He looked so excited that Moss thought he was going to vibrate off the face of the earth.

"Burn is fine," he said. "Hear you want to group up?"

"I do," the kid answered in a tone Moss deemed too excited. At that moment, he envied the young man. All of this had been thrust upon Moss, but this kid was being offered an opportunity.

"Think you're ready?" Burn asked before clearing his throat and coughing loudly into the room.

The kid clapped his hands, the sound ringing in Moss's ears. "Oh, hell yeah!"

Burn folded his arms in front of his chest. "Show me something."

"You want an RL display?" Willis asked, holding his hands open in front of him.

"Yes," Burn replied.

"Old school, love it," he said, one of his eyes projecting a screen full of data as the other eye went black. Line after line moved across the screen and Moss was in awe of someone so young doing something so complex.

Hey, Burn. Moss heard the familiar accent of Seti. *Someone just transferred five mil into squirrel account. I can't trace it but I'm trying. You give access codes or just run a scam or something?*

"Something like that," Burn said aloud, and Willis turned to them as the projected screen vanished, a broad smile across his face.

"Wicked, eh?" Willis beamed with pride. *Hey, Seti, I dropped the cash*, he added in their minds.

"Risky, more like," Burn grumbled. "And you tapped our network?"

"The second you walked in," Willis said. He could not hide his pride. He was good and he knew it. "Plus, it wasn't risky. It was such a small amount and I snatched it from an account in Tokyo. Ran it through D2E servers anyway so anyone smart enough to try and trace it would think it's corporate espionage. Gotta love messing with the bigwigs."

Moss could see that Burn was impressed though he tried to hide it.

Man, Patchwork, you're getting good, Seti said.

"Shit, praise from Caesar. Thanks," Willis said.

Burn cocked his head. "Patchwork?"

"Yeah, mom's the only one who calls me Willis anymore," he explained, sounding like a kid to Moss.

"Right. Well, Patchwork, skills like this, why work with us? Go legit, you could retire in a year, or better yet, just do this a few more times and buy your mom a villa downtown," Burn said.

"Nah, man. You served with her. She'd never abide it," Patchwork said, shaking his head. He began to pull small items from his desk and placing them by a bag near his feet.

"Got that right, I suppose," Burn admitted.

"Plus, I meet a lot of old timers, vets and stuff in the bar. You all got right shafted and I want to work with those who want to make that right," he said, serious and solemn for the first time.

"A respectable answer," Burn told him. "Want to ride with us for a bit?"

"Yes, sir, I do," Patchwork answered reverentially, stubbing out his cigarette. "I'll want to update your systems though. Rosetta had some antiquated shit running—it's how I got to you so easy. Carcer has some sharp techs, too."

"Don't speak ill of the dead, son," Burn thundered and the kid raised his hands defensively as guilt needled Moss once more.

"No offense intended. I didn't know," Patchwork apologized, sounding both genuinely remorseful and sad at the news.

"Not knowing is a good time to keep your mouth shut," Burn put to him. Moss understood the point Burn was making

but it bothered him slightly as Burn himself had been so cavalier about Rosetta's death moments before.

"Heard," Patchwork announced.

"When can you start?" Burn asked.

"Now." Patchwork pulled a loaded duffle bag from under his workbench. "I've been waiting for you." He smirked.

"You can come with us now. You and I will get to know one another while Moss here gets a new hoof," Burn said, pointing to Moss's bloody foot. Moss looked down. The wound still looked bad though he no longer felt any pain.

"Yikes!" Patchwork's eyes grew wide. "Sounds good. I'll run and say bye to mom, go upstairs and kiss my little sis. Give me a minute?"

"Sure thing," Burn agreed easily as the kid left the room. When he stood, Moss noticed a long, slender, curved sword hanging from his belt in an ornate sheath. He found it remarkable that no one he had met seemed to travel unarmed.

Patchwork yelled down the hallway, "nice to meet you, Moss."

"You, too," Moss called after, unheard under the twangy music playing throughout the bar.

"Seems like a good kid," Burn admitted.

"Yeah," Moss agreed before excusing himself to the restroom. When he returned, Patchwork and Burn were speaking of things to come. Patchwork wore all black. Black jeans and a black shirt with nearly three hundred zeros and ones printed in white across the front in tiny font. He caught Moss looking.

"Rad, right?" he asked.

Moss nodded. "Sure."

"It says 'if you can read this, let's talk' in binary code," he explained, grinning like a Cheshire Cat.

"Neat," Moss said in the same voice he used on Gibbs when he changed the posters in his room.

"All right, boys," Burn said. "Patch, do me a quick favor and throw some blockware on Moss."

"Oh, sure thing," he said, turning to Moss as his electronic eye began its work. "Who got you? Armstrong's? Chunder Cats? The Fried Brick? Talk-B-Talk?"

"Bonk City," Moss told him, and the kid guffawed and clapped his hands together.

"Shit, really? You gotta take it easy on those Relief Aide's!" he shouted through his laughter. Moss felt his face burn with embarrassment. Patchwork noticed.

"Oh, shit, sorry," Patchwork said, and he meant it. He clapped Moss on the shoulder. "Can't seem to help but put my foot right in it."

"You're all right," Moss said.

"Let's ride," Burn said and the three left the bar, Burn taking one more shot for the road. They walked in silence through the sprawl as the darkness of the sky gave way to the early morning light. An orange haze lay over the city, making the world monochrome rust and reflected glow.

The narrow streets opened to a large plaza. Families milled about before a sizeable semicircular sign reading "Carnevale of Wonders" in neon lights. They approached a woman by the entrance who seemed annoyed to interrupt her lenscreen feed to speak with them.

"We don't open for a half hour," she said while chewing something, making her seem all the more disinterested in what he had to say.

"We are here to see the Ferrier," Burn told her, looming ominously over her. She did not notice, and Moss guessed that

a life of dealing with the public had made her immune to shows of intimidation.

"We don't open for a half hour," she repeated and turned her face from them to imply that the conversation was at an end.

"Look at me," Burn said, so much threat dropping from his words that Moss saw her lens go blank. "We are here to see the Ferrier. He is expecting us and does not like to be kept waiting. Call your boss and say that Burn is here."

She was nervous and clearly wanted nothing more to do with this situation. "You know where you are going?"

"Yes," Burn put plainly.

"Just head on through." She waved her hand before her lens turned back on and she was gone from the real world. They walked down a path with crude maps of the small hillside carnival. They passed row after row of small, walled off enclosures with animals. Moss stopped to stare at a koala sleeping in a tree. Other than the tiger in the burb, he had never seen animals up close before.

"All true clones," Patchwork told him as he sidled up beside.

Moss didn't turn his head, he just kept gawking. "Not robotic replicas?"

"Nah, those you can buy. Shit, you want a koala for your house, you just need the cash," Patchwork said. "People come here for the real thing."

"Incredible." Moss appreciated the fact that Burn wasn't hurrying them off. He turned and they continued.

Moss had to stop every few feet to stare in childlike wonder at the animals, while the other two smoked and chatted. Employees were beginning to set up booths and tents but paid

no mind to them as they approached a brick building with an open door.

Burn ushered them in and they were met by an unnaturally tall man whose mechanical legs reached nearly to Moss's torso. They looked like that of a drudge with large gears at the knee and ankle. His arms too were robotic but made of finer material, the human form perfectly mimicked like that of a Relief Aide but with clear skyn, revealing the masterful inner workings.

He had no hair on his body, his shirtless chest glistening with sweat and the lack of eyebrows giving him an expression which was difficult to read. Behind him was an old horse stable converted to a workshop, each stall fitted with a table long enough for a person with monitors overhead and large robotic arms, lights, and cameras.

"Burn, my boy, back giving you troubles?" he asked in what Moss took to be a British accent.

Burn grunted. "Always, but not why I'm here."

"Ever the cunt. What can I do for you then?" he asked with a smartass grin.

"Start by leaving that language outside," Burn said. Moss smirked. Burn's language was hardly clean, and he would have a hard time trying to censor himself in front of Patchwork.

"My place, my rules, you old prick," The Ferrier said, enjoying himself immensely.

Burn pointed to Moss's blood-soaked wrap. "We're here to get my friend a new foot."

"That's an easy one, and who are these friends of yours?"

"Little one's Moss and the even littler one is Patchwork," Burn said, pointing to them in turn as he spoke.

"Pleasure to meet you, gents," he said, shaking both their hands. Moss watched the machinery work within the man's arm as he moved and was amazed by how lifelike the translucent skin felt. Warm to the touch but calloused like that of someone who did manual labor.

"Sadly, this isn't my work," the Ferrier told Moss, catching his admiration. "But don't think of it like that old joke about barbers?"

Moss shook his head. "I don't know it."

"Kids and your screens... no one just sits around and tells jokes anymore," he admonished, and Moss caught Burn smile out of the corner of his eye. "More of a riddle than a joke, truth be told. You walk into a barbershop and see two barbers, one with a wonderful haircut and one with a shite one. Who do you have cut your hair?"

"The one with the good-ass hair, obviously," Patchwork answered quickly, shaking his dreadlocks with a flourish. Moss smirked.

"The one with the bad haircut since he must have been the one who performed the good one," Moss said.

"Right you are, lad." The Ferrier beamed. "Point being, just because I have these wonderful arms, doesn't mean I give a bad haircut. If you take my point?"

"I do." Moss nodded and as they made their way around the building, he couldn't help but notice the overwhelming smell of animal. All of the grounds had smelled vaguely like the wildlife but there was something about this building that stank even more.

"Right, well, what are you thinking?"

"About my foot?" Moss clarified.

"No, about your mother's tits. Yes, about the foot," the Ferrier said with a hearty laugh.

"I don't really know," he admitted. He had never given much thought to augments and had been so consumed with the message from his father that he hadn't even considered what he might want to do about his foot.

"This kid a bub?" the Ferrier asked Burn, who simply nodded. "Right, well, let's show you some options," he said, pointing to a screen on the wall. "We are going to replace from the knee down, give you a little oomph." The screen displayed an MR-98.4 leg: simple and sleek. Two long black spring-loaded retracting shafts with mounted battery and front-facing solar recharge joined to three toes, two front-facing and one back for increased support. "Mid-range model. What do you think?"

Moss looked to the legs of The Ferrier and shook his head. He did not mind the fact that he was going to be replaced in part but did not want to resemble MOSS II.

"Anything more—" he began.

"Real?" the Ferrier interrupted.

"Yes."

"I have it," The Ferrier said, bringing up an image of what looked to Moss like a natural human leg. "Integrates distance detection and impact force with a look so real someone will have to scan you to tell. Made by Atsuko Adroitech, same folks who build the sexbots. Top o' the line."

"I like that," Moss said excitedly.

The Ferrier appraised him. "Just the one?"

"I think I would like both," Moss answered, surprising himself. The idea of moving on two powerful legs excited him.

"In for a penny," the Ferrier winked. "Speaking of pennies," he began, looking at Burn.

"Kid wants both. Do it. This one here is going to treat," Burn hooked a thumb at Patchwork.

"Oh, I see how it is," Patchwork said with a theatrical eye roll before he went to work, his eye firing input from some far-off bank account. "How much?"

"Sort that out later," the Ferrier said, laying a hand on Moss and leading him to a stall. The ground shook with the impact of every one of the Ferrier's massive steps, rattling the tools which lined the walls. He gestured to Moss to lay on the table and he did. One of the arms placed a mask over his nose and mouth. "You'll be down a while, but it'll feel like a warm dream and you'll come out the other end a new man. No one does biotech like me." The Ferrier smiled, revealing perfectly straight, white teeth which Moss stared at as the gas entered his lungs. He thought about how fast everything was happening as he drifted to sleep.

CHAPTER 15

"Moss opened his eyes slowly, confused as to where he was and what he was doing. He was aware that there were no ocean sounds and of the oppressive light flooding his vision. An old man with one eye and a beard entered his field of view.

"I know you?" Moss asked, his voice hoarse and mouth dry, tasting of chemicals.

"Some would say," Burn answered, looking down kindly on Moss. "How you feeling?"

Moss blinked, beginning to recall. "Blinded," he answered and Burn nodded, sliding away the large, round, three bulbed light.

"Better?" he asked in an uncharacteristically sympathetic tone.

Moss looked around, trying to get his bearings. "Yeah," he mumbled. He was having a hard time moving, his limbs feeling slow to react as if he was underwater.

"Feet hurt?" Burn asked and Moss began to remember. He tried to raise his head to look down, but he couldn't muster the strength.

"They shouldn't," a voice said from somewhere else in the room.

Burn hissed over his shoulder, "weren't asking you."

"Nothing hurts," Moss smiled. "I feel wonderful."

"And drug addicts rejoiced," Moss heard Patchwork joke. He rolled his eyes around as his focus returned.

"The kid also got into your implant some when you were under. A couple of upgrades. Hope you don't mind," Burn informed him.

"Fine by me," Moss said. "Is Issy okay?"

Burn grimaced. "Don't rightly know," he said. "Patch will get you through to her when we get back."

"Good. I miss her," Moss said, thinking about how beautiful she was to him.

Burn smiled, but Moss saw the sadness in his eyes. His smile wasn't a very good liar. "Sure, you do. We'll help her out," he promised.

Moss smiled and felt the table shift beneath him as the Ferrier approached, looming over him. Moss grinned up at the man. "You're big."

"It's what the fellas tell me," he said with a wink, but Moss was too groggy to understand innuendo.

"Neat," he said, and the Ferrier smiled, those teeth reminding Moss of a time which felt long removed.

"Think you can wiggle those toes?" he asked. Moss attempted to lift his head again to look down but to no avail.

"Am I doing it?" he asked. His mind was telling his body to move the digits, but he could not feel if it was actually happening.

"Yes, sir," the Ferrier said. "They look good. Very real."

"Scars?" Moss asked as The Ferrier poked at his foot with a stylus. "Oh, I feel that."

Looking at Moss's legs with pride, he said, "good."

"Did good work," Burn added. "No scars, kid."

Moss felt a weak smile cross his lips. "Can I get some water?" he asked and the Ferrier moved quickly to get him a hydrogel tube which he slurped down quickly.

Burn lit a cigarette and the Ferrier turned on him quickly. "This is a medical office, take that shit outside," he snarled and Burn shot Moss what he took to be a wink as he stood and left, appearing on a security monitor mounted on the far wall opposite the stall. "Up to standing?"

"Not quite," he said truthfully, and the Ferrier tapped at a screen, sending one of the mechanical arms down with a needle that stuck Moss in the bicep. Like a video of morning fog played in fast forward, the weakness and haze lifted from Moss's mind and body. He knew he could stand. Felt like he could run if asked to.

"That *is* something," he remarked, amazed at how good he felt.

Moss sat up and looked down his body to the legs which looked nearly identical to his natural ones. The pigment of the skin was slightly off but as he watched it seemed to be slowly shifting to that of his thigh.

"Remarkable," he uttered, wiggling his toes and bending one leg at the knee. As he did, he realized for the first time that he wore only a towel from the waist down.

"Oh," he said.

The Ferrier took his meaning. "Think of me as a doctor."

"Sure," Moss said uneasily. "But all of my doctors have been drudges."

"Of course, they were," he snorted derisively. "Takes a machine to diagnose a man, eh? Sure do things different in the burbs."

"The programs are able to determine illness at a much higher accuracy rate than a human. Far fewer errors," Moss

argued. He had always liked that it was machines rather than people who had checked him. He had felt a trust for them which he had not with humans.

"Even deep learning algorithmic AI's require human oversight but, whatever you say... Now, don't go trying to kick any doors in," the Ferrier said, smirking at his own comment. "Though you will be able to once you get a handle for them."

"Thank you," Moss said with full sincerity. He thought it truly remarkable that he had been healed so expertly so quickly. He was incredibly grateful to the massive man and to Burn.

"My pleasure," the Ferrier said. "And I mean that. Your little friend paid me handsomely for this."

"I'll bet," Moss said. "I guess getting shot wasn't the worst thing."

"Don't you worry. Keep running with Burn and you'll be back here in no time," he joked and made a gun shape with his forefinger and thumb, leveling it at Moss.

"Can I try them out?" he asked as he slid to the side, dropping his legs over the lip of the table and sending his body crashing to the ground.

The Ferrier unsuccessfully tried to mask his amusement. "The weight is slightly different," he said, pulling Moss to his feet. "They're designed to be similar but it's a little more than just bones, muscle and veins in there."

"Right," Moss said, uneasily taking a step. Though the legs obeyed his mind, the movement did not feel fluid.

The Ferrier watched Moss move, stroking his chin thoughtfully. "The programs are adaptive and will learn how you shift your weight, but it will take time."

"Time is something we don't really have," Moss said, thinking about his father's riddle. He wanted more than anything

to crack the code and prove his value. Especially now, after costing them so much.

He took more steps, clutching the towel tight around his waist. It was remarkable to him that he could feel the cold floor under his feet just as he would have before. The machinery sent the proper signals to his brain. He had known they would, but it still struck him as amazing to experience.

Moss and the Ferrier both turned at once as they heard raised voices coming from outside the door. Moss turned to the monitor to see Burn with his hand on his gun and Patchwork gripping his sword, speaking with unseen people.

Drugged, tired, recovering from surgery, and overwhelmed by everything that had happened, Moss shuddered at the prospect of any more action. His heart began to race. Had Carcer tracked them down? He reached with a new instinct for the Kingfisher but found only flesh.

He hurried to get dressed, his body lurching unnaturally from place to place. His eyes kept flashing to the monitor as the Ferrier boomed from the room out the front door. Moss followed quickly behind on unsteady legs to see the three men flanked on all sides by a semicircle of Legion bikers, their families out for a nice evening huddled behind them. Moss had expected it to be daytime but realized he didn't know how long he had been under.

"Listen, mates, this building has defenses you don't want to test," the Ferrier intoned, and the bikers shifted uneasily, trying to maintain their threatening air. A burly woman with a shaved head and "President" stitched to her vest strode forward, not in the least intimidated by the threat.

"Listen, friend, you don't want any part of this. These fuckers killed one of ours. Blood for blood," she seethed, a grenade clutched in a cheap cybernetic arm. Turrets dropped from the awning above the Ferrier and buzzed to life, intimidating red dots appearing on the shifting foreheads of the bikers.

The Ferrier pointed to the grenade. "You'll be dropped before you loose that. No need to let your families watch you die."

The leader seemed no more frightened but could calculate a loss when she saw one.

"Perhaps we can parley?" Burn offered. "Common enemies can make new friends."

"But you're my enemy," the leader said, her head cocking to the side and eyes calculating.

Burn shrugged and tossed his cigarette to the ground, letting it burn down rather than stamping it out. "Don't need to be."

"We could give you money," Patchwork offered, and Moss watched as Burn's head dropped.

"You think you can buy us, you sewer rat? We're not for fucking sale. The only payment I want is the top of his fucking head," she said, but as she did, the fist which clutched the grenade fired upward and broke her nose, sending her reeling back into the other bikers.

"Run!" Burn screamed as the turrets began to whir. Many bikers pulled weapons while the others rushed to their leader. The Ferrier ducked back inside his office as Moss's new legs sprang him forward and away. The bikers screamed obscenities after them.

They darted between the caging, birds squawking and flapping all around. They stayed low and moved away as quickly as they could, knowing they were severely outnumbered without the protection of the turrets.

"Never get a deal now," Burn hissed.

"Called me sewer rat," Patchwork justified. Burn shook his head with disgust but even in the heat of the moment, Moss had to admit to himself that the kid's skills were impressive. As

they weaved through the carnival, Patchwork said, "I saw a ride we can borrow."

A performer sent a breath of fire into the air to the oohs and aahs of a gathered crowd. The three moved to the entrance, hearing the threats of the bikers closing in behind them. They rushed through the people standing by the gate, Moss constantly tripping and falling over himself.

The legs carried him at a remarkable speed, and he was easily able to keep pace with Patchwork who guided them back into the plaza, now full of ground cars. A sleek silver Audon coupe turned on, lights flooding the lot and doors swinging open. The engine revved at Patchwork's command and drove right over to meet them, the three jumping in as the doors began to close.

"Borrow," Moss huffed as he jammed into the back of the beautiful automobile. It had a wide, thin grille that turned slightly upward like a grin and a strip of bright headlight that curved along the entire front from side to the other. The car was low to the ground and lighted beneath.

Patchwork shot him a shit-eating grin, "semantics." The vehicle fishtailed nauseatingly, navving toward the nearest road. The first shot rang out as they fled, terrified screams following closely behind. The rear windshield crunched and spiderwebbed.

"Debris has collided with the vehicle. Please return to the nearest Audon authorized dealership for repairs. Great deals can be found at Otomo Auto Repair. Please select YES to make that your destination," a computerized voice offered through the speakers. The nav screen went blank as Patchwork took over the remainder of the systems. They accelerated fast along a narrow alley of fresh tar. Moss gripped both sides of the car, his head swimming.

Patchwork grinned over his shoulder. "Normal post-op, right?"

Moss was too nauseated to answer. He turned to look back as he heard the roar of a motorcycle behind them. Headlight after headlight rounded the corner, streaming after them like bees from a kicked nest. Moss pulled his weapon, sliding around the leather upholstery as he moved. He focused hard, trying to regain control of his mind. He would need it now.

The car was tight, with almost no room to move around and he could hardly extend his arm to aim. He wondered what was going to happen when he pulled the trigger with the muzzle pressed against the glass. As one of the bikes neared, the rear windshield hissed and rocketed off the frame of the car, slamming into the bike. It pinwheeled up, sending its rider slamming to the ground, wailing as his body broke. Patchwork let out a satisfied little snicker.

"They should put that in the ads: saves you from being trapped *and* from gangsters!" Patchwork laughed as they passed out of the alley onto a four-lane road. The bikers whooped and hollered as they got closer, brandishing pipes and bats. A bike with a sidecar neared, the man riding along pulling out a long double-barreled shotgun. Moss felt Burn's sleeve against his cheek before seeing the line laser split the beam connecting the sidecar, sending it spinning into another bike.

Video games had taught him that vehicles all exploded upon impact but all he saw was crunching metal and blood. Moss could not believe his eyes as one of the thugs jumped up, feet on the seat of his bike, fixing to jump to the car. He pointed his Kingfisher but fired wide, the biker grinning wildly as he neared. Moss fired again, striking the tire and sending the bike flipping through the air.

The thug crashed on top of the trunk.

Crazed, he reached in and grabbed Moss by the throat. He and Burn both fired at once, demolishing the man's face and,

for the second time, spraying Moss with blood. The man's grip went limp as his body slid off the car.

Moss sputtered and gagged for air. He coughed as he fired wildly at the remaining bikes, missing every shot.

Flashing red lights filled the sky as drones buzzed in.

"When it rains," Patchwork said, his second eye going dark.

"Bounties have been issued for the drivers of these vehicles. Pull over at once," a harsh robotic voice commanded from one of the drones. Moss fired into the sky and managed to hit one of the drones, sending it plummeting to the ground where a biker crashed into it, the rider flying forward ten meters before slamming to the road.

Another drone wheeled around and fired a net on to one of its partners before crashing into the lighted sign for a hotel. Only two drones and three bikes remained but Carcer was not about to lose any more hardware. A machine gun dropped from the bottom of each drone and began firing, spraying the road, car, and bikes with bullets. Like in a monstrous rainstorm, the car rattled and shook violently as the bullets dented and passed through.

"I can't do everything at once!" Patchwork yelled as the fire stopped, giving the drones time to cool off. "You're old, drive this thing manually!" He ordered to Burn as a steering wheel unfolded before him.

Burn gripped the wheel and the car shuddered as he took control from the computer. Burn then spun the wheel, sending the car turning back the way they had been driving moments before. He reached out the driver's window and grabbed a thug clear off his bike as his machine zoomed passed them. Burn dragged him, kicking and thrashing before throwing him to the pavement. The

car leapt as the rear wheel struck the biker. The two drones began to fire again, spitting metal and glass into the car.

"Gotcha," Patchwork said with a grin, and one drone turned its weapon on another biker, shredding her back in a waterfall of blood before turning on the other drone, blasting it from the sky. The final bike squealed as it turned to leave and the final drone crashed itself to the street.

The road was empty as they kept driving, Moss's ears ringing in the silence. Burn took the first exit, driving them onto a side street, hidden from above by the scaffolding apartments. They pulled into an alley and abandoned the car.

Patchwork, panting and smiling, looked at the destroyed vehicle. "Some rich fucker is in for a bad day."

"Yeah, it'll be little more than pieces within an hour," Burn said, lighting a cigarette and opening his duster to reveal blood. "Just grazed me," he announced and put his finger through a hole in the duster, clicking his tongue with disappointment. "Let's get a drink."

Moss looked around, his apprehension obvious. "Won't this area be swarming soon?"

"No doubt, but they will secure the skies and roads for a while, so laying low'll be our best bet," Burn said as he led them away from the car. "You two all right?"

Moss nodded, his new definition of "all right" being markedly different than before.

"Hell, yes!" Patchwork said. "That was some action right there."

"Promised your mother I'd keep you out of harm's way," Burn reminded him.

"And you did. I put us in harm's way myself," he said unabashedly.

"Not wrong," Burn agreed as they rounded a corner onto another large thoroughfare. They walked for what felt like an eternity to Moss, occasionally ducking into market stalls when a drone buzzed overhead. "Moving pretty good," Burn said, and Moss took a moment to register. In the attack, he had completely forgotten he had just undergone surgery. The only reminder was the fact that it felt as if it had been night for as long as he could remember.

"Yeah," he agreed. "Think the Ferrier got out of it okay?"

"Sure, he did," Burn said. "Man's been through worse than a couple of ruffians at his door."

Patchwork nodded as though he knew. "I bet."

"Kid, you're going to have to calm yourself some if you want to keep a position," Burn told him.

"I know I messed that one up, but you have to admit I helped us get clear of it pretty good, too," he boasted.

"You've got skills, I'll grant you, but that's only a part of it," Burn said. "Moss, here, is straight off the turnip truck but has good instincts for what to do and when. Natural talent will only get you so far."

Moss couldn't help but smile at that.

Patchwork took a deep breath and promised, "I'll do better."

"See that you do, things are only gonna get hairier from here."

"What is our next move?" he asked, and Moss once again racked his brain over the one-word puzzle. It helped him to focus on that rather than the smoldering ruin of a bullet-ridden vehicle they had left behind or the fact that, once again, he had nearly been killed.

Burn gave a little smirk. "We're gonna take down ThutoCo."

"That's what I'm talking about!" Patchwork said, and though his enthusiasm clearly rubbed Burn wrong, it amused Moss. "How?"

"In here," Burn said, ushering them into a street-side bar stall. Wood framed with paper walls; it was a tight space with three stools set before a bar. A drudge worked behind the counter, dusting bottles with shots of air from its fingertips. It turned as they entered, and Burn held up three fingers, "with drinks."

The machine set three empty bowls before them as they sat on the stools. It prepared their meals in silence, served them, and placed small cups and a pitcher of warm sake down on the bar. "Turn its ears off," Burn ordered Patchwork and he obliged, the drudge shut down. After a short while, Patchwork spoke.

"Whoever owns this place will get information that he's still active and I used his vid-feed to mockup a quick video of us chatting," he informed them. "Wouldn't stand up to scrutiny but it'll do so long as we pay when we leave."

"Good," Burn said. "You have a screen?"

"Something we can all see? Yeah," Patchwork said, pulling the duffle bag he had been wearing as a backpack and moving it to his lap, producing a tablet.

Sync his system, Burn told Seti, and the screen soon displayed the goodnight password screen.

"What we know," Burn began, "is that Moss's father was a part of a ThutoCo initiative that could put their employees and possibly the world at risk. Rosetta got us as far as this password, but we need Moss to crack it, as we know his dad wanted it to be him."

"Just goodnight?" Patchwork asked. "Could it be some kind of cipher or anagram?"

Moss considered the possibility. "Maybe," he shrugged, his disappointment in himself obvious in his tone.

"I'll try and Blackfoot this, maybe we don't need to solve it at all?"

"Okay," Moss agreed sullenly. He wanted to solve it.

Burn slurped his noodles loudly, little specks of food sticking to his beard as Patchwork worked and Moss thought about his father. Nothing was coming to him. Nothing seemed to fit. He tapped at the password screen, red outlines shaking the input bar every time he gave an incorrect answer.

He pushed the tablet away and began eating. The food was better than anything he had eaten in the burb, save the occasional home cooking. The dish was flavorful without being too salty. Everything served in the burbs relied heavily on the imitation salt made from compounds sent from the colonies. He had enjoyed it until he had tasted real food and now, he would never be able to go back. Though he knew he never would.

"This is some locked down shit," Patchwork said. "Your dad was no slouch. I've never met anything as impregnable as this. He must've written the book on encryption."

"He was more into biocomputing, I never thought of him as having those type of skills," Moss said. "Though I'm coming to realize I never really knew him." His own words only deepened his sadness.

"Nah," Burn said, his mouth full. "He always said he wasn't keen on that kind of work."

Moss felt a little better, at least he had been right about something.

"Well, someone has amazing skills. Rosetta was a beast even getting you to this screen," Patchwork said and Moss's eyes went wide as he kicked himself for not putting it together sooner. He snatched the pad and began typing rapidly. "What's 'bubba bear?'" Patchwork asked as he read the screen.

Moss hit ENTER as he said, "It's what my mom called me as a kid. She was a systems analyst and would have known this kind of thing. I can't believe I didn't think of it sooner, but I didn't realize until now how far outside of my dad's realm of understanding it was."

The password was accepted, and a new screen appeared. "Danger," it read. "This program will short circuit anyone other than Mossy. It will self-destruct if hacked. Only run this program somewhere safe." There was another enter key displayed below the words.

"We have to get back to the safe house," Moss ordered. Patchwork packed his tablet as Burn finished his meal and downed the sake straight from the carafe.

"Let's get you back," Burn agreed as he stood. "Hopefully things have calmed down. Patch, can you make us invisible to the drones if we need it?"

Patchwork grinned. "Have you met me?"

CHAPTER 16

The mood was low.

Things were calm back at the apartment. The crew had left Gibbs alone as they went to a bathhouse and he had been busy tidying the place. Broom in hand, he looked up as the three entered.

He looked up at them hopefully. "Figured it out?"

"With some help," Moss said and introduced Gibbs to Patchwork. Burn flopped onto a cot as Gibbs joined Moss on a couch. Patchwork sat at Rosetta's station, pulling out and carefully placing knickknacks to make it his own.

Moss watched him, the guilt returning. The seat had been occupied by someone else only a day earlier and now they were gone. He wondered if he would ever get used to it, to losing people. Then he wondered if he even should get used to it.

Gibbs looked at him with intense interest, pulling Moss back into the moment. "So, what was it?"

"Long story, well not that long really, but largely uninteresting. I mean, it could be, but for a later time," Moss answered hurriedly. "Turns out my mom was the mastermind of the program."

Gibbs laughed. "Oh, Bubba Bear," he said, tousling Moss's hair.

"Shut up." Moss smiled, playfully shoving his shoulder.

Sitting next to an old friend and having cracked the (now infuriatingly simple) riddle, he felt a bit better.

Planting the broom and leaning on it, Gibbs asked, "how's the leg?"

"So good I keep forgetting about it," Moss admitted. He took that as a good sign that he was going to recover with ease.

"Can't beat that," Gibbs said with a smile, clearly happy for his friend. "So, what's next?"

Moss sighed. "Run this program my parents set up and find out."

"Ready when you are," Patchwork informed them.

"You know what," Moss said, "I think I need a few."

Patchwork nodded and went back to what he had been doing. Moss looked at his friend and smiled, happy just to take a break for a moment. They had not really stopped since the moment they left the burb and Moss knew he needed to rest a bit if he was going to be able to continue.

"What were your next posters going to be?" Moss asked and Gibbs looked like a child given a surprise gift.

"Well," he began and talked at Moss for the better part of an hour about which ones he had planned on choosing and why. Moss had never cared much about the posters, but he knew how much they meant to Gibbs and he was happy to listen to an old friend talk about something that excited him. It made Moss feel like he was home, forgetting for a brief moment about surgery, betrayal, death, and evil.

As Gibbs spoke, the other members of the crew filtered in one by one, having done different errands after their baths,

and each one simply sat down and listened. They were all clean and in new clothes which still reflected their personal sense of style. Gibbs didn't seem to even notice, too engaged in his passion to care about anything else.

As Moss looked around the room at these people he had dedicated himself to work with, he noted them all smiling. Just like him, they all seemed pleased to listen to Gibbs wax on. For as hard as they were, or as mean or cold as they had been, he liked them.

Stan had taken him in and been kind, Grimy had saved his friend, Judy had saved his life even after disagreeing with his plan, Ynna had opened up to him when she had no reason to and Burn (who lay snoring) had supported Moss when he had needed it most.

He looked at Chicken Thumbs and saw a kindred spirit. The man clearly wanted to help but did not yet seem capable. Moss very much felt the same way, even though he knew he could rise to an occasion when put to it.

When Gibbs had finished, they all moved around him to ask questions and give input. Patchwork seemed to already know everyone and so turned to Moss, saying, "Ready?"

Moss simply said, "yes."

"Right, come sit here," he said, setting Moss down before the bank of monitors, and bringing up the warning screen. "You know what to do," he said, and Moss reached out and hit ENTER.

His world went white as he heard "synchronization complete" echo in the nothingness. He blinked and was standing in his childhood hex. Feeling a tap on his shoulder, he turned to see his father, just as he remembered him, standing before him.

He knew this wasn't real.

He knew this was some kind of virtual reality.

It didn't matter. He hugged his father the way he had wished he could since that night. He wept and his dad gripped his shoulders to look at him.

"You're all grown," his dad said, tears streaming down his face also.

Moss managed to mutter, "I love you, dad."

"I love you, too, Mossy."

"What is this?" Moss asked, looking around the room.

"This is my life's work," his dad told him. "This is what I created and what they've bastardized."

Moss was amazed at his father's skills. "You uploaded your consciousness?" he asked.

His father smiled and shook his head. "No, the 'me' standing before you is an AI construct based on my life experience. The brainwave scans in our implants are constantly running and analyzing. Everything I've seen and done factors into how I read moments and respond. I'm as close to a copy of myself as can exist."

Moss was amazed. His father's mannerisms were just right, his tone and the way he spoke *was* his father. It was amazing and so lifelike that it nearly fooled his mind. "So, this isn't real?"

"No, not in the way I'm sure you want," his dad said and then his face contorted with pure sadness. "I'm so sorry I never told you."

"It's all right. I was a kid. I know you just wanted what was best," Moss said, and he was beginning to believe those words.

"I'm so happy you understand. Burn took you in?"

"He did."

"That's great, and grandma?"

"She died between when you left and now," Moss told him. It didn't matter that it was a program, he was going to tell his father everything.

"That's too bad," he said, registering the loss of his mother with almost no emotion. Moss knew the two of them had a complicated relationship and wished he could have asked more about it but his father said, "she would have loved to see you now."

"I would have loved to have her, too. I feel so lost," Moss admitted.

"I know. I wanted to leave you a message, but I was terrified the company would find it," his father said and began pacing around the room. Moss smiled; his dad had even programmed his small neuroses into this version of himself.

"What happened to you? I have only vague memories," Moss asked.

"I don't know, this system was created before then," he explained. "I'm sure it didn't end well for me."

"And mom?"

His father grimaced miserably at the idea. "For her too. I wanted to protect her from this, just like you, but you know your mother," he trailed off. "So, they erased the memories of what happened?"

"Seems that way," Moss admitted. He tried to shake the thought of what fate had befallen his parents from his head. He had seen so much death recently and picturing his parents meeting some violent end made him feel ill.

"May actually be for the best," his father said.

"I just wish I had known enough to prepare me for all this," Moss said.

His father looked at him with pride. "I'm sure you are doing great."

Moss smiled. "I'm trying."

"Your mom and I always knew you were capable of greatness."

"Thanks, dad." Moss was overwhelmed by the moment. Spending his whole life thinking he would never see his parents again, it was an unbelievable gift to be standing before his father. He wanted to stay in here forever, spend time with the man he had lost so long ago but he knew they had a mission. "So," he said seriously, "what is ThutoCo up to?"

"Ah," his dad said. "The crux of it. I helped create this technology for the drudges, so they could read and react to their operators. So, you could 'work with yourself' as the catchphrase goes. But I soon realized they wanted more. The managers began asking questions that made me nervous. I began to understand that they wanted to use this to *replace* the employees."

Moss narrowed his eyes. "Replace us, how?"

"They intend to upload these reflective AIs into the drudges and do away with their human counterparts."

"Do away with?" Moss asked, though he was sure he knew what he meant.

His father's face was grim and serious. He had stopped pacing and was looking at his son with piercing eyes. "Kill, Mossy. I expect them to use the prophet root bacteria to infect the employees and replace them with the AI."

"But why? Why not just program the drudges to do the work?"

"Skills, experience. Programs can do a lot, but nothing is as powerful as the human mind. Combining the employees with their drudges would make the workforce the best automated in the world."

Moss was shocked, though not as shocked as he would have been a week earlier. "But what about the people, their families?"

"A tragic accident. The company will pay off the families. It'll be a pittance according to our contracts. Then they clear out the bodies and rent the burbs as high-end apartments— all profit. Without having to feed staff, all the crops can be sold off world."

Moss stood aghast, mouth open, hands shaking. He had heard ThutoCo called evil. He had known hearing their plan would make him sick, but this was beyond his worst nightmare. For a company to murder its entire workforce, use homegrown technology and skill against the very people who dedicated their lives to it was something he could barely understand.

Money.

It was all for money. Somewhere in those golden towers, all the members of the AIC would be getting even richer.

"I know it's a lot to take in," his father assured Moss. "It's why I started working with Burn, helped to get a team ready to do what needs to be done. If you are seeing me now, it means the plan is already in motion."

Moss looked into his father's eyes. "I know it already is."

"How?"

"In the last year, everyone in the burb got sick. They must have been testing the system, laying the groundwork for what was to come," he explained. He thought back to that day, laying on the floor of his hex, the skin under his fingernails turning white as he gripped the rim of the toilet. Covered in sweat and sick, he had felt pangs of guilt for having to miss work. Now he knew, now he understood that it had all been a

part of the plan. He had suffered and for all the people he knew, that illness would be only the beginning.

"Then the time is now," his father said, grim determination in his eyes.

"Who's the team? I know Burn got you but who else? Still got the lovebirds: Stan and Judy? How about Cutter and Grimy?" he asked.

"All in except Cutter, don't know him," Moss said.

"Her. Cutter was a street samurai, good people but always rushed in headlong. Too bad, she'd have been helpful."

Moss nodded with a slight smile. "Sounds like what Ynna does."

"No kidding? The despondent rich girl really made something of herself? Burn can have that effect on people. Happy to hear it. Who's your breaker?"

"Patchwork," Moss said, before correcting, "this kid, Willis." His father looked astonished.

"Willis?" He laughed. "He was showing me action figures last time I saw him. My, how things change. I'm surprised his mom loosened her grip enough to let Burn take him."

"Jo had another kid—a daughter. Maybe that's it?" Moss offered.

"That's wonderful, I'm happy for her. Don't know if that's it, but I'm not surprised any kid of hers would want in on the action. Those vets got hit pretty hard." His father's eyes drifted absently away for a moment.

"So, I keep hearing…" he trailed off, letting the silence hang a moment. "Life outside the burbs is very different," Moss said. It felt like the greatest understatement of his life. His days in the burbs had been so easy, so cushy. It was a shock to see the way most citizens lived: shuffling down the filthy streets to

jobs which paid nothing just so they could afford their palmscreens.

"Sure is, nothing is taken care of and nothing is certain. So, I have poverty because a few assholes want another yacht," his dad remarked with venom.

Moss's eyes went wide "You swear."

"People act differently around their kids, but you're all grown now," he said. He appraised his son thoughtfully. "I'm really proud of you."

"Thanks, dad. Or whatever you are," Moss smirked. "So, what should we do?"

"You have to expose them," he said, no hesitation. "Your mother put a Trojan Horse program on this drive which will reprogram Marisol Mac to run a bulletin throughout the burbs, telling everyone of the plan and encouraging a companywide revolt. The moment the upload is complete, her new broadcast will begin. Have Willis, or Patchwork rather, add the bit about the illness last year."

"Will that be enough? The company will try to play it off, say it was rogue hackers," Moss pointed out.

"Certainly. But the damage will be done. The AIC will never abide such a public disgrace. They will do everything in their power to tear apart ThutoCo. There is nothing these companies fear more than the others. It will be the beginning of the end for them. Trust me. Seti still your eyes?"

Moss nodded. "Yeah."

"Great. D2E controls the television and internet but Seti should be able to get the feed out just long enough so that the world can see it, too. The counter breakers will shut her down quickly but once it's out there, the genie can never be put back in the bottle. ThutoCo will be under such intense scrutiny from both within and without that they will have to scrap the plan."

"Scrap the plan?" Moss parroted, his ire up. "Dad, we need to take them down, this is some sick shit. The company may come apart, but the world will stay the same!"

"This isn't just about taking down the big bad, kiddo. It's about saving lives. You're stopping corporate genocide," he said, his voice resigned.

Moss thought about all the people in all the burbs. "I guess…" he murmured.

"I know you want to do more. I admire it. But you must focus on what's before you and all the people you can save." He grabbed Moss's hand and looked him in the eyes. "You'll be a hero, even if the people you save don't realize it."

Moss knew he was right. He had spent his whole life feeling small and insignificant, but now he was vital to saving lives.

"There are a couple of problems though, as you would expect," his dad said. "First, you are going to need to get this program to the server banks at ThutoCo HQ. It'll be heavily guarded and complex to get to.

"Once you're there, it has to be *you* who uploads the program. Mom didn't want to put you in harm's way, but we needed to code it to someone's unique login and scan so that some rogue group couldn't use this for their own purposes. You are the key now."

Moss swallowed hard and nodded. "I can do it."

"You have someone on the inside? Issy or Vihaan your person in BurbSec?" he asked. Moss didn't want to admit what happened, didn't want to believe it.

"Issy is BurbSec, but I messed it up," Moss groused, telling his dad everything.

After listening intently, he assured Moss, "she'll forgive you," but his words lacked conviction.

"She shouldn't," Moss argued. He could not shake the image of his oldest friend when she realized what Moss was going to do: the sadness, disappointment, and fear written all over her face.

"She will. She loves you," he said as though it was the most obvious thing in the world.

"That only makes it worse." Moss's head dropped. Even within the program, he could feel the guilt. His heart raced and his palms were damp. He swallowed hard. "I betrayed the one person I could count on."

"Sounds like you saved her life," his dad reassured him.

Moss had tried to convince himself of the same thing but always came back to the same point. "From a man I brought into her life," Moss said. He couldn't bear the memory.

"Try her, see what happens. Failing that, talk to Vihaan, he always had my back, and hopefully yours as well."

Moss told his dad, "he was good to me after."

"Good. What I wouldn't give to have his korma one more time," he trailed off longingly. Moss smiled at the memory of home. "Speak to him. Tell him what's happening. His sense of honor will compel him to help you, no matter what happened with Issy."

Moss knew he was right. Vihaan had a sense of propriety to a fault.

"All right," Moss said.

"I believe in you, Mossy," his dad told him, and his son felt an encouragement which only a parent can provide.

"Thanks, dad, though—" he began but let the silence fill the room, staring at a vase of digital daisies on the counter. His mom had always tried to keep flowers in the hex. It was a nice touch programmed in.

His father cocked his head. "What?"

211

"Mossy. I never really liked it. Such a lame nickname. You know I called my drudge MOSS II? I blame you for that," he said with a weak smile.

"Fair enough," his dad answered with amusement, spreading his hands wide. "You going to be all right?"

"I am," Moss said, and he believed it. Despite everything, he had a sense of confidence in his—and his new friends'—abilities.

"Good. If you ever have any doubts, look to Burn, he'll be there for you."

"I know," Moss said. He had come to think of Burn as a mentor and a person he could count on.

"But he'll need you, too," his dad said, an unreadable expression on his face.

"How?"

"To help lead."

Moss could not believe the words and he laughed. "I think Burn has that covered," he said.

"For now, but he is aging. Biotics are keeping him alive. He will need you; the crew will need you. When this is done and all eyes turn to the AIC, it will be important to have someone with experience from inside the corporate structure. Your family helped to create this, and it will fall to you to continue that legacy." He was deadly serious.

Moss shook his head. "I'm no leader. Ynna or Stan would be a much better choice."

"Ynna is driven by resentment and Stan is too volatile," he said. "Do you remember when we took you to Castle Dome as a kid?"

"No," Moss said. "I haven't been outside the burb until now."

"Assholes really did scrape your memory." His dad snarled. "We took you there when you were eleven. A bunch of kids are taken on an adventure by a guide while the parents drink mimosas poolside and watch from a drone feed.

"You were the youngest in the crew by a few years and when you got to the end, everyone wanted to rush headlong into the dragon's den. But you had been listening to the clues along the way. You realized that if you painted the rocks outside the lair to look like gold, you guys could coax the dragon out and steal its riches, saving all the kids from certain defeat.

"The guide found us after and said that she'd never seen a kid so young solve the little puzzle. Mom and I knew, then and there, what kind of man you would become." He beamed. Moss thought about outwitting Ira, about making the quick decision to save Issy and believed his father.

"Right," he said with certainty.

His father asked in nearly a whisper, "Moss?"

"Yes?"

"Can you... tell me about yourself?" He looked sad, miserable and, though Moss knew it was a program and that his father was long dead, he sat and told him all about the years that had passed and everything which had happened recently.

When he was done, he looked at his father. "Is this it? Am I able to come back here?"

"Certainly," he answered. "Though I won't be of much help to you once this is all over."

"Even still, it's nice to see you, to talk," Moss said.

His father smiled thoughtfully. "You too, though admittedly, I only exist when you're here."

"That's an odd thought," Moss said. The program felt so real, he kept having to remind himself of the truth.

"Yeah, I wish I—the real I—could be there for you now," he said. His voice was pained. It was obvious that he felt tremendous guilt for not being there for his son. Moss had to marvel at the program once again. Conversing with this version of his father was exactly what he remembered.

He thought about MOSS II then. The robot who had felt like a true friend, but which had been mining his mind to create a duplicate. He knew that on a server somewhere, there was a recreation of himself which was as true to him as this was to his father.

"This is more than most get," Moss pointed out.

His dad let out a sad chuckle. "I suppose that's true."

"Did you do this to mom?" Moss asked hopefully and his father's sadness deepened, his eyes instantly welling.

"She wouldn't let me. Knowing what this technology was being used for, she didn't want a copy out there," he said in a tremulous voice. "She also—" he began but seemed to be lost in thought.

"What?" Moss coaxed. He wanted to know. Needed to know.

"She didn't think it would be good for you. To have this version of us when you really didn't," he explained.

Moss nodded his understanding but assured his father, "I like it."

His father sat silently a moment before turning to look at Moss. "Honestly, kiddo, I don't think that was it. I honestly believe she didn't like the idea that a program of her would get to watch you grow up when she didn't." Tears began to stream down his face. Nonplussed, Moss didn't speak.

"I think it's time." His father's words seemed to need to be forced from his mouth.

"Okay." Moss was reluctant to leave. He knew he had work to do. He knew people were waiting and lives depended on him, but he wanted to stay in the false reality.

"You'll come back and let me know?" his dad asked hopefully.

"I will," Moss said. "I love you, dad."

"I love you, too, Mossy," he said, then smiled, "Moss."

Then white.

Moss blinked and he was back in the cramped, stinking apartment. The room was silent, and when he swiveled in the chair, all eyes were on him.

"You all right?" Burn asked and Judy strode over, cup of coffee in hand. He took it and winced at the taste.

Judy offered a kind smile. "You'll get there."

"What was it?" Ynna asked.

Moss fixed his eyes at Gibbs. "It was my father—or a program of my father, rather," Moss said, and he explained everything. When he was done, they all looked at him in stunned silence.

Ynna stood and cracked her knuckles. "Let's break these fuckers."

"Let's save some lives," Burn corrected.

Moss smiled.

215

PART III

CHAPTER 17

"Seti, bring it up," Burn ordered. "And Patch, help get Moss a secured call. We don't have all day to take him back to church, so make it secret—and I mean 'porn on your mom's computer' secret."

"Heard," Patchwork said and got to work as Seti brought up a rendering of ThutoCo HQ. As Moss strode over to Patchwork, Judy grabbed his arm.

"I feel like I'm saying this to you a lot, but I'm sorry," they said, smiling as striped hair fell over their face.

Moss looked into Judy's dark eyes and smiled slightly. "It's all right."

"It's not, I just want what's best and I'm still adjusting to having bubs involved. I know you guys are trying to help but it's like sleeping with the enemy."

Moss sympathized. "We're all trying to figure this out."

"Right," Judy said with a nod and released Moss so he could make his call.

Patchwork informed him that, "she won't be able to see us."

"I know the rules," Moss told him. He was nervous. Though he was excited to see her face and hear her voice, the guilt sat like a cinderblock on his chest.

"Cool, man. I'll patch you through," he said. One of the screens went black as ringing entered Moss's mind.

The caller you are trying to reach is unavailable, please try again later, a robotic voice offered helpfully and Moss's heart sank. He looked over to Chicken Thumbs. Fresh clothes hardly covered the wounds of his questioning. As the voice repeated the phrase again and again broken only by ceaseless ringing, Moss imagined his oldest friend, stripped and shackled as they accused her of things she did not fully understand. He hated himself, hated Stan, hated this mission. He swore he would do anything he could to help her and spend the rest of his days trying to make amends.

"Try her dad," Moss demanded, giving Patchwork the information. He answered after the first ring.

"Isabella? Is that you? I cannot see you. Are you all right?" he said, breaking what was left of Moss's heart.

"No, it's Moss," he forced, saying the words aloud though he was meant to transmit them through his implant.

"Moss, my boy, what has happened? They tell me nothing," Vihaan said, his voice cracking. For a man of his stature in BurbSec to be locked out of something meant that it was highest level security. Not surprising, but disappointing.

"Are you alone?" Moss asked, and the black screen turned on, revealing Vihaan's face in an empty hex.

"Yes," he said, and though Moss knew there were any number of tricks to keep other security officers hidden from a camera, no one could fake the parent's fear written on the man's face.

"She helped me. I know you know what that means. BurbSec must have her," Moss explained. He could feel himself rubbing his hands together nervously.

"Not Carcer?" Vihaan asked, sounding slightly relieved.

Burn had taken a break from the planning to stand by Moss's shoulder. "ThutoCo would want to question her, wouldn't want to share with Carcer," he whispered in Moss's ear, the hair from his beard tickling his flesh. Moss repeated the message.

"Yes," Vihaan agreed. "You will help her, yes?"

Burn nodded silently. Moss promised, "yes."

"Thank you," he said graciously, and Moss felt all the more guilty that the man did not ask what Moss's role had been in her capture. He wanted to tell him everything, beg for forgiveness, try to pull this guilt from himself, but he said nothing. "You need my help?"

"Yes," Moss answered, the word heavy. He hated having to do it, having to put Vihaan at risk after everything.

Vihaan knew already. "Clearance codes?"

"Yes," Moss answered again.

"My life here is done?" Vihaan's eyes looked around the room behind the camera. This man who had dedicated his life to the protection of the burb would now have to flee from it. His name would be hissed with disdain by people who had worked at his side for a lifetime.

Moss said, "yes," with a heavy finality.

"I will go into hiding, I have family," he told them. "I knew this day would come."

"My father warned you?" Moss asked, his voice breaking.

He looked sympathetically into the camera. "Oh, yes. You understand we had to keep that from you?"

"I know," Moss said, sick to his stomach at the apologetic nature of the man. He had done so much for Moss

and now he was doing him one final kindness. He had asked so much of this family in so short a time. Moss knew the only thing he could do to repay Vihaan. "We will bring her to you."

"Thank you," the man said, his eyes glinting. "I will transmit the codes. They may not work for long when they discover I've left."

"We will move fast," Moss assured him. "You can get out undetected?"

"You do not do this so long as I have without learning a few tricks," he said with a wink and wry smile.

Moss smiled at him even though he knew the man could not see him. "I'll see you on the other side."

"On the other side," Vihaan repeated, standing and looking around the room as if deciding what he would take with him when he left. Watching his face, Moss realized that the man had clearly known this day would come. He did not look sad but thoughtful and determined.

"And if you ever need anything," Moss began, but Vihaan held up a hand and looked back.

"Just get her out and do what you are planning," he intoned. Moss thought it was odd that his digital father had shown more emotion about him than Vihaan had shown about his captured daughter. But Moss's father had always been a more emotional man. While many scientists were more stoic and logical, Moss's dad had always been more delicate- even tearing up at the packaged backstories of the Burbz Haz Skillz contestants. Vihaan was different. Though he would laugh and smile over dinner, there was always the underlying seriousness of someone who had spent a lifetime working in security. The technique he used to survive a difficult job was the same technique he was obviously using to deal with the capture of his daughter.

Moss knew there was something to learn from both men.

Patchwork nodded as the screen went black once more. Everyone in the room went back to planning as though they had not been listening in. Gibbs could not hide his sorrow.

Seti informed them, *Even though it's a corporate headquarters, it's damn near impenetrable.*

"What if we all dressed up like janitors," Gibbs exclaimed, excited by the idea of a clever ruse. "We could wear false beards!"

"You've seen too many movies," Ynna mocked. "Cleaning is all done by bots."

Gibbs nodded in disappointment, his eyes examining Ynna. "Right, burbs are the same way."

"Server room is deep underground," Patchwork explained, the display spinning and zooming to a massive room filled with row upon row of electronic towers.

"Where is Issy being held?" Moss asked forcefully.

"That may be our only stroke of luck," Patch said. "She's probably here at HQ, being held for questioning by management. They wouldn't want to use any facility partially run by Carcer. If her dad doesn't even have clearance, she's likely here on the sixth floor: BurbSec main office. It's a shock to no one, but they have a holding facility there as well for internal investigations."

Moss nodded. "We go there first."

"It has to be you in the server room, we can split up and a couple of us can get her out while you do your work," Stan said.

"No!" Moss bellowed, sounding like Burn. His controlled passion demanded the attention of the room. "I will be the first face she sees. We can split up and you all can clear

a path but I'm getting Issy." This earned nods of agreement from around the room.

"We'll obviously place charges here in the server room, but we will want to knock out the lab as well." Judy continued to plan.

"What charges?" Moss asked and Burn grabbed him by the arm gently and led him away from the group.

Once they were out of earshot, Burn looked at Moss seriously. "Your father's work. It may be important to you, but we cannot leave it to persist. And those servers with the hacked minds of the employees, they must be destroyed."

"No," Moss said quickly, and Burn furrowed his brow. "I mean, no, his work is not that important to me. When I was inside with him, I told him I wanted to do more. He said it was about saving lives, but I see now he was trying to protect a legacy, no matter how it was being used."

"Ah," Burn said, appraising his words with a smile. The way he looked at Moss then was with a similar look of pride to that his father had shown. "So, you're with us then?"

"With you, and more," Moss said. Though it sat uncomfortably with him to betray his father's trust or even the trust of a rendering of his father, he agreed with the plan. He had wanted to do more to ThutoCo and now they would.

They moved back to the group and Burn pointed at Ynna. "Call it like you see it."

"Right." Ynna grinned. "After breaking in twice and breaking CT out, they will be on high alert—on the lookout for anything. We will need to get the new kid into the control room first thing so he can open doors, turn off guns and cameras and guide us along.

"Moss is dead set on finding his friend, so half of us will go with him and get her out. Gibbs, she'll be in rough shape

so we'll want you to get her back here to Grimy quick as you can once she's free. Burn, Stan and Judy, you all will move to the servers, get us in and find a spot for the charges. Once they're set and I get Moss to you, Burn will watch his back while the three us find the lab and set up there too. I miss anything?"

Burn simply smiled.

"Yeah, you missed something!" Chicken Thumbs said, pacing around the room in a huff. "What about me?"

"You'll be Patchwork's back. He'll be busy and you'll need to keep him safe," Ynna said. She pointed at the slight kid sitting at the desk who shot Chicken Thumbs a grateful look.

"I promised his mother, so you better keep those guards off him, Blood Bath." Burn smirked.

CT whined, "I vetoed that."

"Moss, Gibbs, what you guys know which we don't?" Burn asked. Gibbs shrugged but Moss thought back to Issy before taking the BurbSec exam. Helping her study had familiarized him with policy and protocol.

"After a security incident, many of the corporate offices will be locked down after hours and they will use thermal scans to ensure no one is in the building at any time," Moss told them.

Ynna scoffed. "Well, that's easy, we just wear thermaskyns. Pretty lame security measure, you ask me."

"Only lame if you know you need them," Moss said and Ynna laughed.

"Right," she said. "The question becomes: how do we get Patchwork into the control room? Even if they don't pick us up on thermal, they won't let us just waltz in there."

Seti moved the 3D schematic so they could all see the control room located at the top of the building. It was a small space, banks of screens surrounding a single chair.

Judy squinted at the rendering. "One person, seriously?"

"Corporate wouldn't trust too many people with that much responsibility," Moss pointed out.

"We should just pay that guy off and save ourselves a whole lot of trouble," Chicken Thumbs put in as though it was the obvious answer.

"Never could, the person who sits at that desk would be a first-rate stoolie," Burn said. He lit a cigarette and took a long drag before letting the smoke slowly drain from between his lips.

Gibbs shrugged. "Cut the power?"

"They must have backup generators?" Patchwork said quickly. "And the servers will be on their own supply."

Moss thought about it. "Gibbs, during that big storm last year, how long between when we lost power and the backup came on?"

Gibbs smiled. "One minute, twenty-three seconds."

"How do you remember that?" Ynna asked with pure surprise upon her face. Gibbs smirked and leaned back, lacing his fingers behind his head triumphantly.

"I'm really rather something," he boasted, holding his shoulders up.

Moss narrowed his eyes and pointed a finger at Gibbs. "Something to do with the game."

"Fine. Destroy the illusion," Gibbs said, plucking a plug converter from between the couch cushions and throwing it at Moss.

"We were doing a timed endgame raid and our score was beaten by those jerks from Burb 2049 when the power went out. It was the longest minute and twenty-three seconds of my life," Gibbs whined.

"You've lived a pretty cushy life then," Judy half-joked.

Ynna's eyes went wide and she asked excitedly, "what game was it?" It was the first time she sounded her age.

"P—Pirate's Scourge," Gibbs stuttered, surprised by the question.

"Nice! Cracken Uncorked Mod?" Ynna asked eagerly.

Gibbs looked at her as though his very honor had been offended by the question. "Obviously."

"Ah, man, you ever—" Ynna began but Burn interrupted.

"Children, can we please return to the potentially life-threatening endeavor at hand?"

"How do we get in?" Stan asked, steering the conversation back to the mission.

Slice a window? Seti suggested before amending, *scratch that, they have sensors.*

CT offered, "micro EMP?"

"That'll set off the alarms," Judy said.

"Seti, trace a path from the windows to the control room and time it out," Burn ordered.

After a moment, she said, *it'll be tight.*

"Burn, we're all going to have assignments, how can we knock out the power and be by the window at the same time?" Ynna asked.

"Reckon we'll need help," Burn said and Ynna snorted followed by a chorus of groans from around the room.

"Oh no, zero two?" Ynna groused.

Burn stamped his cigarette out on the wall, sending sparks cascading to the ground. "Can't do this alone and of all the teams in the city, they are the most reliable crew."

"Most arrogant crew," Ynna muttered under her breath, crossing her arms over her chest.

"They your Burb 2049?" Gibbs asked playfully.

Ynna nodded and huffed. "Exactly."

"They are not so bad," Grimy said to Moss's great surprise.

Judy snorted. "You would think that."

Patching you through, Seti announced.

One of the screens displayed, CONNECTING, before revealing an image of a heavy man in full tuxedo, standing in an immaculate white room full of men and woman similarly adorned. His white hair was slicked back with precisely groomed mutton chops shaved into arrows pointing to his mouth. His skin was tight, an older man whose fountain of youth was found at the top of a needle. He smiled broadly, blue eyes glimmering as the skin stretched unnaturally.

"Captain Bernstein, to what do I owe this dubious pleasure," he said with no accent but in such a stilted manner as to nearly give him one. "Has the refuse before you piled to your nethers such that you wish us to attend to your abode?"

Burn let out a long sigh. "That ain't it."

"Have I before mentioned that the boorish manner in which you speak is an affront to the world's most elegant language?" the man asked, his words so crisp and clear as to sound robotic. Moss felt that the man was more performance piece than personality.

"Every time we speak," Burn put plainly.

"Condescension and patronization will get you nowhere as I imagine a favor is coming forthwith," the man said.

"Right. Listen, James, we need your help and we need it tonight," Burn said.

"Sir James," he corrected. "A proper man demands a proper title."

"We're making a run at ThutoCo, you think I give a hoot about titles?" Burn was beginning to fray. His hand moved toward the pocket from which he always produced his cigarettes but stopped, making a fist instead.

"Titles are a cornerstone of a civilized age, wouldn't you agree." He stalled, obviously willing to wait until Burn used the proper name.

Once more, Burn took a long, soothing breath to calm himself. "Sir James, we need your help."

"And you shall have it, your disquiet dispirits me," Sir James said, half of his mouth turning up. Moss understood why the others seemed to dislike the crew so much. He was relieved to be getting the help but the ridiculous man immediately annoyed him.

In the burbs, expressions of one's personal taste were discouraged. Nearly everyone wore the same things, ate the same things and watched the same things. Gibbs and his posters were one of the few expressions of personality that Moss had ever seen. Outside the walls of the burbs, things were the opposite. Everyone had their own way of expressing themselves- through their speech, their attire and attitude.

Looking down at himself, he realized that he was still pretty much a blank slate. He kept picking black outfits with little to no expression about them.

Burn interrupted Moss's thoughts as he told Sir James, "we need you all to hit a power station tonight at an exact time we designate."

"Ah," the man crowed delightedly, clasping his hands before his chest, "a task worthy of this aggregation."

"Good, we'll get you the info," Burn said. "Thanks."

"You wish to continue this correspondence further?" Sir James asked, tilting his head and raising an eyebrow.

"Not even a little," Burn said and Seti cut the feed. Burn produced the whole pack from his pocket and pulled another cigarette. Moss noticed for the first time that the old man's hands were shaking as he held the lighter to the tip of the smoke.

"Prick." Ynna snorted. She reached out and snatched the pack from Burn, plucking the cigarette from his mouth and using the embers to light her own.

"Man may be a thorn but he's great in a pinch and that crew don't mess around," Burn said, taking his things back from Ynna. "Plus, they are nothing if not efficient- we know they can scramble quick. Who even knows how long it would have taken the others to get their shit together?"

Ynna nodded and Moss let a wide grin cross his lips "Bernstein?" he asked, unable to hide his amusement.

All the faces around the room turned too.

Burn shook his head, obviously disinterested in this line of questioning. "Think I got my name from burning my enemies?"

Gibbs stroked his chin dramatically. "Plausible," Gibbs said and Ynna snickered.

"Right?" Moss added.

Judy cleared their throat. "So, they'll hit the power station and we'll have a little over a minute to get through the window and to the control room."

"That'll have to do," Burn agreed. "They might have some turrets on battery for just this play so we'll still want the thermaskyns to be safe."

"We'll go see Chu," Stan offered, standing in unison with Judy.

"Don't tarry," Burn commanded. "And bring back some food."

"Your wish," Judy said, and they left.

Moss looked around the room. "What now?"

Burn shrugged. "Rest."

"That shower work?" Moss asked, pointing to the small bathroom.

"Yeah, water use is unlocked but don't use too much or it'll raise suspicions with the landlords," Burn told him.

Moss nodded and shut himself into the small room, the smell of mildew filling his nose. Damp towels hung from hooks and lay crumpled on the floor. A light flickered above a broken smart mirror, serving as the only light in the room.

He turned on the water, undressed and stepped in. The warm water robbed him of thought for a time until he found himself tracing lines with his fingertips along the fusion point of his real and artificial leg. He felt as if he no longer knew who he was, who he had been, but allowing himself a private moment of immodesty, he liked who he was becoming.

CHAPTER 18

Clean and wrapped in his trench coat, Moss awoke to the sound of Stan's heavy footfalls on the floor and the smell of cooked meat and fried potatoes. He knew he had not slept enough. It felt as if there was a thin layer of mold on his brain he couldn't shake, but he roused himself.

Judy handed out the thermaskyns. They already had theirs on, Stan wearing nothing but his usually tight pants over form-fitting fabric which glimmered slightly as he moved. Judy wore theirs under jeans and a button-up, patterned shirt, the skyn only peeking out at the wrists. Moss set his to the side as he slid from the cot and made straight for the bags of food. Stan smiled and handed him a paper bag, grease coating the bottom.

"Had pizza, now you gotta try burgers," Stan said with a smile. "In case it's your last meal, better make it a good one, right?"

"Right," Moss said, hardly hearing the words as he and Gibbs plopped onto a couch and tore open the bag. He didn't care that he burned the roof of his mouth as he jammed a handful of fries in, moaning with delight.

"A royale with cheese," Gibbs said, giddy as a child as he took his first bite, warm liquid from the meat sliding down

his chin. Neither of them noticed as the rest of the group watched them in fascination.

"They're like children," Judy noted as the rest changed and sat down to eat as well.

As Moss sucked the tip of his fingers, taking in the remaining savory flavors, Gibbs nudged him with an elbow and nodded to Ynna across the room. She was eating a French fry and standing in just the thermaskyn, the material tight against her body. Moss knew better than to stare.

Gibbs winked and whispered far too loudly for Moss's liking, "she gives the Butlers a run for their money."

"Keep staring and she'll put you through a fucking wall," Moss hissed before excusing himself to dress.

When he returned, everyone stood about, grim-faced and determined. Judy was making the rounds, checking equipment.

Burn walked over to him. "You ready for this?" he asked, putting the recharged Kingfisher in his hand.

"Yes, sir," he said, feeling as if he had never spoken truer words.

"This may be the end of us," Burn began.

"Or the start of something big," Moss cut in, tucking the gun into a holster and shaking the old man's hand. Burn turned to the group.

"Let's set the world on fire," he said, and they couldn't keep themselves from cheering.

The dronepacks carried them over the city and Moss watched the people bustle about, blissfully unaware of what they would see on the morning news. He had been one of them. No one looked up and they avoided the airplanes to remain unnoticed.

ThutoCo HQ came into view amidst a sea of skyscrapers in the heart of the city. One by one, they buzzed close to the top of the tall, dark structure. They paused, hovering next to a window near the top. For someone who didn't even like elevators, hanging so high in the air only added to Moss's stress.

Now, Burn ordered to Sir James.

They heard no answer. They waited, a terrifying, heart-pounding time. Nothing happened. Moss imagined somewhere nearby, an immaculately dressed group infiltrating a power plant—some substation redistributing the energy from the panels which he and MOSS II used to repair. Moss turned his head to see Patchwork next to him, shifting awkwardly but he turned and smiled.

"This is new," he said with an uneasy chuckle. Both their heads cocked as a security drone rounded the corner of the building, scanners working. Moss kicked himself for not thinking of this and was sure others were feeling the same.

"No rest for the weary," Patchwork said through the thermaskyn mask as his eye undoubtedly went black beneath the goggles. The drone moved past, its scanners running over the crew gathered before the window, not changing course. Moss's heart thudded as the grid passed over his body, the trench coat swaying in the mild wind. Moss felt no relief, only anger that they hadn't predicted this. The plan had come together so hastily. Were there other things they had missed? Were they walking into a trap?

"Good thing he's here," Gibbs said from Moss's left side, his words disappearing into the air around him. Moss agreed, wondering if Rosetta would have been so quick to act before feeling guilty at the question. Hanging there, exposed and unprotected, the moment felt interminable. He began to

worry that the other team had been caught, that all this would be for nothing.

Then the few dim lights inside went out and without thinking, he thrust his bot forward. The spiderlike machine skittered on sticky legs, sending a laser through the glass which hissed as it was cut. The sound surrounded him on both sides and soon there was a square cut in the windowpane large enough to crawl through. He pushed and the heavy glass fell with a soft thud to the carpeted office. He pulled himself inside as the drone released from his back and flew off- the heat signatures would have been a dead giveaway had they worn them inside. Cold shimmered over his body as the thermaskyn worked.

They all ran the plotted course, Patchwork opening electronic doors before they reached them. Seti was counting down from eighty-three in their minds and time seemed to be passing too quickly. The night vision from the goggles made it possible to see but they still had to be careful, moving through a building they only knew from schematics. Long hallways stretched out leading to more offices, conference rooms and workspaces as they made their way to the interior.

One minute, Seti informed them as she continued to count down. They kept moving in silence. Gibbs wheezed from the exertion behind Moss whose new legs carried him easily.

Thirty, twenty-nine, twenty-eight, the countdown was terrifying. Moss couldn't tell how much further they had. A cold sweat coated his body. As they rounded a corner, a gun turret with small green light was mounted on the ceiling and Moss waited to see if it would open fire. The suits worked. He had been right about one thing and the presence of the security meant they were close.

Fifteen, fourteen, thirteen, Moss's nerves were getting to him. He no longer felt the tips of his fingers. Stan held up a

fist and they all stopped, pressing themselves against the wall. The large man peeked around a corner and nodded to Judy and Patchwork.

Ten, nine and Stan and Judy disappeared around the corner followed by two thuds and Patchwork ran. Moss rounded the corner to see an open door flanked by two BurbSec bodies on the ground. The lights flickered to life as Moss entered the control room. Stan stood over another body and Patchwork swiveled in a chair before the bank of waking monitors. His fingers danced as he worked the rebooting system.

"We got it," he announced, and a collective sigh was released. "Lucky I'm smart: started hacking this door from outside, could 'a been caught standing in this hallway with our pants down if I hadn't thought of it."

Moss snorted. They had gotten lucky again, and all thanks to Patchwork. The youngest among them was proving to be the most valuable.

"That was quick," Judy noted.

"When you think you own the world, you don't plan for this," Patchwork said before adding, "I did a lot of work on the front end to be ready. Wasn't like it was child's play."

"Bring up some feeds. Let's see what we're up against," Burn demanded, and Patchwork isolated several images from around the facility. BurbSec officers paced and chatted by all the points of interest.

"How come they can walk free?" Chicken Thumbs asked, pointing to the guards.

Judy explained, "their armor works the same as the skyns."

"Shit!" Patchwork gestured to a monitor in the corner, and all eyes turned. In the server room, large drudges with guns for arms moved mechanically through the banks.

"Shit," Burn agreed. He sounded tired and annoyed.

Gibbs asked nervously. "What?"

"Human guards can be taken down, but we can't do the same with machines," Burn grumbled.

"Hack'em," Chicken Thumbs suggested as though it was the simplest of solutions.

"Oh, I hadn't thought of that," Patchwork said sarcastically, rolling his eyes. "I'm trying already but they are on a different system and breaking in may raise the alarm. I may make this look easy but, you know, this megacorporation *is* trying to keep things like this from happening."

"You keep working at it until we get there," Burn said, patting Patchwork on the shoulder.

"Where's Issy?" Moss had held his tongue as long as he could. Patchwork brought up the feeds. The corporate investigation rooms were empty, metal chairs facing each other across a metal table. In the security office, there were a few officers sitting around playing cards. Behind them was a row of windowless numbered doors. "Where do those lead?"

"Almost the worst part, that is," Chicken Thumbs said in nearly a whisper, his voice weak and tremulous with the memory.

"What?" Moss asked more aggressively than he had meant to.

"Those doors lead nearly nowhere, just an upright coffin. You stand, stripped, as long as you can or until they come to get you. It's the most isolating and terrifying experience you could imagine," CT explained, his voice cracking at the memory of it.

Moss turned, not saying a word and Ynna put a hand on his chest, staring into his eyes. "We will go, but you need to be ready, alert," she said and turned to Gibbs, "you, too."

The two young men nodded and followed Ynna out the door. "New kid, I think I know the way but let me know if we miss something."

"I got you," Patchwork told her, and they left the crew to do their work. Ynna was out in front as they moved through the hall quickly and once again Gibbs nudged Moss, pointing to Ynna's backside.

"Will you look at that," he whispered, and Moss wanted to put him through the wall himself, unable to believe his friend at that moment. He knew Gibbs was trying to distract himself from the terror, but he did not care, and Ynna wheeled around to face them.

"A woman doesn't need to be modest to be respected!" she said, boring a hole in Gibbs with her eyes.

"Y—Yes, ma'am," he stuttered. She let the moment hold before laughing, "You fucking bubs are so easy to scare. But seriously, stop staring at my ass."

Gibbs nodded frantically and Moss just looked in confusion at the pair.

"Can we just save our friend," Moss hissed and strode forward, having memorized the path. His legs carried him easily to the stairwell where they descended level by level. As they reached their floor, Patchwork alerted them to guards walking the halls outside the door.

"Wait here," Ynna said as she pushed the bar slowly to look. She winked at them and exited, the door shutting quietly behind her.

"You have to get your shit together," Moss said, cold seriousness in his words. His friend's eyes were wide with fear.

Gibbs whimpered, "I'm scared."

"I know, but you need to stuff it. We are all counting on you and Issy is going to need a friend. I wish it could be me, but I have things to do," Moss said seriously.

His friend registered the words, his eyes hardening with resolve. "I can do it."

"I know you can. You're the one who got me here, remember?" Moss said.

"Right," Gibbs agreed with a smile. They heard the door. Ynna had made short work of the guards.

Moss! Patchwork yelled in his mind and Moss turned to see a guard at the door. Moss had no time to think, grabbing the guard by the collar of his armor and pressing his leg against the wall. The machinery in his leg worked at his command, rocketing his body toward the concrete stairs, releasing his grip on the armor as he grabbed for the railing. The guard flew down the stairs before landing on his head, his neck cracking into a right angle. The body slid a few stairs and Gibbs winced.

"How did you do that?" he asked in disbelief.

"I guess adrenaline hits me differently," Moss said, panting as he hoisted himself to his feet.

"I'll say," Gibbs agreed.

He looked at his friend in a way Moss had never seen before. "What?" Moss asked but he suspected the answer.

"I mean, I guess I've known what you were capable of. Fresh from the burb, you tased a biker. But this was something different," Gibbs said, looking at the body. "The kid I brought to the city is gone."

Moss knew he was right.

They both turned as the door opened once more, and they were relieved as Ynna entered. She looked at the body, her own hands dripping crimson.

"Wow, nice job, Gibbs," she said in affected seriousness, placing a hand on his shoulder.

"I didn't," he said, missing the joke.

"Yeah, no shit." She slapped him gently on the cheek. "Let's go."

Red splashes covered the white walls and seeped into the blue carpet as they walked through the fluorescent hallway to the security office. Signs guided their way now.

Thermal offline, Patchwork informed them, and they all pulled their masks from their faces, sweat spraying into the air. Ynna yanked a zipper at her throat and pulled it down to just below her navel, revealing cleavage and toned muscle.

She looked at Gibbs and shot a wicked smile. "Something gross to say?"

"No, ma'am." Gibbs said and made a show of averting his eyes.

They were close now. Moss pulled his Kingfisher and whispered. "I'll go in first."

"Your fight," Ynna said, sweeping her arm in front of her so Moss could take the lead.

He moved forward and saw the door with SECURITY Zero-Zero-One written above. Patchwork had already done his job and the lock panel displayed green with the word OPEN. He raised his weapon as he pressed the button, the door hissing open, followed instantly by blazing blue and flying cards. Two guards vibrated and shook, collapsing to the floor.

The remaining man lifted his hands, the insignia of a supervisor on his chest plate. "I'm just doing my job," he pleaded.

"Me too," Moss snarled as he flicked his thumb and pulled the trigger. The electric shot struck his face, sparking

hair, sizzling flesh. Red bone with white eyes still in shock were all that remained as the body slumped to the ground.

"Not evil if you're just following orders," Ynna scoffed but Moss wasn't listening. He pulled his trench coat from his body and darted for the doors, opening one by one. On the third, as the door opened, Issy puddled into his arms. He wrapped the coat over her back, and she looked up at him, blinking with fear, joy, sadness, and anger all at once.

"I'm sorry, Moss!" she wailed, and began to weep. He couldn't believe her words.

"No, Issy. You have *nothing* to apologize for. I'm sorry," he said, clutching her so tight he never wanted to let go.

"She's in shock," Ynna informed him, glancing around the room cautiously.

"Did they hurt you?" Moss asked but Issy seemed to be looking behind him. Her eyes were wide and vacant. He wanted to pick her up and leave, get her as far from this place as he could, but he knew there was still more to do.

"Just questions and threats," she answered, but even in his arms, she seemed far away. "That room. Moss, that room."

"I know, I know," he said. His heart was heavy.

"We are going to take you home," Gibbs said, pale at the sight of his friend in such a state.

"Wha—where?" she asked. She was shaking.

Moss soothed, "to your dad, he's safe and far away."

"Oh, Moss," she said, looking into his eyes again. "I didn't—" she began.

"I know. I'm so sorry, Is—" Moss said, tears streaming down his face.

"And you should be," Ynna interrupted. "But we have to keep moving and need to get her to Grimy."

Issy seemed to fade away again as she asked, "what's grimy?"

"A friend," Moss said. "Think you can walk?" He helped her to her feet and tightened the coat around her.

"Yeah," she said, standing. Free of her cage, she was regaining herself. "I was always the toughest one."

"You are," Moss said as she held his hand to stay upright. "Gibbs is going to get you out of here."

"Not you?" she asked, desperation written on her face as she wrinkled her nose.

"None taken," Gibbs joked softly. Ynna punched his shoulder.

Moss looked into her terrified eyes. "I have something more to do here."

"Right," Issy responded with recognition.

"I'll come to you as soon as it's done," he assured her. He had never meant anything he had said more than he meant those words.

She smiled weakly up at him. "You'd better."

"I love you, Is," Moss couldn't help but tell her.

"Me, too," Gibbs added.

"I love both you guys," she told them and smirked. "Though I have no idea how you lasted this long without me." She was beginning to sound more like herself. Moss was relieved to see her this way and felt as though he could breathe for the first time in a long time.

"I took care of them," Ynna said and Issy seemed to notice her for the first time, blinking quickly and turning to look.

"Thanks, then," Issy said, extending a hand and looking the woman over.

"Ynna," she said and seeing Issy's eyes move, "you like the outfit?"

"Yeah," Issy said with a half snort laugh. "Really subtle."

Ynna chuckled as she posed a few times for Issy. "Right?"

"I think this is where Burn tells us we need to get going," Gibbs said after clearing his throat.

Issy looked at Moss with a note of recognition. "Burn, that's your dad's friend?"

"Yeah. But Gibbs is right. We need to get you out of here and I need to go finish this," Moss said, embracing Issy again. "You good?" Moss asked Gibbs.

Gibbs nodded, pulling his gun with an unsteady hand. "Yes."

"Give me that," Issy said as she snatched the weapon. She smiled. "Come on, Gibby."

"All right," Gibbs said and extended a hand which Moss took. "Make your father proud."

"I will," Moss said, and the pairs left the room in different directions.

Out of earshot, Ynna said, "she's cooler than you deserve."

"Don't I know it," Moss agreed.

"I was only kidding," she clarified, but he had always felt that way.

Moss smiled and hoped to turn the tables on her. "What's with you and Gibbs?"

"Ha, nothing," she protested. "He's just easy to fuck with."

Moss rolled his eyes at her. "Suuuure."

Charges in the lab are set. Moving to the servers, Judy informed them.

We are too, Moss thought to them as they moved to the restricted access elevators.

CHAPTER 19

Burn, Judy, and Stan were waiting for them as the elevator door slid open.

"The kid couldn't get the drudges offline," Burn said with a sorrowful look. Though he still had the skyn on under his clothes, he had removed the mask and was just wearing his old, beat up hat on his head.

"So, we better be ready for a fight?" Moss clarified.

Grinning maniacally as he loaded a weapon, Stan said, "oh, yes."

"How many?" Ynna asked. She did not seem nervous to Moss, just hard and resolute. He admired that in her and vowed that he would try to learn to be more like that if they made it out of the room alive.

"Counted twenty," Burn said darkly.

The words hit Moss like a shot. He looked around at them. "Against five?"

"It gets better," Burn said, flipping his pistol in his hand and checking the battery life.

"Right," Ynna said, realizing what Moss didn't.

He asked, "what?"

"Once we start a firefight down here—" Ynna began.

"The world will come crashing down," Burn finished. "May just be a one-way trip."

"But Patchwork can guide us. Maybe we can take them out quickly and leave as they are scrambling defenses?" Moss said. He wanted desperately to believe his own words, but Burn's face left little doubt.

"We are deep underground now," Judy explained. "Patchwork and Seti can watch but won't be able to do anything or communicate with us. We told the new kid and CT to run at the first sign of trouble."

"Then we will save a lot of lives," Moss announced, though, at that moment, he knew he had already saved the one which mattered most to him.

"Yes, we will." Burn looked on Moss with pride. "It was an absolute pleasure working with you all. I've seen every one of you grow into the people who stand before me. Heroes who are about to change the world yet will never see its gratitude. Each and every one of you has my eternal respect," Burn said, his eye turning to each one of them individually.

Ynna spoke for all of them when she said, "thanks, boss."

"Now gear up," Burn told them, pulling Moss aside. "I know we've only just met, but I want you to know how impressed I've been by you. You have your parents smarts and your grandma's grit. They'd have loved to see the man you are and what you mean to do to honor their efforts. They, and I, are proud of you," he said. Moss was also proud. He was pleased with the man he had become and was willing to sacrifice himself now.

"Thank you, Burn," he said. "In this short time, I've learned more from you than I can ever tell you and it will be an honor to die by your side."

Burn grinned. "Shit, son. Don't count your chickens just yet. We're going to at least try to make it out with our hides. Now, get ready."

Moss walked over to Stan and Judy as Burn went to speak with Ynna. Moss was awkward as he approached, the two had their heads pressed together and were speaking in hushed tones. Judy looked up at him, those hard eyes now soft and wet.

"We'll have your back while the program uploads," they said, holding out a hand. As he shook it, they said, "it's been nice getting to know you. Showed me that not all bubs are total dumbfucks."

"Thank you," Moss said with a smile. "And thanks again for saving my life. Maybe I'll get the chance to repay you?"

"Doubt it," Judy remarked with a heavy sadness as they laced their fingers into Stan's. Seeing the two of them together made him wish he had spent just a few more moments with Issy.

He took solace in the fact that by now she should be returning to safety.

"When all is said and done, I'll take you for falafels. Continue your culinary education," Stan said with a smile. Even he looked worried, though he was trying to cover it with confidence.

"Sounds good," Moss said, not believing he would ever know its taste.

Burn strode over. "Ready?"

"As we'll ever be," Ynna said, sliding a clip into her autorifle for dramatic effect.

"Let's ride," Burn said and walked over to the door. He stopped for just a moment and pulled his hat from his head and pressed its base against the door as he ran his other hand over

the greasy gray hair on his head. He returned the hat and sighed deeply.

All the moments which lead Moss to this flashed before him as the large doors began to slowly open.

They stepped into the dark, massive room lit solely by blue LED lights on the server towers. The room seemed to stretch on forever, precision air conditioning keeping the rows upon rows of towers at an exact temperature. It was ominously peaceful, silent but for the electric buzz. Burn led them quietly through the towers, every one of them waiting for the moment they were spotted.

The drudges did not disappoint. As Judy knelt to place the first charge, one rounded the corner and began beeping wildly, the targeting system coming to life in an instant. Stan wasted no time, blasting the machine with a heavy laser rifle. Sensors picked up on the gunshots and sheets of metal unfurled to cover the towers before fans turned on to suck out any smoke. The world became a torrent of movement and noise.

"Keep going!" Stan hollered over the sound of rapid gunfire, the drudge spraying sparks and chunks of steaming metal everywhere. Moss and Burn ran. They heard more mechanical legs thudding as they moved toward their destination.

"They are programmed not to shoot the towers so that'll buy us some time when they close," Burn huffed over his shoulder.

Moss didn't speak, clutching his pistol in one hand and the chip in the other. The sound of gunfire continued to echo through the space, mixing with Stan's delighted cheers as he shredded the machines. Another drudge stepped into the lane they were running, and Burn shot a line through its head, cutting

the circuitry and causing it to stop mid-motion before it toppled to the ground like a statue being pulled down. They kept moving until they saw it: a pillar in the center of the aisle with monitors and keyboards on three sides. Two drudges awaited them, flanking the pillar.

"Left!" Burn commanded and the two opened fire. Moss fired at the broad chest plate of one, the first two shots demolishing the metal as the next few fried the electronics, blasting the thing back. Burn sliced his but it got shots off, shredding Burn's shoulder before he dove between some towers. It looked to fire at Moss but could not target him from around the pillar and Burn popped out with his good arm, the line laser cutting the thing in two.

Moss approached the tower and moaned as he had to wait while it powered up. Burn stood and approached. Having cast his weapon aside, he was now clutching his blood-soaked shoulder.

"Have to wait," Moss said nervously, hearing more machines moving in.

"Line's out of juice," Burn said, releasing his shoulder and pulling a rifle from his back. "Second you start the upload we make for the door.

"We need to protect the pillar," Moss said. "Need to make sure it finishes the upload. Don't want one to come and stop it midstream."

Burn grimaced. "Shit, right."

Moss did not want to share his desperate need to get the chip back, to save what was left of his father for himself. He might die, but if he didn't, he wanted the opportunity to speak to his dad again.

"They'll know we are here now, so no time to waste." A welcome screen appeared, and Moss entered his data before flipping open a panel and inserting the chip.

UPLOAD 1% appeared on the screen with a bar filling slowly. Four more drudges appeared and Burn loosed a grenade, clutching his rifle in a weak left hand. The grenade bounced and pistoned toward the robots before exploding, sending metal everywhere and shaking the ground. The screen flickered as Moss ducked but felt warm metal shards pierce his back.

"Fuck!" he screamed as pain coursed through his body and looked up to see 19% was all that had uploaded.

"You're all right," Burn announced. "But this is taking too long."

Moss agreed, wondering how many more waves they could withstand. Three more approached and Moss fired, taking down one. The red flashing battery light screamed at him from the side of his Kingfisher. With the precision targeting of his eye plate, Burn destroyed another, but not before the third began shooting back.

Bullets whizzed around them, Moss's vision going white as one passed through his arm and another through his new leg. Burn snarled as he was hit, blood spraying through the back of his duster. He fired back and eviscerated the last drudge before collapsing.

62% Moss read, red liquid pouring down his arm. Burn hobbled closer. He asked, "How you holding up?" Moss could see blood in his mouth.

"Got shot." Moss panted at a loss for words. He knew he was losing blood, but that Burn was worse.

"Fixing to be our last stand," Burn said, producing a canister that he sprayed on their wounds.

Moss winced and nodded. "Looks that way."

They could both hear more drudges approaching, no doubt the ones stationed further back in the room. Moss's eyes flashed to the screen and saw little progress was being made, every percent increase seemed to take an eternity. They reloaded and waited. The spray had helped to stop the bleeding, but he still felt himself fading slightly, like trying to force himself to stay awake with too little sleep.

"I could stay," Burn offered. "You could run, try to get out with the others."

"Not sure there are any others," Moss said, and five more drudges came around a corner. They both opened fire, but Moss felt that this was the end. There were too many and they were too weak now. They blasted two as Moss's Kingfisher overheated, the plastic beginning to melt, heat radiating through his hand.

He watched the three remaining drudges begin to target and Burn looked over to him, defeat in his eye. The volley was deafening, and Moss simply closed his eyes for impact. But it never came. He opened his eyes to see the three drudges getting blasted with gunfire from behind, their systems trying to turn to face the attack too late.

An explosion rocked the machines to the ground and Moss saw a pink shimmer fly through the smoke as Ynna landed before them, a rifle smoking in each arm. Blood dripped from a wound in her neck but she looked mostly untouched.

"Charges are nearly set." She grinned. "Figured I'd check in with you idiots. Looks like I came at the right time."

"Surely did," Burn said. He looked at the young woman with pride.

"We have to move," Ynna told them, gesticulating wildly. They all turned to see 79% and frowned.

"You lot go, I'll hold them till it's done," Burn said, grim determination in his voice. He looked at peace, as though after a lifetime of fighting, he was happy to make his last stand here.

"No!" Moss wailed.

He couldn't stand it.

He couldn't lose them both at once. "My dad's on that chip," he admitted with a whimper.

"We can't wait," Ynna said. "Stan and Judy are clearing a path now. We have to go!"

"You have to go," Burn clarified. "Say goodbye to me and your dad."

The words landed on Moss more heavily than any of the wounds he had taken. He needed Burn. He needed his father. Even if he survived, he didn't think he could live without them. "I can't," he said but Ynna was already pulling him to his feet.

"You can. You've done us all proud, but now you have to try to live," Burn said, slumping against the pillar. "I'll hold them."

Ynna's eyes were wet, but she held her composure as Moss looked at his dying friend and the computer that held his father. He wanted to survive but not like this. Mechanical footfalls were moving closer.

Ynna smiled miserably at Burn. "Thank you for everything."

"You've both come a long way. Now get out of here," Burn sputtered as Ynna passed him a bag of weapons.

"We'll honor this," Moss said, determined to make those words true.

"I know you will," Burn said and nodded to Moss as Ynna pulled him away. He took one final look over his shoulder to see more machines moving in on Burn and the pillar.

CHAPTER 20

They moved quickly back toward the door through which they had entered but Moss knew he was slowing Ynna down. His shot leg crunched with every step and he knew it was starting to fail.

"The Ferrier's work is going to waste," he said, trying to distract himself and Ynna turned a sorrowful face to him.

"We get out of this, he's going to be getting a lot of business," she said, the words weak on her lips. The two crushed souls trudged forward. No drudges moved toward them and the sound of explosions and gunfire echoed behind them. "We could have stayed," Moss said, wanting to turn back.

"This is what he wanted," Ynna forced through gritted teeth and Moss knew she was right.

At the door, Stan stood waiting, pressing a massive hand over a stump where his left arm had been. He looked wild and tired, blinking in confusion at their approach. His face registered, then dropped.

"Just us then?" he asked pitifully. Blood seeped out between his fingers.

"Just us," Ynna affirmed, putting a hand on Stan's cheek and giving him a little slap.

"Building is locked down and the elevator is our only way out. Judy is working on it now," Stan informed them. Ynna rummaged in a pocket in her jacket and produced a small canister and length of rolled bandage.

"They'll be waiting for us," Moss said, thinking about the elevator doors opening and being blasted off the face of the earth. He didn't want to have made it this far and lost this much just to be shot dead like a fish in a barrel.

"Truer words," Stan said as Ynna sprayed his wound and began wrapping him. "I liked that arm."

Ynna shot him a little smile. "I'm sure Judy did too."

"You are not wrong." Stan smiled back. Moss liked seeing them like this, joking when all seemed lost. It made it all easier, made him feel like maybe they could survive this. Judy rounded the corner.

"Taking care of my man?" they asked, striding toward them purposefully.

"What's left of him," Ynna joked with a smirk. "We ready? Burn didn't stay in there for us to lollygag."

"We're ready," Judy said, taking Ynna's meaning and they all moved to the elevator. As they approached, they saw an unfolded turret facing out toward them. "Whoever's up there is in for a surprise," Judy smirked. "We'll ride on top, take it to the second to last floor, drop out and take the stairs to the roof. Hopefully, we can blast our way out."

"Sounds good," Ynna said, looking into the small hole at the top of the elevator. "Moss, you first then give me a hand with Stan."

"He's a big fucker," Judy said as they laced their fingers and hoisted Moss up. He clambered into position and dropped his arms, pulling on Stan's one arm until he got an elbow inside and pulled himself up. He turned and pulled the other two up as

Judy hit the button for the one hundred and twentieth floor. The door shut and the elevator rocketed upward. Moss's stomach lurched with the movement and he thought about himself in a previous life, being made sick by short rides up and down the burb.

It glided to a halt and the door opened and bullets rattled the structure before the turret opened up, firing a constant barrage of auto-targeted shots. It whirred to a stop once no one was left and Ynna dropped down. They heard a few more shots before she reappeared.

"Clear," she said.

Seti, Moss thought in a desperate gambit.

Transmission blocked, was all he heard in reply. He was sure the others had tried the same, but now he knew Patchwork was gone and the building was no longer theirs.

Burn must already be dead, but hopefully, around the burbs, people were hearing of ThutoCo's plan. Employees would be rioting—demanding answers and their lives would be safe. They would never know Burn or Moss's dad, though they would forever live in their debt.

As they dropped down, Ynna told them, "It's Carcer." She pointed to the guards.

"The AIC is involved," Judy noted. "Council probably wants more than just BurbSec fighting us."

Two more officers were stationed at the door to the stairwell but Ynna and Judy took them out quickly and they opened the door. The hustled up the stairs to the roof door. Judy stopped them a moment, pressing down on a button at the top of a handheld detonator. As high as they were in the building, they still felt the impact as the explosives went off. Tremors shook the structure.

"We did it," Judy said with a beaming smile. "The people are safe, and the technology is destroyed."

All the people Moss had known his whole life were safe. He felt a joy which he had never before experienced. They had accomplished something impossible, helped countless people and stopped evil.

He thought of his father and how happy he would have been to know what they had done. He was overcome with happiness and pulled the other three into a large hug. Their sweaty and blood-soaked heads were all pressed together. Through the tears of joy, Moss said, "You are all heroes to the people of ThutoCo."

Looking right at Moss, Judy corrected, "we all are."

"Thank you," Moss said as they released one another and turned to the exit.

Stan cocked his weapon like in an action movie. "Blaze of glory?" he asked and they all nodded.

He kicked the door open.

They rushed onto the roof, but as Moss pulled his trigger toward the sea of Carcer officers with weapons raised, nothing happened. Stan was able to get two shots off with his revolver, but the electronic guns were jammed by overhead drones.

"Hold your fire!" ordered a man as the two shot were dragged back into the throng. Spotlights from the drones highlighted the four people holding useless weapons in their hands.

This was it.

They were caught. A fate worse than dying, Moss suspected.

"Put your hands in the air," the man ordered through a loudspeaker. He was tall, with thicker armor than the usual Carcer officer and the scorpion pincer logo emblazoned on his chest. He had curly black hair, a robust mustache and the superior eyes of someone who had caught their prey.

They all dropped their weapons and raised their hands, knowing their few remaining days would be long and excruciating. The man strode toward them.

"I am warden Ninety-Nine," he announced. "I have been tasked with bringing you in for questioning."

They said nothing as the officers swarmed around them. "I will begin with an easy one: who is the leader here?" He appraised each one of them. None spoke, knowing the torture would be worse for the self-proclaimed leader. "This is not a hard question," he said. "So, I ask again. Who is the leader here?"

"I am," Moss said, standing as tall and proud as he could. He knew what it meant but also knew he had the least information to give them, and if it meant his friends would be hurt even slightly less, he wanted to do this. The Warden cackled—a shrill high-pitched laugh that didn't match his intimidating voice.

"The former employee! I should have known," he said. "I guess that means the rest of you are useless to me." He pulled a pistol and shot Ynna in the gut. She grunted, eyes wide with shock and fell to her knees, clutching at her stomach.

"No!" Moss screamed as Ynna slumped to the roof. Judy and Stan pulled and thrashed against the officers but were tased into submission. The Warden smiled a sickening grin.

"Not willing to pay the price, are we?" he asked. "You think you are so noble, but you are playing at a game you can never win. We own this world and all the people in it. You've

done nothing. You've accomplished nothing. And you will die for nothing."

"We'll have died for something," Moss said, brimming with righteous pride.

The man's face contorted with anger. "No, you haven't!" he screamed and stamped his foot.

"We have, and you were not able to stop us until it was too late." Moss looked to the drones, knowing the AIC was watching. He smiled at them, just before a baton was brought down on his head. He saw white, felt the pain and smelled the blood as it poured down his head. The Warden stepped into his blurred vision.

"I will enjoy your suffering." He snarled, pressing the bloody baton on Moss's chin.

Moss blinked in confusion as the man turned. One of the drones exploded overhead. Rockets whistled through the air and the sky was alight with smoke and fire. Moss did not understand what he was seeing. The Carcer officers all turned to fire into the night. Then he saw them: men and women in suits and tuxedos flying in, firing pristine weapons into the officers. Then more.

Scruffy looking kids with blades dropped off drones. Beat up flighted cars opened doors, tossing grenades and firing rifles, shaking the building like an unworldly earthquake.

The Warden looked down at Moss in rage, raising his arm to strike the final blow. His hand fell away as he swung down, his arm moving uselessly as the cybersaber passed through. He turned and ran amidst the gunfire.

Moss saw a woman he didn't recognize holding the blade. She was dressed plainly, with a shaved head and her eyes were two telescoping cylinders which slid in slightly to focus on him.

"They all came," she said in a familiar Australian accent.

"Seti?" he asked as she helped him to his feet. Grimy blew passed them to help Ynna.

"Yes," she said as, behind her, Patchwork decapitated one of the remaining Carcer officers with his katana. "When I put the word out that you guys might need help, every group in B.A. City came. It's hard to get the crews to agree on anything, let alone work together, but they all came."

Moss smiled at her. "For Burn?"

"For what you're doing," Seti said. "And it worked. We got the message out. Even got it on all news stations before D2E got wise and shut it down. It only took a few minutes and all the burbs were in an uproar. ThutoCo was exposed. You guys did it."

Moss breathed a deep sigh of relief.

One of the officers tried to raise a weapon and was shot in the face by Sir James as he walked over to Moss.

"You must tell that old curmudgeon that it is profoundly rude not to invite his friends to a soirée such as this," he said, extending a hand. Moss took it.

"Moss," he said before adding, "but Burn stayed behind."

"A great dysphoria it brings me to hear this but for a nobler cause he could not have perished," Sir James said.

Behind him, there was a great bustle as all the people who had come to their rescue met and commiserated. The scene was abuzz with excitement and celebration. One crew began stripping the Carcer officers for parts and scraps.

Gibbs and Issy ran over and embraced Moss and he nearly burst to see them. After so much loss and sadness, he still

had his best friends. Sir James gave a slight bow and returned to his people.

"We came back," Issy said, her eyes wet and red but happy.

Moss pulled them both in close. "Thank you, guys."

"The eagles came to save the day, eh?" Gibbs joked. As he looked at all the burns, bullet holes, bruises and blood on Moss's body, he added, "you look like shit."

"I feel good," Moss told him without thinking. He saw Ynna being loaded into one of the cars with Grimy at her side. She gave a slight wave as the door closed and the car took off.

"We have to get out of here," Seti told them as Patchwork approached with packs for their escape.

As they geared up, Moss looked at his friends. "We did it," he said.

"Thanks to you." Gibbs smiled and Issy kissed Moss on the cheek. His heart raced and he forgot all about what they had just done for a brief moment.

While her face was still pressed against his, she whispered into his ear, "I'm still pissed."

"I know," Moss admitted. He hung his head with shame.

She gave his hand a little squeeze. "But I still love you."

"You, too," Moss answered.

"I know," Issy said, rolling her eyes and stepping back. The sky was full of people taking flight, leaving the roof of the now destroyed ThutoCo headquarters. Moss felt pain and elation, misery and joy as he lifted from the roof. Gliding over the neon city, he thought of his grandmother, of his parents, and of Burn.

"We did it," he told them and smiled into the night sky.

THE END

EPILOGUE

Arthur Smith was nervous. He had never been nervous meeting with the other members of the Amalgamated Interests Council before. He resented it, hated that he was made to feel less than, that the other members were making him wait outside while they had a discussion. He felt like a child waiting for the principal to call him in.

He had helped to make this council what it was— brought others to the table and given them a unified goal. His trade deals with the off-world corporate separatists had made them all richer. He had made ThutoCo a guiding force for global profits.

Not that any of that mattered now.

He had been brought low. His plan had been exposed. His research had been destroyed. He had put the council at risk and now he would pay. He had his talking points planned, though. He knew how to spin it, sell optimism from failure. He had done it before. He could do it now. He pulled the glasses from his nose and cleaned the already pristine lenses between his thumb and forefinger with a lens cloth.

The door opened and he knew to enter. He strode in with all the confidence he could muster and looked up. He was surprised. The room was empty save for Alice Carcer, CEO of

Carcer Corp who had changed her surname to reflect her dedication to the company.

"There has been a vote," she said in a calm but calculated manner. Her unnaturally baritone voice had always thrown him.

"You can't vote without me!" Arthur shouted; the composure gone in an instant. When he yelled, the South African accent he worked so hard to hide came out.

"Emergency measures," Alice told him. "Take a seat, Arthur." He sat in a plush leather chair around a circular wooden table opposite the severe woman who stood in a freshly pressed suit. He had known her a long while and knew her calm façade covered a serpent's den mind.

He seethed. "What vote did you take?"

"Don't worry," she began, "you will remain on the council."

He wanted to spit. Of course, he should remain on the council. His ire was up. He wanted to stand and hit the woman but knew she was stronger than he.

"Good," he hissed, trying to cover his anger but failing.

"But I have been made president and was asked to speak with you," she said with a crocodile smile.

"Just like that? Without giving me a chance to present my case?" He could feel his blood boiling.

"Just like that," she repeated, adjusting the ceremonial blade she was famous for wearing so she could sit. "Listen, Art," she began in a conversational tone. "You fucked up. We all know it and you know it. This plan was your baby and we all loved it, but you were revealed to the world."

"We can still achieve our goals," Arthur forced.

She stared at him with cybernetically enhanced crystal blue eyes, piercing him. "Perhaps, but it will take time and planning, and everyone is pissed."

"A mechanized planet was always going to take time," he defended.

She nodded thoughtfully. "Yes, but we were right on the cusp of beginning. This cockup exposed the frailty of your plans and set us back years, if not decades. The colonies are growing and expanding by the day and we will continue to waste valuable resources here."

"I know," he said, rubbing his face with the palms of his hands. "I was the one who came up with the plan."

"So, you keep saying," Alice said, inherent condescension laced into her words.

Arthur said, "I have a plan to get us back on track."

"Enlighten me!" Alice smirked. "Your employees are rioting, ThutoCo is being mocked in every city, you are having to pay off families, facing lawsuits and even investigations from the mayors of Seattle and Mumbai. But you have a plan?"

"Yes," he affirmed. "But I'm not inclined to share it with you now."

"Fine, you got yourself into this mess, let's see you claw your way out," she said, rapping her fingernails on the table. "As to the employee Moss," she began.

"I will find him and his little group, and they will suffer." Arthur snarled. He hated to hear that name. The little pissant had caused him nothing but headaches.

"You'll do no such thing!" Alice laughed. "I have wardens in every city clamping down on these little groups. The bounties are so high, that any of these so-called 'detritus' even sneeze and we are banging down their door. Your corporate

security couldn't stop them before, so it will be Carcer to stop them now."

It was Arthur's turn to laugh. "You didn't stop them either. Bernstein had a bounty worth, what? Fifty million? And he still eluded you for years."

Alice bristled and her eyes narrowed. Arthur had watched as powerful people had crossed her, before disappearing off the face of the earth. She had not become head of the world's most powerful security company for nothing. At that moment, he didn't care. He was wounded and angry and had his own reputation to think about.

"My employees keep this planet safe while yours cause headaches. My wardens are not at issue here," she stated so bluntly that Arthur hardly knew how to react. He knew she wouldn't see her own failings and had already pinned everything on him. He wanted to hurl the proverbial bag of shit she had laid at his feet right in her face but knew he had to play nice if he wanted to keep his seat at the table. He had scraped his way up from the bottom before and he could do it again.

"What makes you think you can catch them now?" he asked in as conciliatory a manner as he could muster.

She smiled and stopped letting her fingers click their eerie sound. "Because I had something set aside for a rainy day and now it's pouring. I always have an ace up my sleeve."

Arthur found this answer almost comically vague despite her attempt at gravitas. "What have you done?" he asked dubiously.

"I have cast a line and soon Detritus Sixteen will be caught. Then we can figure out what to do with you," she said, her voice so low it sent a chill down Arthur's spine.

NOTE TO THE READER

Thanks for reading *Into Neon: A Cyberpunk Saga*. If you enjoyed the book, please leave a review; it is incredibly helpful to new authors. Reviews are one of the ways in which people can discover new work and help me to create more of it. Thanks again for reading.

For free content, a glossary of terms, cosplay, concept art and much more, visit Thutoworld.com

AUTHOR BIO

Matthew A. Goodwin has been writing about spaceships, dragons, and adventures since he was twelve years old. His passion for fantasy began when he discovered a box set of the Hobbit radio drama on cassette tape in his school's library at the age of seven. He fell in love with fantasy worlds and soon discovered D&D and Warhammer miniatures.

Not wanting to be limited by worlds designed by others, he created Thutopia (now called the Thuton Empire), a fantasy world of his own, which he still writes about to this day.

Like many kids with an affinity for fantasy, a love of science fiction soon followed. He loved sweeping space operas and gritty cyberpunk stories which asked questions about man's relationship to technology. That led him to write his first published work, *Into Neon: A Cyberpunk Saga*, which takes place in a larger science fiction universe.

He has a passion for travel and wildlife, and when he is not off trying to see the world, he lives in San Francisco with his wife and son.

Made in the USA
Las Vegas, NV
27 November 2022

60446251R00163